New Museology

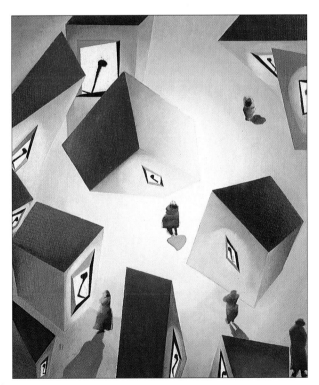

Zoe Zenghelis, Vive la difference, *June 1991, oil and collage, specially painted
for this issue of* Art & Design

eople will be call...

Assassination is the extreme form of censorship.

GEORGE BERNARD SHAW

Goebbels Forbids Art Criticism

Because this year has not brought an improvement
I forbid once and for all the continuance of art critic...
form, effective as of today [November 27, 1936]. Fro...
reporting of art will take the place of an art criticism ...
itself up as a judge of art—a complete perversion o...
of "criticism" which dates from the time of the Jewish ...
art. The critic is to be superseded by the art editor. T...
art should not be concerned with values, but should c...
description. Such reporting should give the public a cl...
its own judgments, should stimulate it to form an opini...
tic achievements through its own attitudes and feelings.

An Art & Design Profile
Edited by Andreas C Papadakis

New Museology

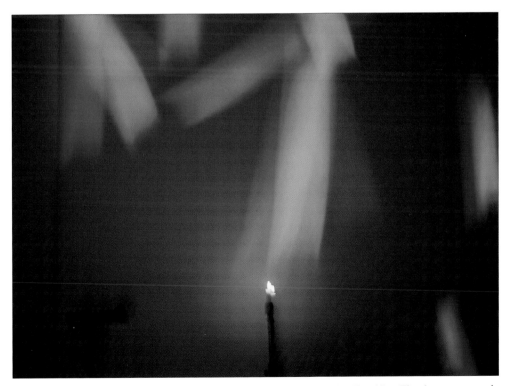

Nam June Paik, One Candle, *1988, video installation, Museum of Modern Art, Frankfurt. The observer enters the room to find a candle on a tripod at approximately eye level. A video camera films the flickering light of the flame. The camera is in turn hooked up to four video projectors which transfer the image simultaneously – or so it appears to the human eye – onto the walls of the exhibition room. As Nam June Paik writes, 'This is the first piece in which I have combined a candle and TV projection. The shadow of a candle is always very poetic . . . especially the flame, which is eternal. Can we electronically amplify or even beautify this thousand-year-old technology?'*

Joseph Kosuth, The Brooklyn Museum Collection: The Play of the Unmentionable, *1990, installation detail, The Brooklyn Museum, New York*

ACADEMY EDITIONS • LONDON

Acknowledgements

This issue takes its theme from the
THIRD ANNUAL ACADEMY FORUM ON NEW MUSEOLOGY
at the
Royal Academy of Arts London

We are grateful to the President Roger de Grey and to the staff of the Royal Academy of Arts, in particular MaryAnne Stevens, Librarian and Head of Education, for her help and collaboration in realising the event. We would also like to thank Edwina Sassoon for her assistance in organising the forum.

We would like to thank the following artists, architects, museums and galleries for their assistance in providing material and information: *Front Cover*: Museum of Modern Art Frankfurt; *Back Cover*: Solomon R Guggenheim New York Panza Collection, Varese, photo Clare Farrow; *Inside Front Cover*: Rem Koolhaas (OMA); *Inside Back Cover*: capc Museum of Modern Art Bordeaux; *Half-Title*: photo *Art & Design*; *Title*: Centre for Art and Media Technology (ZKM) Karlsruhe; *Frontis*: Joseph Kosuth; *Contents*: Saatchi Collection London.
Royal Academy Sackler Galleries *pp6-7*: drawing from the Royal Academy of Arts London; **New Museology** *pp8-37*: This text is an edited version of the Third Annual Academy Forum recorded at the Royal Academy of Arts on 15 June 1991. The Sackler Galleries and forum participants were photographed by Mario Bettella. We would like to thank the following for providing material: *p12 centre* Solomon R Guggenheim New York *below* Waddington Galleries London; *p13* Waddington Galleries; *p14* Museum of Installation London; *pp16-17, 19, 20* Joseph Kosuth; *pp26-27* Coop Himmelblau Vienna; *p30 above* Izan Ritchie, *p31* photos of the Sainsbury Wing, Venturi Scott Brown & Associates. **Wittgenstein's Plumber** *pp38-39*: Material from Joseph Kosuth. **To Exhibit, to Place, to Deposit: Thoughts on the Museum of Modern Art, Frankfurt, and A Positive Equilibrium** *pp40-49*: We would like to thank Hans Hollein and the Museum of Modern Art Frankfurt for permission to publish photos of the museum and its contents, together with extracts from the catalogue texts by Hans Hollein and Jean-Christophe Ammann, published June 1991. **Beyond the Frame: An** *Art & Design* **Interview** *pp50-61*: Interview and photos at the Villa Litta Varese by Clare Farrow. We would like to thank the following for providing visual material: *pp52 above and centre* MOCA Los Angeles; *pp58, 60, 61* Solomon R Guggenheim New York. We are grateful to the Guggenheim for permission to publish works from the Panza Collection and in particular to Michael Govan for his assistance. **The Conversation of Accommodation: The New Museology** *pp62-63*. Anthony d'Offay London. **Conservation and Colour** *pp64-69*. A new translation by Geoffrey Bennington, from *Jean-François Lyotard: The Inhuman*, to be published by Polity Press Oxford. We would also like to thank Martine Caeymaex at the Palais des Beaux Arts Brussels for material on Daniel Buren. **An Abstract Definition of Space** *pp70-71*: This text was compiled and translated from texts provided by Jean-Louis Froment, in particular writings by architects Denis Valode and Jean Pistre; illustrations capc Museum of Contemporary Art Bordeaux. **Centre for Art and Media Technology, Karlsruhe** *pp72-81*: Text and visual material reproduced by kind permission of Heinrich Klotz, Centre for Art and Media Technology (ZKM) Karlsruhe. **On Display** *pp82-83*: Judith Barry material from the ICA; Mario Merz photo from Deichtorhallen Hamburg. **Art Towards the Year 2000** *pp84-89*: Translated by Paolo Valli; illustrations from the Lisson Gallery London. **The Last Picture Show: Thoughts on Screen** *pp90-96*. We would like to thank Charles Chabot, producer of *The Last Picture Show* (*Relative Values*), the programme's participants and BBC Television for permission to publish film stills and extracts from the programme.
pp6-7, 9, 31 right, 34 below, 41 above, 43 below photos by Andreas Papadakis. Other uncredited photos by *Art & Design*.

EDITOR
Dr Andreas C Papadakis

EDITORIAL OFFICES: 42 LEINSTER GARDENS LONDON W2 3AN TELEPHONE: 071-402 2141
HOUSE EDITOR: Clare Farrow ASSISTANT EDITOR: Nicola Hodges DESIGNED BY: Andrea Bettella, Mario Bettella
ADVERTISING: Sheila de Vallée SUBSCRIPTIONS MANAGER: Mira Joka

First published in Great Britain in 1991 by *Art & Design*
an imprint of the
ACADEMY GROUP LTD, 7 HOLLAND STREET, LONDON W8 4NA
ISBN: 1 85490 078 1 (UK)

Art & Design Profile 22 is published as part of *Art & Design* Vol 6 7/8 90
Published in the United States of America by
ST MARTIN'S PRESS, 175 FIFTH AVENUE, NEW YORK 10010
ISBN: 0-312-07141-8 (USA)

Printed and bound in Singapore

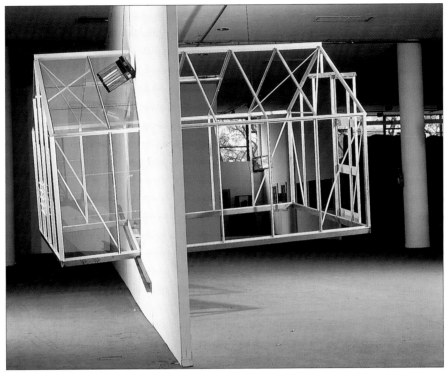

Richard Wilson, High Rise, *1989, glass greenhouse, wooden wall, steel beams, Saatchi Collection, London*

Contents

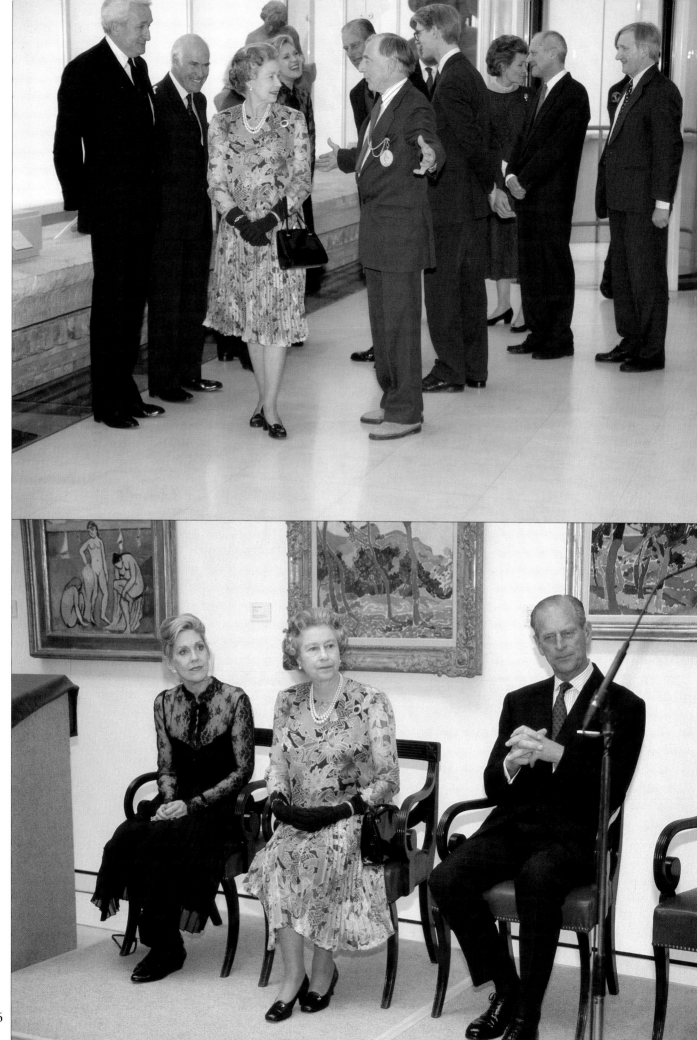

ROYAL ACADEMY SACKLER GALLERIES
A COUNTERPOINT IN SPACE

The opening of the new Jill and Arthur Sackler Galleries at the Royal Academy of Arts by Her Majesty the Queen on Monday 10 June signified the realisation of an outstanding new exhibition space in London. At the same time, it opened a new chapter in the story of the Academy and Burlington House. Traces of the original 17th-century building can still be seen in the facade of the Academy, which was transformed by Colen Campbell in the 18th century, by Samuel Ware in the early 19th century and by Sydney Smirke in 1867, with the addition of the main galleries in the garden behind.

The Sackler Galleries represent a radical remodelling by Foster Associates of the third-storey Diploma Galleries, which modified the original facade of Burlington House in the 1870s. Constructed within the frame of the old structure and naturally-lit from above, with a sophisticated system of louvres to monitor light levels, the new galleries contain an air-conditioning system that renders them suitable for the display of prestigious loan exhibitions such as *The Fauve Landscape* from the Metropolitan Museum of Art in New York, which opened to the public on 18 June.

A solution to the problem of access to the original galleries – consisting of an undistinguished Victorian staircase intruding upon the 18th-century Private Rooms – was found by inserting a new staircase and steel lift, with walls of glass, in the 'gap' between the original Burlington House and the Victorian galleries situated behind. In the proc-ess, Ware's garden facade of 1816, hidden for more than a century, has once more been brought to light. Cleaned and restored by Julian Harrop, it provides a vivid contrast, both to the adjacent Victorian work and to Foster's interventions. The new lift and staircase provide communication between all floors, while remaining completely invisible from the entrance hall and the main staircase. In addition, the lift transports works of art from the basement storage to all gallery levels.

The new system of communication, designed to come to terms with the existing spatial complexity, can thus accommodate the ever-increasing number of visitors to the Academy. One of the most striking elements of the new composition is the space leading from the lift to the Sackler Galleries. Constructed over the original lightwell and incorporating the parapet of the main galleries as a base on which to display sculpture from the Academy's collection, the new space, composed of light and glass, becomes a focus for the colour and activity of visitors entering and leaving the galleries, and the permanent container for the Academy's most treasured possession, Michelangelo's *Taddei Tondo*.

By exploring, uncovering and redefining the existing structure, Foster's Sackler Galleries provide an illustration of what seems to be a highly successful solution to the problems confronting museums in the 90s, establishing an equilibrium and spatial harmony between the old and the new, a reading of history that anticipates the 21st century.

Her Majesty the Queen and Roger de Grey, President of the Royal Academy, at the opening of the Sackler Galleries, 10 June 1991.

Her Majesty the Queen and Prince Philip, with Jill Sackler, at the speech given by Roger de Grey at the opening of the Sackler Galleries

The Royal Academy of Arts, London, 1991, cutaway drawing by Brian Delf showing the new Sackler Galleries

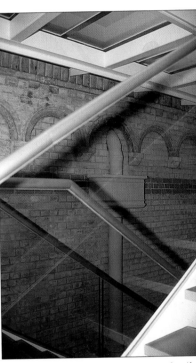

Foster Associates, Sackler Galleries, detail of staircase in the 'gap' showing Victorian facade by Sydney Smirke

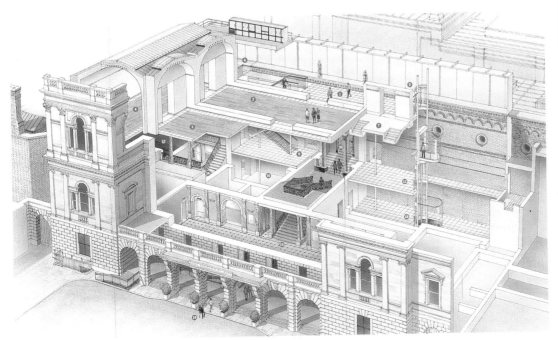

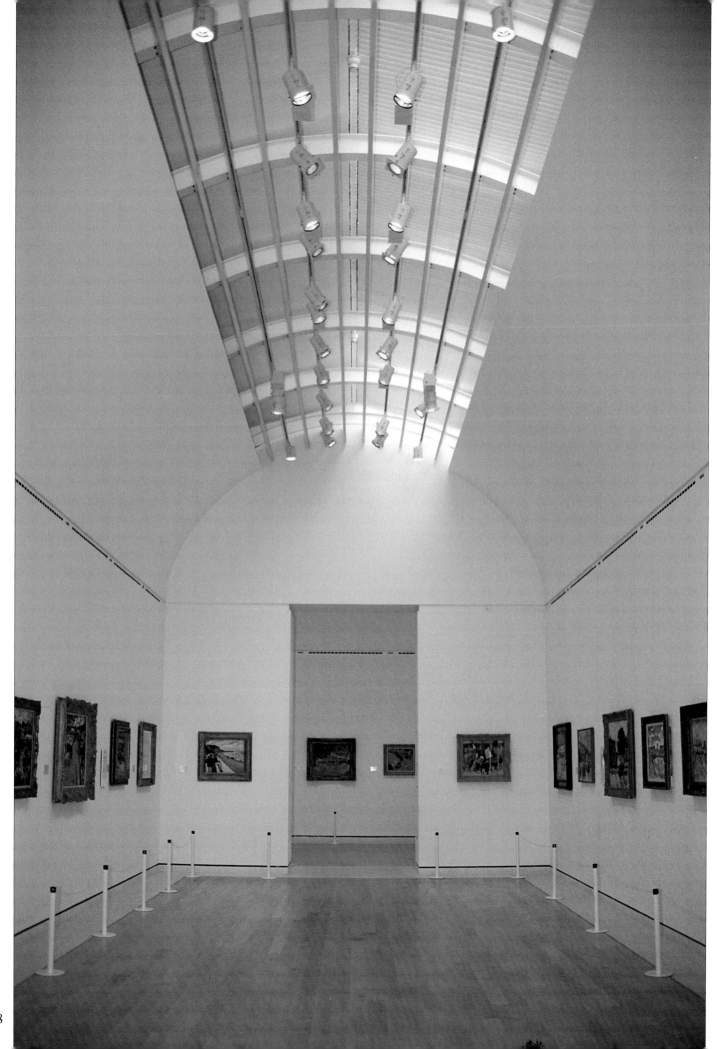

NEW MUSEOLOGY

Annual Academy Forum

The Royal Academy of Arts, The Sackler Galleries, London. Saturday 15 June 1991.
Followed by the Inaugural Academy Architecture Lecture by Sir Norman Foster.

Introduction

June 1991, London: a very appropriate time and place to talk about the new art museum and the old art, the old museum and the new art, about the interaction of different forms of creativity. Foster's Sackler Galleries and Venturi Scott Brown's Sainsbury Wing are prime exhibits. They are both, however, attached to very old museums and intended to contain, on the whole, rather old art. The first questions the relationship between building and contents: the museum as debating chamber. The other confirms it: museum as mausoleum? Not far from the Royal Academy and the National Gallery, the Hayward fortuitously stands, seemingly under sentence of death, but with one of the most striking exhibitions to be seen anywhere this year. Richard Long's sculpture, born in the natural wilderness, finally makes sense of the Hayward's intractable spaces. The new art temporarily vindicates a creaking period piece.

On the international scene, Hollein's Museum of Modern Art opens in Frankfurt (the latest in a line of museums blatantly created to strengthen the city's hand in the impending struggle of the urban titans), Richard Meier's museum-village takes shape in California and Foster opens another museum, the adjunct to a commercial office tower in Tokyo. But the most imaginative concepts of the moment are those established by museum director Heinrich Klotz for ZKM, the Centre for Art and Media Technology in Karlsruhe, designed by Rem Koolhaas. The very title of his creation tells a story. Rather than a museum in the traditional sense, the building will act as a container for experimental research in art and science – an appropriately new modern design for new modern art. Museums were once conceived as places where artefacts were stored and studied. The container was, however grand its architecture, subordinate to its contents. Now the relationship is turned on its head. 'Art' and 'museum' obselete? For 'contents', substitute 'events'; for 'container', read 'catalyst'. The age of the museum as pure monument may well have passed. People are no longer content to be sealed in the built containers which define activities and ways of life. The museum was once the place where you learned from the past and solemnly digested the lesson. Increasingly, it is the place where you go to think about the present and replan the future.

Forum discussion

Chairman Paul Finch, Editor of *Building Design*: This is the third in an annual series of discussions, organised by Academy Group in London, to explore new directions in art and architecture and to examine the interaction between the two disciplines. It is part of an extensive programme of symposia, discussions, lectures and other events organised by the Academy Forum and

Sackler Galleries, view of the main exhibition space showing the hanging of The Fauve Landscape: Matisse, Derain, Braque and their Circle 1904-1908

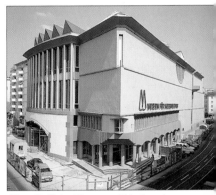

Hans Hollein, Museum of Modern Art, Frankfurt, opened 6 June 1991

Robert Venturi and Denise Scott Brown at the opening of the Sainsbury Wing, National Gallery, London, July 1991

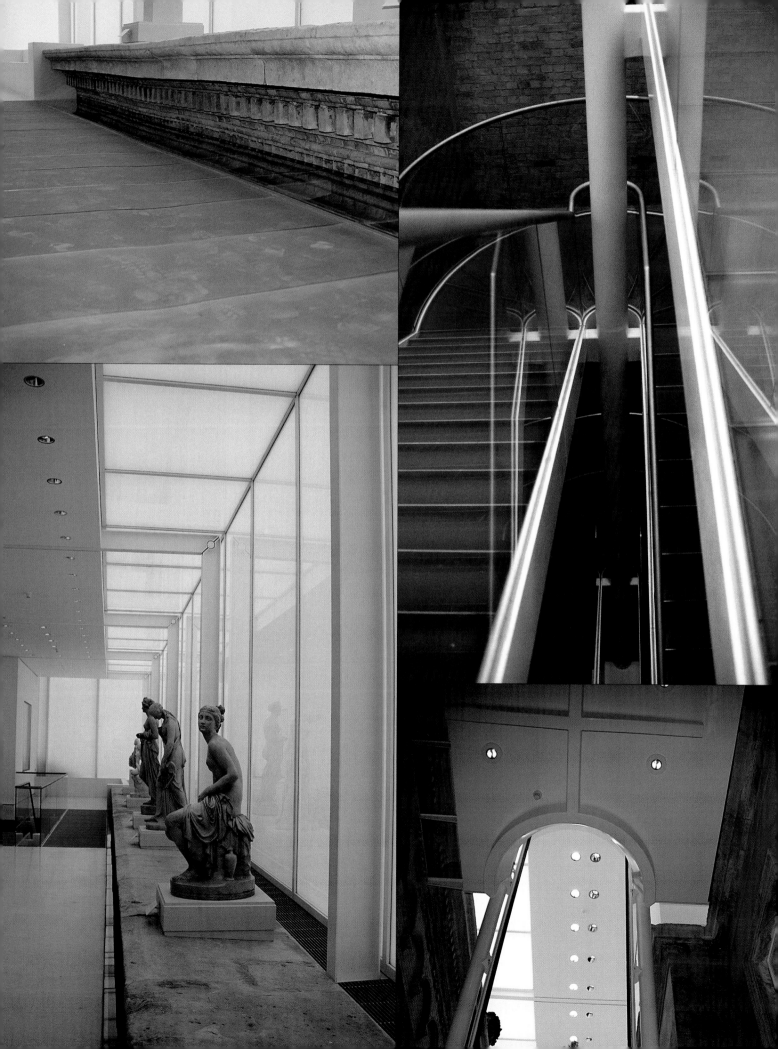

sponsored largely by the Academy Group. Following in the footsteps of *A Vision of Britain* at the Tate Gallery in 1989, and *The New Moderns* at the Royal Institution in September 1990, this year's forum of international artists, architects, critics and curators is taking place for the first time at the Royal Academy of Arts, in the magnificent context of the new Sackler Galleries, designed by Sir Norman Foster – a poetry of space and light that today forms a fitting backdrop, not only to the vivid and theatrical colours of the Fauves in this the opening exhibition, but also to what we hope will prove to be a provocative and lively debate: an interesting prelude, moreover, to Foster's lecture this evening. The discussion, organised by Andreas Papadakis of the Academy Group, in collaboration with MaryAnne Stevens of the Royal Academy, focuses on the subject of New Museology, an important issue in a year that is witnessing the conception and realisation of an unprecedented number of international museums and alternative exhibition spaces throughout Europe, America and Japan. The adaptation of existing structures to accommodate the demands of new media – installations, performances, environments, video, conceptual art – and the construction of new spaces, often in the form of converted factories, with an emphasis on unrestricted light and space, has focused attention on a complexity of issues – the material for discussion today. I would like to call upon Spencer de Grey to open the proceedings.

Spencer de Grey, Foster Associates: When Norman Foster was first approached by the Academy, the initial brief amounted to quite a small project: to look at the old Diploma Galleries which used to be in this space. These were rather run-down Victorian galleries which presented incredible environmental problems: they overheated in the summer and there was far too much uncontrolled light. The initial aim, and I think this grew out of visits to the Sainsbury Centre, was to see how the environmental conditions could be improved. But we soon became aware that in order to create some new galleries here, to show the finest travelling exhibitions, on a small-scale, in the world, it was not only the rooms themselves and the environment that mattered, it was also how you gained access to them. I'm sure many of you will recall that access to the Diploma Galleries was by a rather ill-lit, not very distinguished Victorian staircase and a rickety old lift which Norman compared to that of a third-rate French hotel.

At this point, Jill and Arthur Sackler became involved and, together with the Academy, we studied the building on a wider scale. We then became aware of the hitherto unexploited potential of the gap between the original Burlington House, beneath us here, and the main galleries added in the 1860s. This was an obvious means of completely regenerating movement, both horizontally and vertically, within the Academy. The scheme then took on a much grander scale. Not only were we providing a suite of environmentally highly-controlled galleries, we were also providing new access and, related to that, the potential for displaying sculpture from the Academy's collection. So the project took on a far greater meaning for the Academy, which in turn grew because, in delving into the archaeology of the space between the two buildings, we became very aware of the potential to restore the garden facade of Burlington House and the facade of the main galleries. Therefore a number of different issues came together and allowed us to expose the various periods of the Academy and the buildings of Burlington House, and to add to that the late 20th-century insertions, namely the staircase, the floor of the reception area and the reception area itself. Through a very close working relationship with the client and the principal patron, the project has provided something on a much larger scale than was originally anticipated. It is very different from

Foster Associates, Sackler Galleries, 1991, details

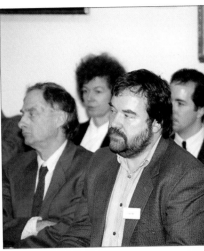

The Third Annual Academy Forum, 15 June 1991, seated in the Sackler Galleries

(left to right) James Gowan and Paul Finch

(left to right) Spencer de Grey and Clive Wainwright

11

(left to right) Ian Ritchie, Michael Craig-Martin and Robert Maxwell

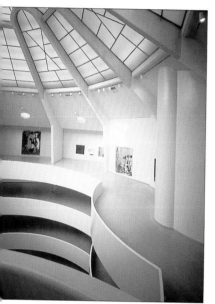

Frank Lloyd Wright, Solomon R Guggenheim, New York, interior renovation, seventh ramp

Michael Craig-Martin, Wall Drawing II, 1990, tape on wall, acetate, 83.8x119.4cm (photo Prudence Cuming Associates Ltd)

the other projects we have done and I think that the challenge of gallery spaces is a very interesting one architecturally. What we are trying to achieve here is a very neutral backdrop to allow the exhibits to breathe and to be shown off to their finest effect. The architecture in itself is attempting to be very discrete: all the servicing, the air conditioning is virtually out of sight, while the lighting and the control of the natural light is also discrete, although there is a very generous amount of natural light. Obviously that has to vary if there is, for example, a watercolour exhibition; then the natural light will come right down. If there is a sculpture exhibition, the louvres can be opened. It is very flexible.

Michael Craig-Martin: I am someone who loves architecture and I love modern architecture. Many of my favourite buildings are museums. But if one takes the Guggenheim as a kind of ultimate example of a great building, as a museum it has curved walls, a sloping floor and it hits at art in every possible way. It is well known that Frank Lloyd Wright didn't like art very much. Here then, we get a full sense of the conflict within a beautiful building, a fabulous building, but one that only rarely looks wonderful with art in it. My feeling is that what you really need to think about, apart from the project and the circulation, is the detailing of the exhibition rooms and this is of primary importance from the artist's point of view. The needs of contemporary art are different from the needs of even the art that we see here – the Fauve canvases of Matisse, Derain and Braque. The Sackler Galleries, with their simplicity and light, are beautiful for this work. However the greatest error of detailing in the room is the place where the floor meets the wall. This is where a lot of contemporary art has its greatest need for simplicity and, in the extreme simplicity of this space, it is actually the most complex point. So it could be very difficult for works to be shown here, especially very contemporary works.

Museums should be built to serve art not architecture. The design of new museums should be based on an understanding of the nature and requirements of modern and contemporary art. These thoughts should be too obvious to need to be stated. The depressing evidence of most of the museums built over the past 20 or 30 years, however, necessitates their re-statement. I want to address the practical problems of designing exhibition space in museums for modern and contemporary art from the point of view of an artist. Since Abstract Expressionism, since Jackson Pollock and Barnett Newman, the nature of the spatial relationship between the viewer, the work of art and the space in which it is shown, has changed radically. No longer windows onto other worlds, other self-contained spaces, contemporary works of art participate in the real space of the viewer, the space in which they are seen. The viewer 'enters' the space of the work, and the work itself interacts with the environment in which it is shown. Because of this spatial interaction, most contemporary art needs a comparatively neutral ambience in order to establish its own space. Where it is unable to do this, where it is forced into competition with the exhibition space, its meaning has been changed. Physical context is as important as historical context. White walls, simple flooring, good lighting may have become clichés, but they are not just fashionable affectations of our time. The problem is how to design exhibition spaces that are neither overdesigned and overdetailed, nor bland and anonymous. Clearly many architects find it frustrating to design relatively neutral spaces and cannot resist a dominant design signature. The space competes with the art, overwhelming it rather than interacting with it, and reduces it to decoration. Unfortunately many architects think of art only as decoration anyway.

Michael Craig-Martin, Painting, *1991,*
house paint with objects, 228.6x129.5x19cm
(photo Prudence Cuming Associates Ltd)

13

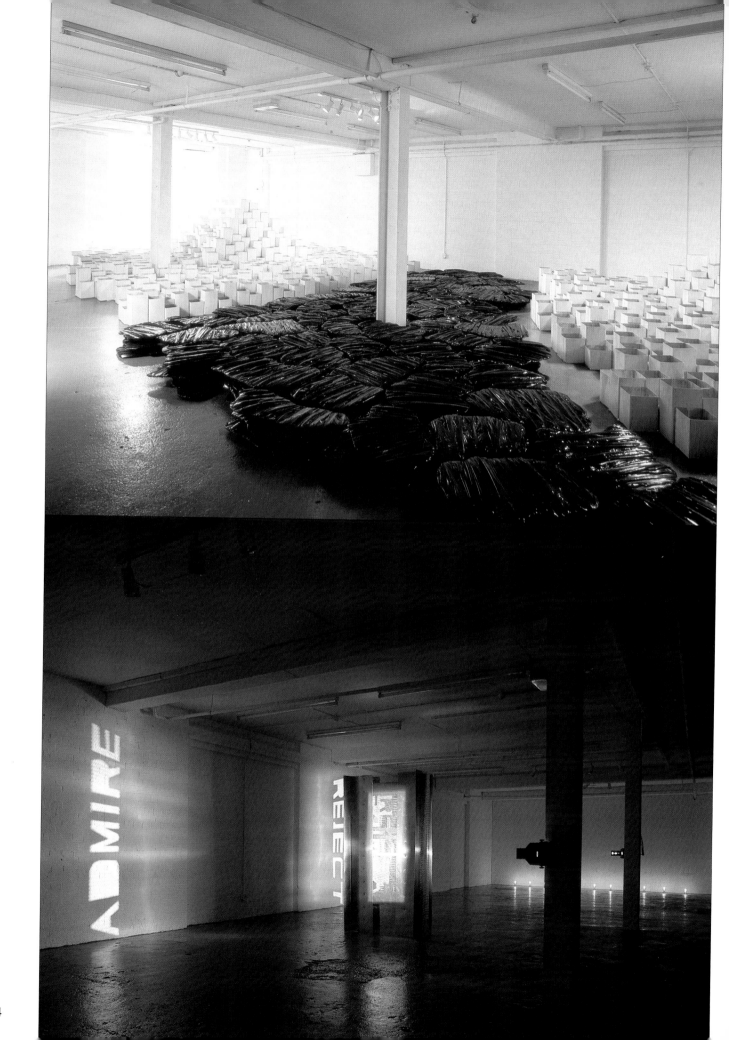

Richard Francis, Tate Gallery: I would agree very strongly with Michael about neutral space and contemporary art. I have real problems with the gap between the wooden floor and the stone floor and walls. It is an interesting length of stone, but it doesn't quite do enough for the lighting of the walls and it doesn't stop you from psychologically getting close to the pictures. I find that a problem. I don't think it would work for contemporary art. Work like Michael Craig-Martin's and Joseph Kosuth's needs a very clear relationship between the wall and the floor and that is something essential for a contemporary art museum. It is less important where there are big frames to protect the works from the environment around them and it works perfectly well downstairs with 19th-century pictures and early 20th-century pictures. After that you have to rethink the sort of room you are putting your art into and make it closer to a studio, a place where the art is made, rather than a traditional, rather grand showing space.

Michael Petry, Museum of Installation: I would like to say, before this discussion goes too far, that we are talking about what I consider to be a spurious notion of neutral space. I just don't think it is possible, when exhibiting contemporary work, even non-contemporary work, for the space not to have a life of its own.

The Museum of Installation (MOI) is about site-specificity and about looking at work within a context. The Museum of Installation exists as a paradox. How does one set the stage for a museum of impermanent art works within the context of the acquisitive world of museum collections? Can a work that is site-specific be transposed to another site and retain the essence, let alone the artistic validity, of itself as a time-based work? How does the curatorial process function, given that one cannot see to assess an installation until it is completed? Can a museum exist in several sites at once? Can a few dedicated artists just open a museum?

These are but a few of the questions the museum has posed for itself in setting up the first museum dedicated to time-based, site-specific art. As the needs of artists grow more and more impracticable for the traditional museum to cope with, due to space restriction, bureaucracy, unconventional methods and the need to preserve the unpreservable, a museum which could function along these lines was needed. MOI cannot and does not claim to satisfy all these needs, but it is a start.

The notion that museums are in stasis is fundamentally in conflict with the historical record and MOI presents an option in the continuous evolution of the presentation and preservation of the art work. We are careful to note that we do not save the art object, as this is for other museums to do. MOI preserves merely the documentation of the past existence of the time-based art work, and in a way the idea of the work. Our archive is a repository for thoughts as well as for deeds. The actions of the artists in our sites are documented by photographs, videos, slides, catalogues and artists' proposals in much the same way as conventional museums, but this documentation is for us all important as the work ceases to exist on its dismantling. To preserve the artefacts, the mere objects of the installations, would be a betrayal of our ideals. So the museum exists as a platform for the creation of art, and the preservation of the idea of that art: a temporary house for contemporary muses.

MOI functions in some similar ways to other museums in that we have lectures, tours, a 'collection' and publications, but what we do not have or need is the physical container. MOI exists as a concept before it exists as bricks and mortar. Installations are created and a house for them is

(left to right) Richard Francis and Maureen Paley

(left to right) Michael Petry and Nicolas de Oliveira

*(left to right) Roger de Grey, Michael Craig-
Martin and Robert Maxwell*

Michael Compton

not. That is not to say that in the future MOI will not take a permanent site. MOI is dedicated to growth, it may be a future need, but even in that situation other sites will still be found and used for projects as we do now, due to the uniqueness of installation art and its relation to site.

Robert Maxwell: I would just like to say that it seems to me that there is a basic paradox about the museum, which is both storing and making available for our cultural enrichment things that have already happened. When one gets on to the subject of new art it is inevitable that it should be questioning, not only the limits of art, but the limits of the museum. The pile of bricks, for example, depends very much on being in a museum in order to be perceived as a work of art. The extension of art as a language, the extension of the edges of art, inevitably calls into question the limits of the museum as an institution. It is inevitable that the artist will try to upset the equilibrium of the institution. However the museum evolves, in whatever new form it comes, art will always want to exceed it. So in that sense we would have to say that there is no end and no final solution. There should be the possibility of extemporalising and the question for me would then be, why would artists who want to question the limits of culture want to be institutionalised?

Michael Compton: Of the types of art created in the last 25 years, those that are formulated as a critique of institutions and of the social systems which support them are probably best exhibited in unreformed museums. But museums do, in spite of everything, continually evolve and, if they have no more permanent references, the works will necessarily be weakened. There is no architectural remedy for this; the museum cannot pastiche its former self as a cultural structure. Those works which require a respectful, refined, neutral space (that is having large, flat, plain surfaces and little decorative detail elsewhere), will be best served by a simplified but well-proportioned gallery of a traditional sort. Those that are contrived by artists to envelope the perceptual organs of the viewer can usually be constructed for limited periods in any large, unobstructed space and may be as much at home in a 19th-century gallery as in a warehouse, since the underlying architecture can be as hidden as necessary, provided appropriate services can be laid on. Those that come alive only when located in the 'real' world, that is the landscape, the street, public buildings (other than the actual galleries of museums), commercial buildings and homes, should not be accommodated by specially designed new galleries until they have become corpses. Exhibiting them in old churches, warehouses and factories gives them charm, but only an attenuated vitality.

The kinds of art that do or will make real problems for designers and curators include those that are too large, heavy, noisy, dirty, or dangerous, those that involve the permanent marking of the building and those that require very special viewing conditions like performance, film, interactive information media, etc. In some cases these can be presented in separate old or new institutions, which have to be adaptable to constantly changing technology and expectations. But some may only gain a point when shown in close proximity to more traditional types of art in permanent collections. Architects, artists, patrons and curators may become excited by schemes to enlarge or adapt museums for them or to build new ones for old as well as new art. This will mean that galleries to house, say, the 20 leading artists of the last 25 years may have to occupy as much space, and cost as much, as all those for the previous two to six centuries. The integrated and very large works of earlier periods have mostly disappeared from museum walls as the demands of new accessions and changing notions of display have shifted the balance between their public appeal (as seen by

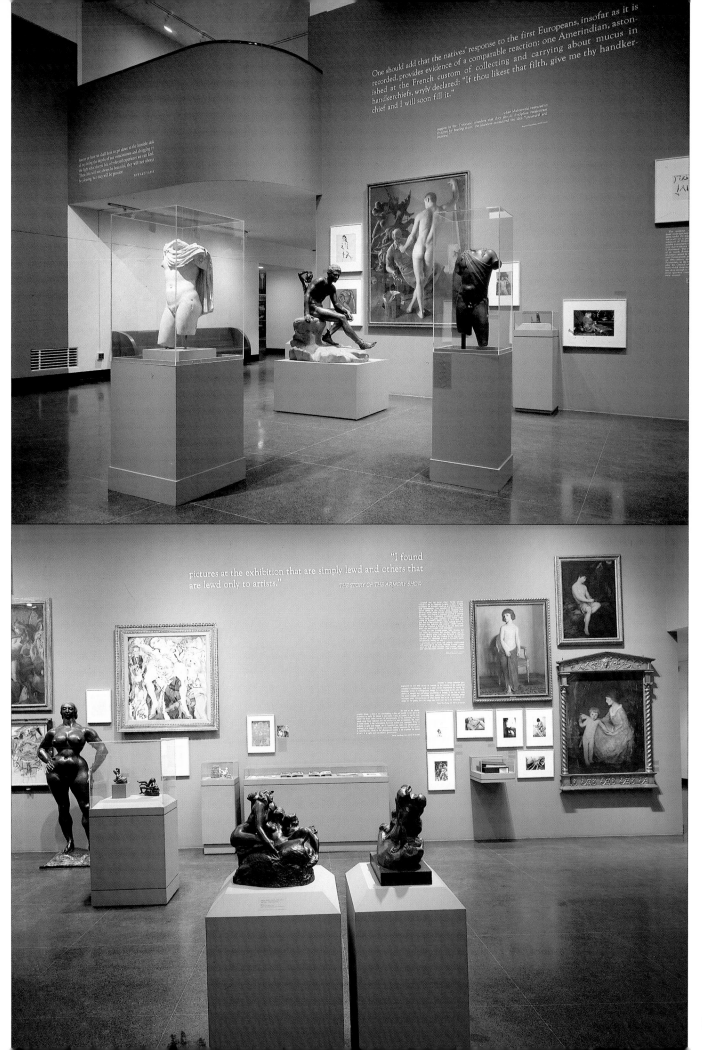

One should add that the natives' response to the first Europeans, insofar as it is recorded, provides evidence of a comparable reaction: one Amerindian, astonished at the French custom of collecting and carrying about mucus in handkerchiefs, wryly declared: "If thou likest that filth, give me thy handkerchief and I will soon fill it."

"I found pictures at the exhibition that are simply lewd and others that are lewd only to artists."

THE STORY OF THE ARMORY SHOW

19

Joseph Kosuth, The Play of the
Unsayable: Ludwig Wittgenstein and the
Art of the 20th Century, *1989, three
installation views, Vienna Secession*

curators) and their exigence. There is little doubt that no matter what we may think now of the heroes of the art that has made these demands, curators given a new building will soon adapt it to whatever they feel they must show in the future. The more demanding the object or installation, the more likely it is to go into storage and, once in storage, it will have little chance to be seen even on special request. A few special museums or wings will remain scattered about the world as a more extended monument to this great work, but its isolation will in all probability make it the passion of a very small, dedicated elite.

Joseph Kosuth

Joseph Kosuth: Marcel Duchamp was once asked what for him was the difference between sculpture and architecture. He thought for a moment . . . and then he said, 'plumbing'! I have always thought that this was a useful guide-line for our considerations. Architecture has always been one of the most political art forms, in the sense that it makes assumptions about the social life and there is a certain level of psychological organisation involved. I have recently gone from living exclusively in Manhattan, to living part of the time in an 18th-century house in Belgium and have been really struck by the difference. We have various tasks that are implied by the word museum: preservation, conservation and the availability of almost a library of works, which certainly calls for certain things. Most of the contemporary work I am interested in deals with context. And of course, when you are invited to work in a museum you are dealing very much with an institutional context that colours works, socially and politically, in certain kinds of ways. The approach to the work is organised very much by the history of that institution and what has preceded your own work. Often the architecture reflects that institutional texture and so you actually come down to struggling with rather pragmatic things. Maybe I am just reflecting my own position, but I have found that architecture in relation to art should be naturalised in a way that serves the art. The meaning of the architecture should be useable. That is why buildings that were originally intended for something else, that have been taken over by contemporary art, tend to work quite well. But it is difficult to be prescriptive. I have a particular experience of making art, certain priorities of my own, but it is impossible to say what younger artists would want from a space.

Two recent installations of mine, *The Play of the Unsayable* at the Vienna Secession and the Palais des Beaux Arts in Brussels for the Wittgenstein Centennial, and *The Play of the Unmentionable* for the Brooklyn Museum in New York, among other aspects, had the intention of disrupting our habituated, institutionalised approach to the exhibition format. I am not an art historian, nor am I a curator. But for over 25 years I have felt that the material of an artist is meaning, not forms or colours; so more than anything else, my material has been the context itself. When the Vienna Secession invited me to do the Wittgenstein show, they made the point that the Secession is perhaps the only museum in the world run by artists. They told me that they felt it would be most appropriate if such an exhibition were organised not by an art historian or a philosopher, but by an artist. It was from this point of view that I began to consider what the difference was if an exhibition is a work of art in its own right.

The primary difference between a show curated by an art historian and an installation curated by an artist, is that the artist, due to the nature of the activity, takes subjective responsibility for the 'surplus' meaning that the show itself adds to the work presented in it. Traditionally, the art historian's practice involves objectifying what is basically a subjective activity, by masking it with a pseudo-scientific veneer. While scholarship has a role to play in the assessment of older works, the

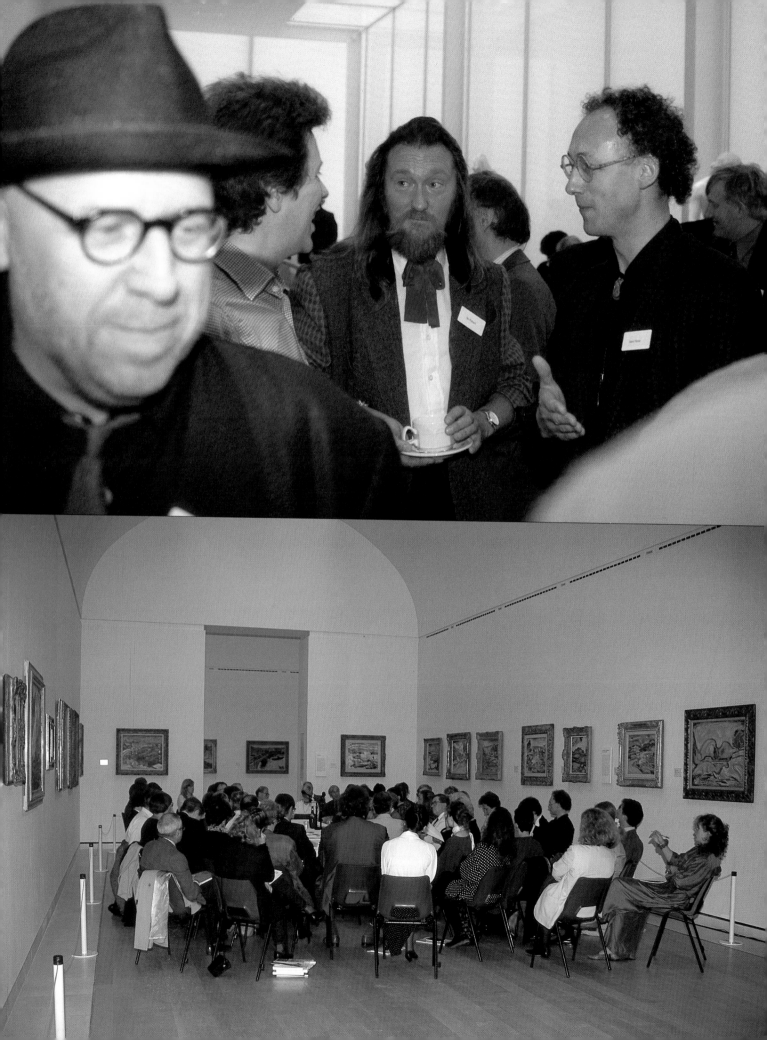

closer one gets to contemporary art, the more the need arises for an informed understanding rather than such 'objectivity'. The role, in fact, played by the latter pretence is to create a history by an authoritative voice. Such a 'voice', articulated as it is by the construction of a cultural Autobahn of 'masterpieces', tends in the end to glorify a particular cultural history and, by extension, a particular social order. What the public then experiences from this sort of 'surplus' meaning is more often authority itself, with the result being that viewers are de-politicised as they are distanced from the meaning-making process in the cultural act of looking.

My agenda in organising the Wittgenstein show, for example, was not to 'craft' history nor to promulgate an historical vision. On the contrary, the viewer was invited to participate with me in a consideration of the meaning my juxtapositions produced. I neither masked the event of my juxtaposition (or my role in doing it), nor made claims of validity, value or importance pertaining to the integrity of the individual works used in my installation. But in viewing the relations between works, in a context of meaning constructed by me, the viewer is invited to participate in the meaning-making process, and in doing so begins to understand and experience the process of art itself. Rather than usurping the integrity of individual works, I was told by many viewers of both the Wittgenstein show and the Brooklyn show that seeing works employed as I did in such installations articulated difference in such a way as to make the works more visible, not less so. In such a context, work unfettered from being signposts of authority is seen as the residue of an artist's thinking and is more accessible. The viewer gets a sense of how art is made and how artists think. My work, that 'surplus' meaning of the choice of works and their form of presentation – all that goes into the installation – is not unlike a writer's claim of authorship to a paragraph, comprised as it always is of words invented by others.

Michael Craig-Martin: It seems to me, Joseph, that the biggest change from living in a loft to living in a house is that you move from a space to rooms. There is a big difference between looking at art in a space and in rooms. One of the reasons why these galleries look so great is that you have a real feeling that you are in three rooms. They feel like rooms, they don't just feel like spaces. When I said neutral space, I did not mean bland space. The more character a space has, the better. But you often don't get that in museum spaces which are designed specifically for art.

Many of the best contemporary exhibition spaces and new museums are conversions of old buildings of great character, created originally for other purposes. Some older museums are removing the accretions of partitions, false ceilings and blocked doorways to return buildings to their original architectural character. Contemporary art sits well in such simple but often charged circumstances. There is, I think, something important to be learned from this for the design of wholly new museums. The old museums, the converted factories, warehouses and hospitals consist of rooms, not 'spaces'.

Michael Compton: In the 60s, and again in the 70s, artists enumerated several kinds of space which they wanted in museums. The last occasion I know of when this happened was when a group of artists tried to form a brief for what became MOCA in Los Angeles, specifying a space which might be rather like this one, whose perfect details and quasi-neutrality would focus attention on the works of art and validate them. They also wanted a space which was just a shell, keeping the rain out, having a strong enough floor to move fork-lift trucks about, or anything else necessary in

(left to right) Joseph Kosuth, Robert Adam, Ian Pollard and Mark Fisher

The Third Annual Academy Forum seated in the Sackler Galleries

Michael Craig-Martin

(left to right) Louwrien Wijers, Victor
Arwas, Michael Compton and Alan Borg

Louwrien Wijers

order to build shapes and light systems, or whatever it was that might serve to change the perception of the viewers who came into it. At the same time, they wanted a space which manifested its own history in the manner which we have just heard now, a sort of space which might well have been an old garage, an old palace, or something which they could then treat as a context, which was hopefully packed not only with gritty physical details, showing evidence of the past, but also plenty of social symbolic material which allowed them to fight or to react. Then they wanted the guts of the building itself, the actual plumbing, the offices, the lavatories, so that they could place their art in a space that would be functional, that a gallery or museum dissimulates.

Those are the types of space that I can recall, but they may also have specified a space for events, a theatrical space where the attention could be focused on the person rather than the artist, on what was being done rather than any physical or symbolic object. The problem is that you can provide a collection of buildings, existing as the residue of history, but the mind boggles at the idea of designing a new museum providing all these sorts of spaces, I suppose that is what we are talking about now. When you design an exhibition space like the Sackler Galleries, you are only making a subtle shift in a system which is already well established, which defines the type of art within it, to some degree consistently, while allowing the art to transgress only partly. But the problem, as I have said, is one of designing a new museum to somehow or other do all these things. I think it is impossible.

Joseph Kosuth: Michael Compton raises an interesting point: why are so few artists on the boards of museums or even consulted on museum design? There are consultations on other aspects of building a museum – but those that are centrally involved in the museum's use are systematically eliminated from the process. Shall we guess why? First, of course, as we see more and more museums being built, it becomes clear that the competitiveness which architects feel towards the artist (and which is several centuries old) is becoming more and more acute. But on a less obvious level, because art is a meaning-making process above all, the artist takes a position and asserts a commitment. Since this commitment is also a subjective one, his or her production is primarily approached as 'nature' by the institutional process (art historians, cultural bureaucrats, architect, client-donor and so on) from which 'culture' (their order) is made. Perhaps the perception is that the self-reflexive process of art itself would provide an intolerable critical consciousness within the desired seamlessness of an institutional flow. In this sense, artists (being less alienated from the result of such a process) are intolerable even if art, as a collectable object, is not.

Louwrien Wijers, Art meets Science and Spirituality: I believe that the new museum will be an information centre and I agree that it is not very easy to build a place of this kind. The museum has to grow with the periods in art. We are sitting here surrounded by these Fauve paintings and this room is excellent for these Fauve paintings. But if you are thinking about the museum of the future, we require very many different qualities. One of the qualities that I believe to be very important is that the museum should be one of the only places where we can be really free. We were talking about institutionalised art. The museum is of course an institution. But art is specifically that part of society that wants to remain free and will always try to break away from any dogma, any rules that we have made. So in the museum a person should be able to feel quite at ease and this is why I think the notion of spirituality should be a very important consideration in the building of a museum.

I see museums in a sense as the churches of today, without thinking of an institutionalised spirituality. A museum is a place in which, when confronted by an object, one can experience some kind of inner depth in a very individual and free way. So the place where this will happen, especially in the 21st century, is going to be very important. The museum is not only about spirituality. It is also about politics. So many aspects of life have their place in the museum. We have seen the museum develop from being a place where we see material objects, paintings or sculptures. In the future I can see it growing into a completely different institution, the sort of place where people can come in and pick up new ideas in many different ways.

I have myself used the Stedelijk Museum in Amsterdam especially for such a purpose when I organised the symposium *Art meets Science and Spirituality in a Changing Economy* in 1990. I called it a 'mental sculpture', in the sense that we use all our mental ability as the sculptural material. Such things will be very important in the museum of the future. But I agree, how are we going to build such places?

(left to right) Giuseppe Panza, Achille Bonito Oliva and Andreas Papadakis

Alan Borg, Imperial War Museum: I was formally at the Sainsbury Centre, so the Sackler Galleries appear very familiar to me. Can I raise the question of the role of light in galleries and museums in general? I think the problem that Norman Foster has gallantly taken on is the regulation of light, which is a natural substance which varies with the movement of the earth around the sun and the movement of the clouds. He tried first of all at the Sainsbury Centre to resolve this by using louvred blinds. After 15 years, the louvred blinds are clearly more advanced than they were then, but I am disturbed by the quite radical changes of light in this gallery and by the creaking of the blinds. I wonder whether the solutions that Foster is looking for are in fact the right way to proceed. The museum I am now in has of course very wide collections of objects and the other question I would raise is how do you produce a museum or gallery that will produce suitable light levels for various objects, not just for works of art?

Giuseppe Panza

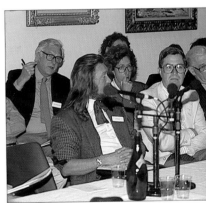

Guiseppe Panza: For me, light is the essential tool for seeing visual art. The wrong light makes the appreciation of the work difficult. Different kinds of light suggest different interpretations. Lighting is an art, not a technical skill. Many people think that a great deal of it solves all problems, which is wrong. Natural light is by far the most beautiful. The art which you can see with daylight looks much better than with artificial light. But natural light has its limitations, in that too much of it destroys colours, the main feature of painting. It changes during the day, but this could be a positive factor when we do not have to look at the subtle details of small paintings. Zenithal light is the best solution for having more wall surface available for paintings, but when it is filtered through a double layer of glass, it loses many of its best qualities and becomes similar to artificial light. Skylights, as large as the roof, are not a good solution, because on sunny days we have too much light which is dangerous for conservation. In a room all painted white, with a floor surface of 200 square metres, windows of six square metres are sufficient on a clear day. However, either on a cloudy day or in winter, we need electricity. Artificial light is another big problem in museums. Flexibility is essential in order to make changes in relation to the needs of different kinds of art. Flexibility needs support structures holding the lighting fixtures which, when they are suspended or protruding from the ceiling, always look ugly and spoil the perception of the space. Diffused light from a few strong lamps is the best solution for the environment, but lamps with a high voltage do not omit radiation

Alan Borg

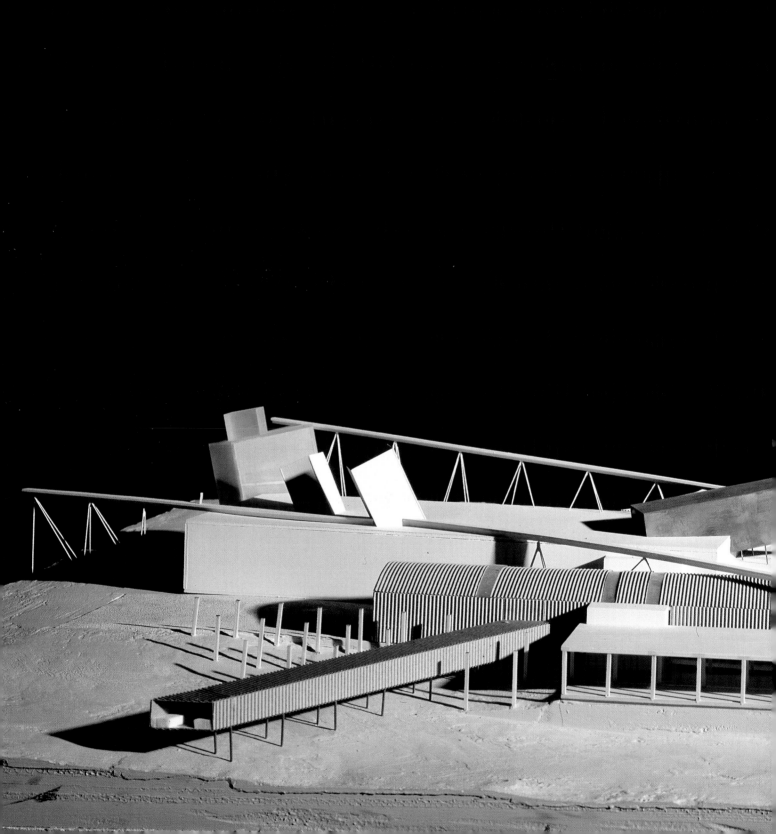

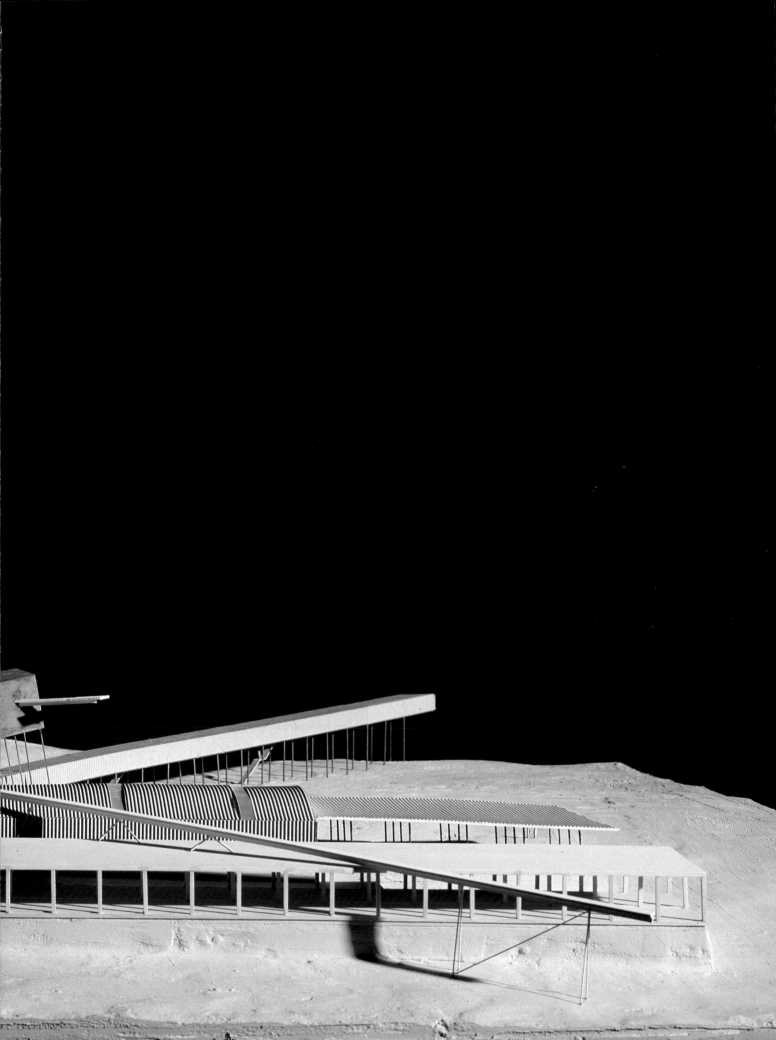

PREVIOUS PAGES: Coop Himelblau (Wolf Prix and Helmut Swiczinsky), Anselm Kiefer Studio, 1990 (unfinished)

Mr and Mrs Wolf Prix

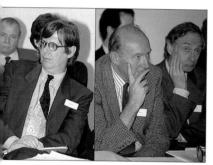

(left to right) Wolf Prix, John Melvin and James Gowan

for a good rendering of colours. Without a technical improvement in the quality of lamps, the problem remains difficult.

Colin Stansfield-Smith, Hampshire Architects: I think that in the future, there is going to be an enormous technological improvement in the control of light in museums and its association with ephemeral artefacts: both with the control of UV and AV in light and also an acceptable aesthetic level of control.

Anna Harding, Kettles Yard, Cambridge: I don't think the key issue has so far been addressed: namely that the purpose of an exhibition space is for the art and the audience to come together. We have been talking endlessly about technical details and finishes of the building. What concerns me more is the relationship between the viewer and the art, particularly in the context of contemporary work. I believe it is important for a museum or a gallery to have a fixed location because people are used to coming to that place to see art. If you have a moving gallery like the Museum of Installation, it will only appeal to the converted who are willing to seek it out. I don't think you can expect architecture to constantly change in order to keep up with the forms of art. Artists' materials and manifestations continuously change: the constant factor, in my opinion, is that galleries contain audiences who go there to look at things. An important issue to be addressed is the identity of the audience for contemporary art. I think that too often it is assumed that people are willing to look at contemporary art and to understand it. I would like to see the gallery become a place where people feel they can debate, discuss and create meanings for themselves.

James Gowan: I think museums are very much a middle-class affair, dominated by the middle classes and for the middle classes. It keeps them busy and interested. I am a little worried about that as a person, but not as an architect. I am perfectly happy about that as an architect because they provide a commission, a project, but as a person it is a little more difficult to accept. As an architect, I have ceased to be a person, but I could refer to my childhood to give you an example! As a boy, the only place in Glasgow where one could go to look at pictures was the Kelvingrove Art Gallery, quite different to this place in every way, in that it was very Victorian, hectic, full of noisy children and very enjoyable on a Sunday. That clearly represented something worthwhile to me and still does. The second fact that I find difficult to reconcile with my position as an architect is that the museum I enjoy most is the Stanley Spencer chapel in Burghclere, Hampshire. It is a very primitive, north-lit space. I have looked for ventilation and students have pointed out that there are cracks in the windows. Very few people go there. The walls are just covered with paintings. It is by no means ideal, but it is a tremendous experience to see the paintings quietly in that setting. For architects the space is primitive and the client clearly built it for the minimum cost. It is built in a really cheap neo-Georgian, there are windows in the side, there's an altar and the paintings can be removed from the wall as they are only wedged in. It is difficult to reconcile the simplicity of the two galleries I have referred to with the highly sophisticated environment we are talking about today.

Wolf Prix: Every time I'm on a panel like this, the question of neutral space is raised. I would be very happy if someone could explain to me what a neutral space is. I have never seen a neutral space in my life!

We, that is Coop Himmelblau, believe that a good museum of the future will, in the next century, make art obsolete. We have never liked museums. We used to prefer going to rock concerts but now, since rock concerts have become increasingly louder and our hearing has got poorer, we occasionally escape to silent, quiet, obliging museums. Thus I have arrived at the assumption that museums are for maturer people.

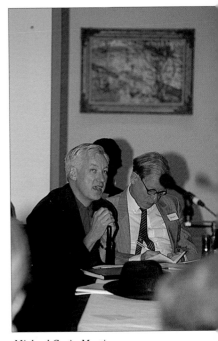

Ten more minutes in this room and I will begin to feel like a framed picture because it is so chilly! This reminds me that a museum is essentially a graveyard and artists appreciate that very much. They appreciate obedient graveyards because a graveyard raises the value of the artist. This is the second theory. The third is that we believe architecture is and ought to be the visual expression of this existing social world and perhaps also of future worlds. For this reason, architecture in the future will have to deal very much with complexity. This is not possible by means of 19th-century additive systems of thinking which we must therefore discard. We have to find complex design methods in order to create complex architecture. Complexity can more easily be found in art, in the developing and resulting processes of art. Therefore, complex architecture becomes art. And if architecture, namely the building, is art, it is a museum all in itself and therefore has no need for art.

But maybe we will have to rethink these theories somewhat as we are now doing a studio for Anselm Kiefer which measures 240,000 square feet. Maybe this is the museum of the future. We have talked a lot about the aesthetic values of the museum and we were very happy to talk to Kiefer, who is an artist, about this subject. It turned out that the more challenging the architecture is, the more challenged the artist becomes. The studio that Kiefer wishes to have, its roofs that are leaking with rain, has a structure that is freezing in the winter. He wants to have sheet-metal roofs because he wants it to be very hot in the summer and very cold in the winter. He needs bridges in the room so that he can see his big sculptures from the top. So this gives me an idea. Can we propose that every artist, before he dies, should do a design for his own museum, so that the architects of the future have no more troubles because they know exactly what they have to build?

Louwrien Wijers in discussion

Michael Craig-Martin

Louwrien Wijers: I want to mention something more about the museum of the future. The Tatlin tower had many different spaces for many different activities and I think that this very much resembles the complexity of the future museum. Thinking about the studio you are building for Anselm Kiefer, I want to mention an anecdote about Joseph Beuys. Beuys said, 'Who needs a studio? I make all my art under the table. If I can't make my art under the table then it's not good enough.' He meant that, above all, you don't need a studio, you need your heart and your thinking as an artist. Another idea coming from Beuys is that we are sitting here around a table and it's a fantastic work of art, in a space that was never built for us to sit in. But in this museum we are actually creating a mental work of art together, a mental sculpture, so you can see how little the environment really has to do with what you are creating.

Clive Wainwright, Victoria & Albert Museum: There has been a lot of discussion about museums adapting to make room for modern objects, but many museums deal with objects that were created for a very specific context, whether it is a chair designed for a particular room or a teapot for a particular table. When these are moved from the context for which they were designed and placed in a museum situation, all sorts of problems arise about how they are to be displayed and organised.

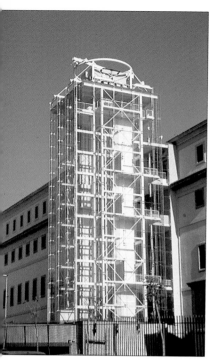

Ian Ritchie, The Glass Tower, Reina Sofia's Museum of Contemporary Art, Madrid, 1991

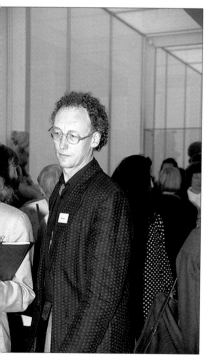

Mark Fisher

Isi Metzstein: I do not really see the need for flexibility; flexibility is for people who do not want to make up their minds about anything. The issue that has not been adequately adressed is the contradictory nature of the process involved. There is the curatorship, the showmanship and the scholarship of the museum. These three must all exist in the same place and must continue to fight each other. The culture of our time effects the fight and the fight effects the culture so that the whole issue of is not about architectural complexity, but concerns intellectual or cultural complexity.

Michael Craig-Martin: I don't think museums need to be flexible at all. I think it is better if they are not flexible and I think it is much better for art to adjust to the circumstances in which it is placed. I also don't think you need to build entirely new museums for new art. The Reina Sofia in Madrid, one of the most beautiful museums in the world for contemporary art, is a very old building. It is also extremely inflexible. The spaces are neutral, but they still have character. I think this is the essential point. What I do not like going to is a place where the spaces are rebuilt for every single exhibition. Places like the Hayward in London and indeed many places built over the last 20 or 30 years, have walls that move. You go through this ridiculous exercise of rebuilding the interior of the place every single time, so that every piece of art is seen on a partition. The idea of the museum as a large open-plan space allowing multiple possibilities of subdivision for each exhibition or arrangement of the collection seems, from experience, to be a mistake. Redesigning or rebuilding the space becomes an an expensive assumption of every installation. The unfamiliar maze of featureless spaces drains both the art and the viewer.

Nicolas de Oliveira, Museum of Installation: I think inflexible buildings provide a kind of context, be it physical or conceptual. Returning briefly to the notion of neutral space, one of the problems I find is that it infers the total bisection of life – on the one hand there is life which happens outside the building, while on the inside there is the attitude that we are 'experiencing' art. I think that this kind of church-like atmosphere, this spiritual experience which is not paralleled by anything else, this attitude of placing art on some kind of pedestal, can be quite damaging.

Mark Fisher: I think the question is really about the number of people who experience these neutral spaces. The spaces all seem to me to share one characteristic, which is that they are all designed to be completely empty of people in order to function well architecturally. This space, with double the number of people here now, would actually be a rather unpleasant space in which to view art. If art is going to have access to the people, it plainly isn't going to do this through galleries. However, it will do it through technology, namely the technologies of video, and increasingly the technologies of virtual reality. The viewer will be able to rub the face of a Cézanne without even making it dirty and to feel the actual texture of the paint through his finger tips. The technology for this is not so far away. That could be the experience of viewing existing classical art. As for what is happening with contemporary artists, who start designing in these new high-technology media, they won't be expecting galleries at all. It will simply be a matter of taking a particular piece of data-storage medium home and slipping it into whatever piece of technology the Japanese are selling us. In view of this, I think that this kind of architectural experience of a gallery is a highly elite activity which has absolutely no bearing on most members of the population at all. I think that

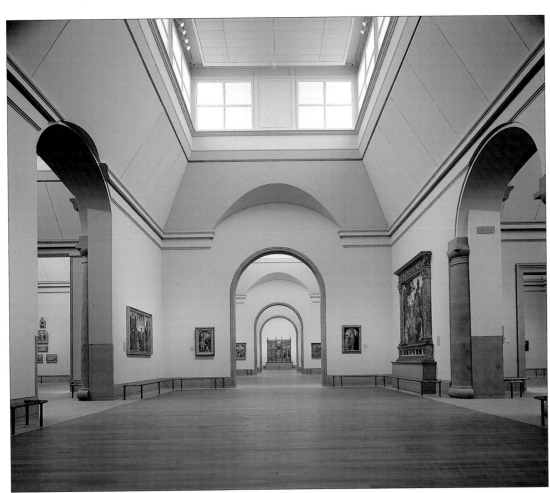

Venturi Scott Brown & Associates, the National Gallery, Sainsbury Wing, view of main hall, 1991

Venturi Scott Brown & Associates, the National Gallery, Sainsbury Wing, exterior view from Trafalgar Square, 1991

The National Gallery, Sainsbury Wing opened by Her Majesty the Queen, 9 July 1991

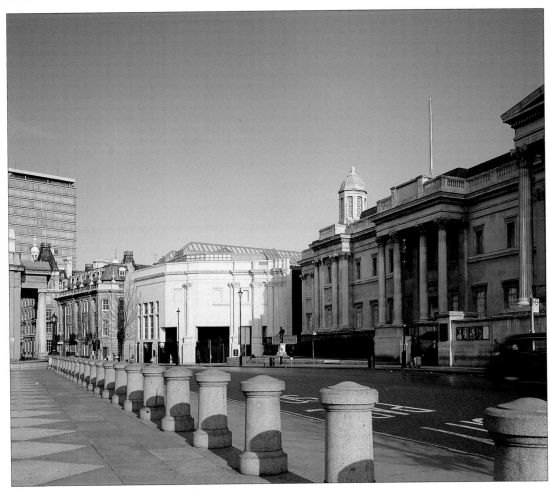

(left to right) Michael Compton, Jules Lubbock and Giuseppe Panza

(far left) Andrew Benjamin

(left to right) Mary Anne Stevens and Ian Pollard

galleries should face up to the fact that they are an elite repository of highly valuable objects for the small number of people who would genuinely appreciate access to the original rather than the facsimile, and in that sense they should be quite prepared to charge enormous amounts of money for the privilege of getting very close to these very expensive works of art. The rest of the population would be far better served by getting good video tapes of paintings with good explanations of why they should like them.

Robert Adam: I think in order to do that, you will have to change the attitude of people who go to galleries and museums. It is a continuation of the argument that Stonehenge should be rebuilt out of fibreglass further away from the original so that no one will damage it. Even if we could produce an absolutely perfect copy of something, people would still want to see the original as it provides a spiritual connection to the figure who created it.

Giles Waterfield, Dulwich Picture Gallery: I am surprised by this implication that not many people visit museums, that it is an elite activity. We are fortunate to see these galleries when there is hardly anyone around, but I am quite sure that once this exhibition is open, it will be almost impossible during opening hours to see the pictures with any degree of relaxation at all. They are beautiful galleries and the paintings are beautifully hung but there will be so many people, the interest in visiting museums and seeing special exhibitions is now so intense, that it will be extremely hard for people to have any degree of personal experience.

Jules Lubbock: We must address the central issue – are these galleries any good? I personally do not think these galleries are worth the money but I'm not about to launch into an attack on their architectural quality, unlike Spencer de Grey who launched into an unspeakably contemptuous attack on the galleries on this site and destroyed them. The very first remarks he made were that there was a 'rickety staircase', and an old lift like that of a 'third-rate Paris hotel'. For those of us who remember that staircase, it was an extraordinary experience, a quiet and beautiful staircase lined with the great Diploma paintings of the 19th century. It was a human experience of the kind that James Gowan was actually describing. Now Foster Associates have replaced it with a very fine staircase, I am not disputing that. The galleries too are beautiful. But what I am saying is that they have displaced something that had real quality, extraordinary quality. If the environment was not adequate for modern museum conditions, then surely it would have been possible to have improved the air conditioning and louvering without replacing the 19th-century galleries. This space is frankly anonymous, but it is actually rather worse than that. The galleries are so exquisitely manicured that it is quite difficult to see the works; in particular I am referring to one of the greatest works in the history of European art which is hanging outside in the lobby: the *Taddei Tondo* by Michelangelo. It is invisible because it is surrounded by a great white space which is lit by an enormous expanse of opaque white glass. As soon as the lighting rises to anything above the level of an extremely gloomy afternoon of an extremely bad English summer, the *Taddei Tondo* disappears.

Andrew Benjamin: To criticise or evaluate these rooms in terms of what might have been, or what was originally there, is, in my opinion, both unhelpful and unnecessary. It seems to me that the first

thing one can say about these rooms is how nice they are, they are extremely nice, enthusiastic, enthusiastically complacent. What they reproduce is that stale and rather tiresome opposition between the work and whoever is supposed to observe it. They reproduce what one has always known museums are going to do and therefore it is as it should be, one expects nothing else and therefore, as an example of what it is, it is a very good example. But it does not help modern art, it does not help developments in new art. The whole point is that contemporary art challenges the possibility of being viewed in these sorts of settings. But maybe it is the case with the Royal Academy that one should ask for nothing more.

Sarah Kent

An example of a museum that has no intention of being complacent is the MASS MOCA project in Massachusetts. What is remarkable about this project, apart from its size, which is enormous, is its acceptance of the fact that the relationship between the viewer and the viewed is something about which a generalisation cannot be made, except for that one generalisation. Therefore the exhibition wants to be exhibited, and how it is exhibited is going to depend on the nature of the relationship between the work and the site itself. There cannot be just one space in which something is located, so there will be a continual reworking of the viewer/viewed relationship. Going back to a word that was used before and that I would endorse, what these buildings bespeak is a complacent simplicity. What is necessary, and what a lot of contemporary art demands, is complexity. How does one demonstrate how a Mario Merz would work? It is already a problem, it can't simply be viewed. The question of its being viewed is already a theoretical problem with which one needs to engage.

Peter Pran

Michael Craig-Martin: The problem about this kind of discussion is that we are talking about so many different things on so many different levels. There isn't an ideal museum and there isn't an ideal space that is right for absolutely everything. The problems involved don't seem to me to be very complicated. But they are discussed as if they were immensely complex. I do not think it is terribly difficult to make spaces that are sympathetic to art, but I think it is amazing how rarely this happens. I do not see it as a great problem. These rooms work very well for some kinds of art but not for others. But that's not really a criticism of these rooms.

Sarah Kent: I would like to mention a few galleries that I find effective as exhibition spaces, in the context of this discussion: the Saatchi Collection, which used to operate as a paint factory; the large DIA Foundation space in New York, which used to be a warehouse; the central sculpture hall at the Tate, which is a very specific space; Frank Lloyd Wright's Guggenheim, which is so specific and extraordinary a space that it is almost impossible to hang any works at all; the Wallace Collection in London; and the very fine room downstairs in Burlington House. What they all have in common is that they are extremely eccentric spaces, with a very strong identity of their own. They are probably all spaces where it is rather difficult to hang works of art and therefore they require a great effort. One thing that they are not is neutral, none of them are neutral. If I had to pinpoint the most memorable exhibition I have seen during the last year, it would be, in terms of the relationship of the work to the space it was housed in, the Richard Long exhibition in the central space at the Tate. This space, recently restored to its original state, was revealed to be a wonderfully fine structure, containing a series of installations that made the space coherent and intelligent. This is a particular skill that Richard Long has; for instance, when you go into the Hayward Gallery you

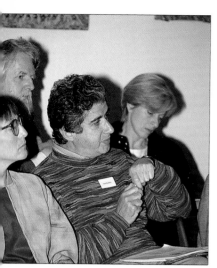

(left to right) Janice Blackburn, Clive Wainwright, David Blackburn and Zoe Zenghelis

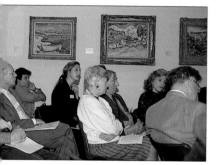

(centre) Iwona Blazwick

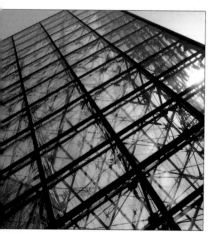

IM Pei, extension to the Louvre, Paris, 1989

normally think what a terrible space it is, how awkward it is. But the Richard Long exhibition seemed to transform it into a clear and coherent space after all. I agree with Michael Craig-Martin that this is possibly one of the most interesting things for an artist to do, to relate to existing traditions, structures, institutions and expectations, to confront them, to challenge them and to have a dialogue with them. If you have a neutral space, if you have no institutions, no traditions, no context, nothing with which you can interact, you are in a kind of limbo. So I think the notion of a museum or an institution that tries to pretend that it isn't part of the establishment, that tries to be accommodating, neutral and flexible, is in fact nothing. My plea would be for spaces that are clear, strong, precise statements of their time. The notion that you should also try to design a gallery that won't age, that won't look as if it was built in the 50s, 60s or 90s, so that in the year 2000 it will still look good, is I think, possibly the worst scenario.

Peter Pran, Ellerbe Becket: I agree very strongly with what you have said. Seeing Mies van der Rohe's National Gallery and Daniel Libeskind's new Jewish Museum next to each other in Berlin, it becomes clear that each new museum must express a strong architectural idea and provide spaces that exist as cultural statements of their time. Mies' gallery represents the essence of 1960s minimalist architecture through its articulated free plan; whereas Libeskind's Jewish extension project promises a diverse linear sequence of interior spaces, shaped by an exterior shell that seems to a certain extent to owe its modulation to a complex absorption of external forces, rooted in the site as well as the cultural and political history of the Jewish people. Other examples of influential authentic spaces can be found in Frank Lloyd Wright's Guggenheim with its dynamic hall space which is also the focus of all the art, and Carlo Scarpa's Museo di Castelvecchio which expresses, in a more articulated way, a series of exquisitely detailed poetic environments.

Internationally, over the last decade we have seen a very positive increase in new museum commissions for architects that either have been or will be constructed. Frank Gehry's Vitra Design Museum, Libeskind's Jewish Museum and the Finnish Science Centre museum by Mikko Heikkinen and Markku Komonen are three of the foremost museums designed today. However, a majority of other museums designed today are more conventional and somewhat uninspired in concept and resolution. Often they are anonymous shells of buildings that do not take any clear architectural stand, and only claim interest through the art work displayed in them. The new National Gallery in London by Robert Venturi and Denise Scott Brown, with its anti-modern, cheap glued-on historicism and uninspired conventional interiors, is clearly a failure. In no way, shape or form does it represent an authentic, contemporary architecture. Instead it seeks refuge in copying out-of-date classicism. Heinrich Klotz's new Centre for Art and Media Technology (ZKM) in Karlsruhe makes it clear that entirely new architectural and spatial concepts must be developed in all new museums to adjust to new media technology and to the task of presenting radically new concepts in art.

To design new museums that make strong and relevant contemporary architectural statements, and to work with the new art that it will present, requires a tremendous amount of courage and creative ability from the architects involved. This commitment to achieve a high level of resolution in a new museum design is a necessity for any architect to succeed.

Richard Economakis: The Classicist today is not a reactionary, he is a visionary, and I think that the point raised earlier about the staircase that was destroyed was very interesting because it shows

the contrast between two very different views of aesthetics. In the pre-industrial age, aesthetics was centred around the human being. With the industrial age, we have a movement away from man and towards a fascination with industry, geometry and abstract thinking which is portrayed and reflected in modern art and architecture. In my view, the latter belongs in many ways to a detatched intellegentsia and does not express the average human being. You can see it in these spaces. These spaces are afraid to talk about form, they are afraid to talk about art. We have to ask ourselves what art is: art is the celebration of something. What is modern architecture and modern aesthetics celebrating today? What was Mies celebrating? They are celebrating the machine. But what about the human being?

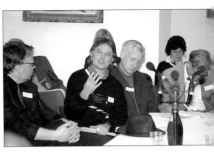

Ian Ritchie

David Blackburn: All these things are part of extending the human experience. It is ridiculous to my mind to say that something was on a human level before the industrial revolution, then came the industrial revolution and then somehow that was all different. The industrial revolution was as much a part of the human experience as all the things that we are going to go on to do in the future. I do not see that it is any less valid to celebrate a steel beam now than it was to celebrate a cornfield five centuries ago.

Jill Sackler

Iwona Blazwick, Institute of Contemporary Art: It seems to me that architects today have to deal with important new criteria in approaching museum design. Rosalind Krauss recently described her experience of walking with a curator around an exhibition of minimalism in Paris, and stopping to admire the glow of a work of art by Dan Flavin, not the work itself, but the reflection of its light in an adjoining passageway. A far-reaching effect of minimalism is that it established new spatial and viewing relations in the gallery. Spaces devoted to the presentation of contemporary art can no longer be described as store houses, the repositories of a cultural patrimony; neither are they the museum as archive, or data bank/ educational space. The industrial spaces converted by Saatchi in London, the Crex Collection in Switzerland, the DIA Foundation in New York, or the hospital building converted into the Reina Sofia in Madrid, are galleries where the visitor experiences objects in a physical way. Their immense scale, the hard-edged utilitarian aesthetic of their architecture, and the way objects are arranged in these buildings make the experience of viewing an exhibition a sensory one. The single Richard Serra sculpture that occupied an entire gallery at the Saatchi Collection presented a radical departure from the salon hang or the postage-stamp effect of rows of framed, two-dimensional works. This approach to installation is also characterised by a paring down of contextual information, creating a static and immensely dramatic effect. For some this is too theatrical, making the work of art a mere spectacle; for others it creates dynamic interplays whereby a whole room and the spectator become implicated in the work of art.

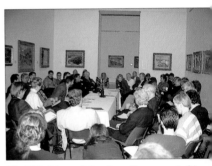

The Third Annual Academy Forum seated in the Sackler Galleries

 Different imperatives apply to the museum shell, especially when viewed within a broader civic context. Curators and administrators are under enormous pressures to raise money, increase attendances, draw tourists, generate political and financial support; and the museum exterior provides the vehicle. It can be argued that people flock to the Pompidou to ride up and down the escalators; or queue in their thousands outside the Louvre, not to see the collection but to see IM Pei's pyramid. Museum architecture is used to generate excitement, entertainment, the enthusiasms of patrons or trustees.

 These essentially economic imperatives should, nonetheless, provide opportunities for the

Norman Foster lecturing at the Royal Academy 15 June 1991

The audience

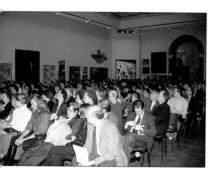

Concluding remarks by Lord Gowrie

commissioning of important works of architecture. If the design of the museum shell is foregrounded, then that publicly testifies to the importance of housing art, of its place in the urban fabric; the museum as both public facade and temple. However, can the desire of many contemporary artists and curators for neo-functional, industrial spaces with large spans, uncluttered perspectives, built of hard-edged materials, be reconciled with a civic desire and financial necessity for opulent facades and architectural flourishes?

Ian Ritchie: I believe that the last decade, architecturally speaking, will be looked upon as the great era of museums. The late Victorian era may be to some the inaugural period of museums, but there can be no denying the recent impact of these typologies on post-industrial society. Many architectural masterpieces have been realised, whether as recycled buildings, extensions or completely new structures. These museums are the Kings, Queens and sometimes Aces in each city's hand, as these cities vie with each other across the western world for attention. Museums have become the barometers of a city's, and in some cases of a country's, cultural virility.

Museums should be public architecture. As such, they can be perceived singularly as the art and science of building for a specific purpose, that of storage and the exhibition of objects and artefacts. They exist publicly in their own right. Museums, significant as municipal or national repositories of collective memory are, more often than not, sited prominently and as such are a dominant component and even generator of a particular urban composition. They act as stimuli for the regeneration of local areas in addition to existing as city monuments and as important venues they form human encounters, especially for visitors.

The desire, indeed the perceived need, to attract as many visitors as possible, has revolutionised museums. The days when they were frequented by the researcher, the odd school party, the Sunday family, are very distant indeed. Today, clean shoes have become trainers and the walking stick has been replaced by the rucksack. This revolution has had a dramatic impact on the spatial programmes of museums, on the very nature of their organisations and, in many instances, on the very role for which they were created. Most dramatic, perhaps, is the ability of these buildings to accommodate the flow of visitors and, from a marketing point of view, to hold them for a length of time sufficient to encourage a visit to the book shop, but short enough to allow more visitors in.

Jill Sackler: The role of the patron hasn't actually been talked about at all. If this conference were happening in the States, I think this would be a central issue. Private patronage is very important over there and the museums that have been constructed in America are often small buildings for a certain person. I became involved in the art world and museum world through my husband, who was a great collector. He sponsored many buildings, among them the Princeton Asian Art Gallery, the Chinese Sculpture Gallery and the subsequent Sackler Wing at the Metropolitan Museum, the Sackler Museum at Harvard by James Stirling and the Sackler Gallery in Washington.

In this project, the patron had a significant role in determining the final outcome. We were approached by the Academy to redo the Diploma Galleries, in terms of the temperature, lighting and humidity control. Arthur said that he did not think the access was adequate and would therefore be interested only if this was included in the proposal. Norman Foster then found 'the gap', and presented the idea of the new elevator and staircase. In fact Arthur contributed what I consider to be an extremely successful part of this project, which was to use the pediment of the

old building as a sculpture platform. This has pushed out the wall and created the glass lobby, making it seem spacious when in fact it is rather a small space. So I think in this project the patron has played an important role. Patrons tend to be unpopular, but I hope that some of these projects will be thought of as important, successful and good in the future.

Conclusion

Robert Maxwell: To provide some concluding remarks to such a wide-ranging and, at times fastidious debate, is not easy, but I will try. Much of the argument has been about the alternatives of a neutral and flexible space versus a space of character. I don't think there is any way in which I, or indeed anyone, could decide about those alternatives; we need spaces of character and we need other spaces that are more neutral and more welcome to the unexpected. However, I do not think there is any possibility that we could conclude with a single idea for the ideal gallery; there are going to be many different galleries, many different venues for art. I would like to address the point that I raised at the beginning, which was not taken up until Andrew Benjamin mentioned it, which is to do with the limits of art. Is art always going to be of the dimensions that will allow it to be hung in neat lines on walls, ticketed and labelled, as gravestone markers in a sense?

(left to right) Sir Norman Foster, Dirk Köhler (VCH) and Lord Gowrie

There is another idea that is frequently voiced today which is to do with the fact that art is somehow inventing the future; in extending its own boundaries, art is is playing a major role in the whole global enterprise of human consciousness. I am not siding with the future – I believe it is easy to side with the future and put everybody else down – nor am I siding with the past. I would just like to point out that every new work of art of whatever kind that is preserved, enters into an archive which is constantly growing. This came to my mind when we were asked to design a hanger for Concord 002 to be preserved for posterity. One realised that in order to preserve it for posterity, you had to make it impossible to get close to it and touch it. 001, which had already been on display with full access to the public at the edge of Orly airfield, was now in pieces, and we had to learn from that. So we became conscious of the fact that to display something is also, in a sense, to prevent it from being used up. There are clearly a lot of problems with museology and one has to acknowledge that curators have a job in preserving what everybody wants to consume. I would say that there is a clue to be found in the idea of human institutions; the gallery is in one sense the enemy of the artist, as Duchamp tried to show, but it is also the means of preserving art for future generations. Such is its role in my opinion.

Dirk Köhler and Andreas Papadakis

The issues that I find important here are, on the one hand, the importance of the institution of the museum which, in a certain sense, has taken over the role of providing a space for spiritual regeneration. In a way, it has extended or displaced the role of the Church, but with a less peremptory demand: one does not weep in museums as one does in churches. On the other hand, I think we have to constantly revise, not only the past, but also our sense of where we are in relation to the past. The gallery of today has to extend and the Royal Academy, because of restrictions of space, has had to find its extension space inside. Thanks to Mr Sackler they found it up here and also thanks to Norman Foster they found a very beautiful space, even though it is complacent and returns us to the history of the museum.

Sackler Galleries, view of staircase

Joseph Kosuth

JOSEPH KOSUTH
WITTGENSTEIN'S PLUMBER

After reflecting on our discussion at the *New Museology* symposium, I began to think a bit more about my Duchamp plumbing anecdote. More than anything else, it is a reminder of both the limits and social relevance of architecture as an art form. It is only within its pragmatic constraints that architecture can self-reflexively actualise the politic within its own cultural moment. The rooms which architects make presume the social life which will take place within those walls. To pass through the rooms of an old building is, in an act of cultural re-location, a psychologically anchored return to a social past. As such, it reconnects us to the lived reality of what preceded us. It is, simply, philosophy made authentic without the spector of academic speculation. But, philosophy always manifests a political life. The power of old architecture articulates the heavy responsibility of new architecture.

In the over-enculturated urban environment of the present day, the politics of the architecture get naturalised along with the building itself. New buildings cannot avoid saying: this is the future. With the same subtlety with which we commune with the past in old buildings, new buildings authenticate as real and inevitable the cultural and social presumptions – and the future it thereby prescribes – of architect and client. Architecture stages the psycho-social meaning from which use flows. The experience of the peasant in the cathedral of the Middle Ages is reconstituted not only in the corporate power manifested in the modern (and 'post'-modern) office building, but in the real heir to the cathedral: the art museum.

As I see it, the present role of the art museum as cathedral is one result of the poverty of science as a religion. With contradiction experienced by no one, the seamless texture of daily life establishes its truths through the proclamations of physicists, statisticians, engineers, biologists, chemists and the family doctor. That is, through the self-validating institutional dynamic which constructs truth: science. We don't ask, finally, our priest, minister or rabbi to answer our profound questions about the nature of reality. Established religion became a social club organised around the theme of 'spirituality' at the same time as philosophy died its institutional death in the academy. With this, the crumbling of ideology, and the process of an increasingly heterogeneous culture within a global market economy, among other things, has brought about a crisis of meaning. As a result of this, it is my opinion that the potential importance of art for society is unprecedented in modern times and the attack on its essential identity by a market ravenous to supplant its meaning is at an equally unprecedented risk. At this point, let me add parenthetically, that it would seem that art will go in either of two directions. Either it will be completely subsumed by the market and become simply a form of expensive decoration – in short, neckties-for-over-the-couch, first validated by the museum – or art will be seen to be a kind of post-philosophical activity.

As society feels the risk of living adrift from meaning, art increasingly becomes established as a 'need'. How can one explain the increasing interest and presence of contemporary art in our society? In contrast to the immediate gratification of the entertainment commodities of mass culture, such work appears specialised and obscure, if not esoteric and elitist. Nonetheless, socially and economically,

such artefacts have not only had a continued cultural presence in this century, but the audience and participants for this activity continue to grow, not decline. Part of how we experience this crisis of meaning resides in our approach to our accumulation of cultural forms, and the struggle now to find their meaning outside the networks of power relations, economic or otherwise. The question rests at whether it is possible to make work which can maintain itself as a critical presence without simply pragmatising its view of history. Can the self-reflexivity necessary for its criticality avoid an instrumentality which threatens to deny a cultural location (and contribution) of any work which 'sees'? This, as yet, unresolved question may very well be the legacy of my generation.

If society, gripped by a belief system that denies traditional religion and marginalises academic philosophical speculation, now perceives art as a source of meaning, it does so because increasingly contemporary art constructs itself from the same horizon of mass culture within which everyone's consciousness is formed. Within the larger celebration of culture, of course, confusion abounds. For many, the authority of form which traditional views of art purvey, provide a psychological comfort as it disenfranchises the public from the process of signification. That struggle which conceptual art began in the 60s with the institutional critique of forms of authority and the realisation that art was a question of context, can be no more relevant than now in terms of the effect of museums on our perception, and conception, of art. The presumptions of museum architecture, in most cases. can be seen to naturalise (and protect against critique) precisely that conservative institutional framing which the best art of the past 30 years has rallied against.

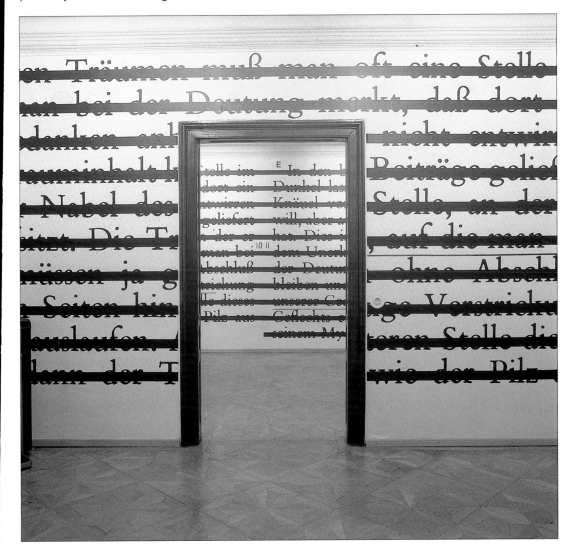

Joseph Kosuth, Zero & Not, *the 50th Anniversary of Sigmund Freud's Death, September to December 1989, installation view, Sigmund Freud Museum, Vienna, Austria*

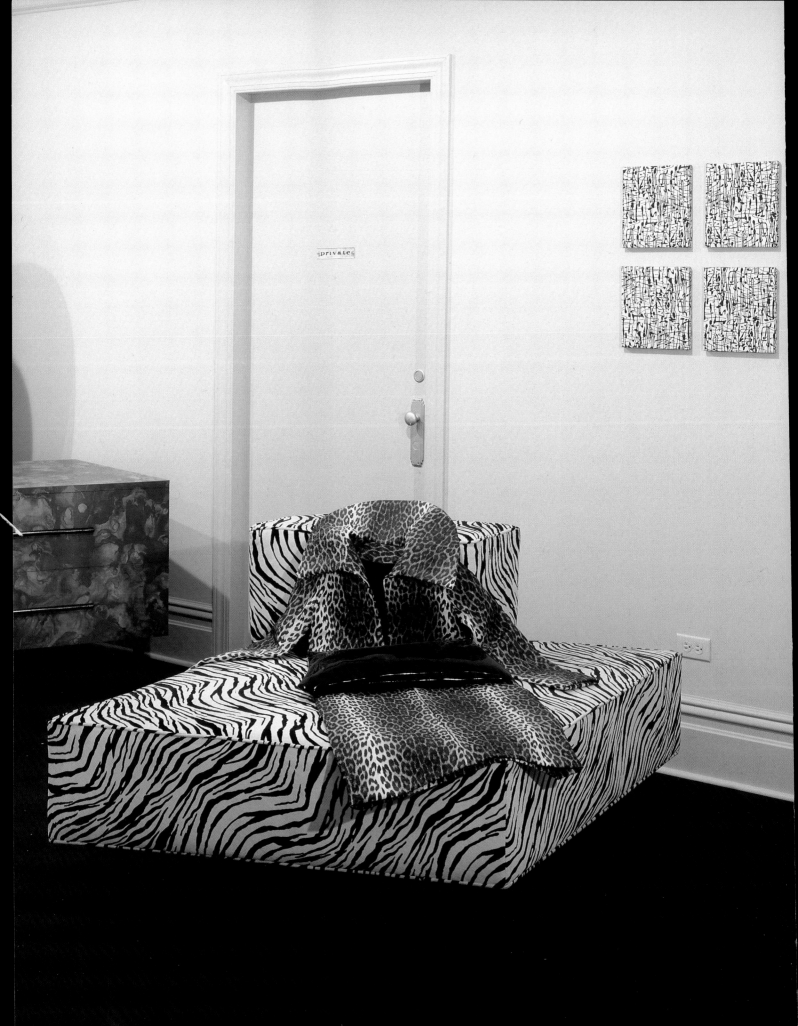

HANS HOLLEIN
TO EXHIBIT, TO PLACE, TO DEPOSIT
Thoughts on the Museum of Modern Art, Frankfurt

The design and building of the Museum of Modern Art in Frankfurt represents a further step in my coming to terms with the theme of 'Museum', in particular with museums of art. It is also a further step in my involvement with Frankfurt museums.

My occupation with the presentation of art began early – both as an architect involved in planning and as an artist affected by those plans. In particular, the mediation of contemporary artistic expressions calls for an approach which goes beyond the traditional notion of the museum, since sculpture has broken away from its pedestal, the picture has dispensed with its isolating frame and the installation (environment) has come to represent a spatial totality which goes beyond an additive series of works and exists in a specific dialogue with the space containing it. New media are brought into play, materiality confronts immateriality, colour becomes light. The approach and derivation of various contemporary artistic manifestations to and from architecture, or to an everyday object, bring about a complex overlapping of exhibition environment and work of art: for example, is a fire extinguisher really a fire extinguisher or an exhibit? Furthermore, a more complex, multi-dimensional networking is typical of modern developments in art, different developments going on simultaneously and requiring museum presentation beyond linear or chronological enfilades or those oriented to sphere or school, requiring in fact a matrix-like structure of relations. Beyond this, the role of the museum is generally in the process of being re-structured as far as both tasks and content are concerned; as are its relations with the public.

The relationship between architectural space and work of art – perhaps including necessary artificial and natural lighting and its handling – is the essential foundation of museological concepts, the question of the tectonic and architectonic nature of wall, floor and ceiling is the basis of accommodating works of art and conveying their message. Neutral space doesn't exist: there are only characteristic spaces of a different magnitude (and access to them), with which the work of art enters into a dialogue – in reciprocal intensification. Whether individual room or hall, the direct confrontation of the work with the building is the essential characteristic of the display – compartments and partitions are only adequate in specifically temporary situations and run the risk of becoming a backdrop.

My first contact with the main sections of the collection took place in the late 60s when, on the initiative of Joseph Beuys, I developed a museum project for the Ströher Collection in Darmstadt. At the time of the competition, the Ströher Collection and further recent acquisitions of single works and series (constantly being extended) by German and international artists constituted the starting point of the museum.

There were works and series by, among others, Jasper Johns, Robert Rauschenberg and Jim Dine, high points of Pop art by Lichtenstein, Warhol, Rosenquist and Wesselmann, objects of minimal art by Carl Andre, Walter de Maria, Judd and Flavin, pictures by Morris Louis, Cy Twombly, Dorazio, Imi Knœbel, Yves Klein, Piero Manzoni, Noland, Rainer, Frank Stella, On Kawara, Tàpies, Palermo, Richter, Graubner and other recent native German artists.

Over and above a customary museum concept, it was important that from the very beginning, space be allocated for the staging of performances and, above all, for the inclusion of environments or installations, and that the museum's collection be constantly extended. For the architect, parallels between the task at hand and the Mönchengladbach museum were interesting. The programme there – size of area and volume, location (city centre, proximity of cathedral) – was almost identical but the realisation turned out to be quite different (save for certain basic principles) due to new peripheral requirements.

Furthermore, it was important and significant that there be intimate knowledge of many works and even close personal contact with many of the artists represented. So it was that I saw Oldenburg's *Living Room* at its first installation at Sidney Janis' in New York with the artist himself; likewise in the case of Dan Flavin at Heiner Friedrich's in 1968. In the same way, I had countless discussions with Beuys about the question of museums and the displaying of art and his works. And, over the years, I was able to work at the question of adequate presentation in a concrete way together with many artists, not least as commissioner of the Biennale.

Late in proceedings there was a change in the direction of the museum. Jean-Christophe Ammann had a new concept to add to and overlap with the existing one; at this stage in the construction (and in the accumulation of the collection) this led to a certain discontinuity. Works by young, current artists were included, the emphasis was shifted more to permanent installations in the most varied media created explicitly for rooms, flexibility was reduced, spatial qualities redefined, classics were evacuated, retrospect made way for prospect. There will be further differentiated acquisitions in the course of the museum's and building's existence. The quality of a good museum building is also its suitability as a utensil, dwelling, catalyst of art.

Claes Oldenburg, Bedroom Ensemble, Replica I (detail), 1969 (photo Rudolf Nagel)

(left to right) Germano Celant and Hans Hollein at the opening of the Museum of Modern Art, Frankfurt, 6 June 1991

Claes Oldenburg, Bedroom Ensemble, Replica 1, 1969 (photo Rudolf Nagel)

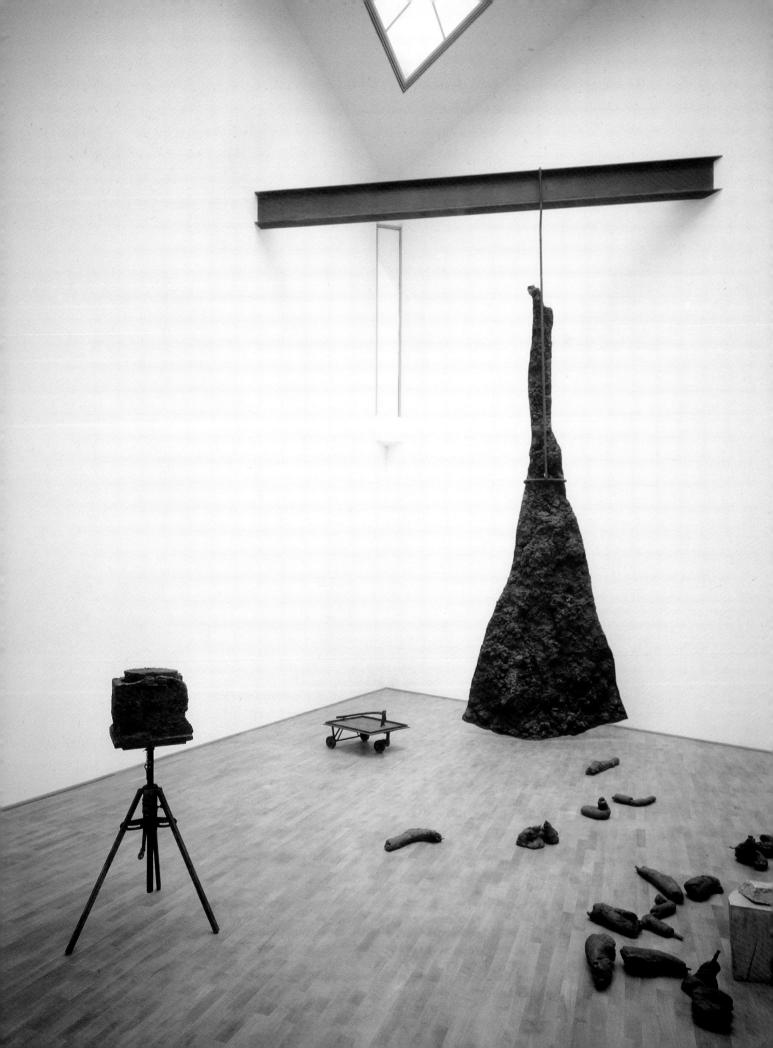

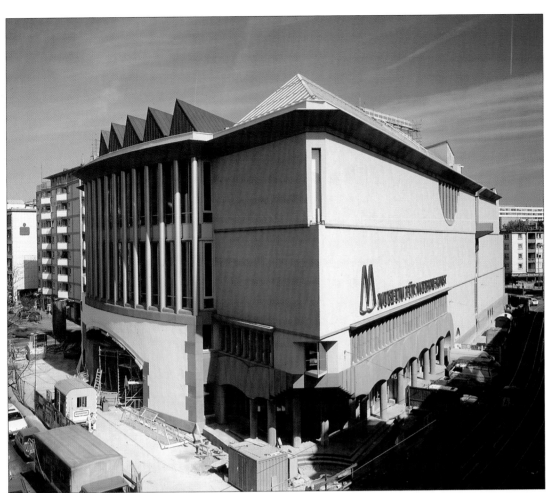

Joseph Beuys, Blitzschlag mit Lichtschein auf Hirsch (Lightning bolt with a glare on the stag), *1958-85 (photo Rudolf Nagel)*

Hans Hollein, Museum of Modern Art, Frankfurt, 1991 (photo Rudolf Nagel)

View of interior showing Mario Merz installation, At the still point of the turning world, *1991*

43

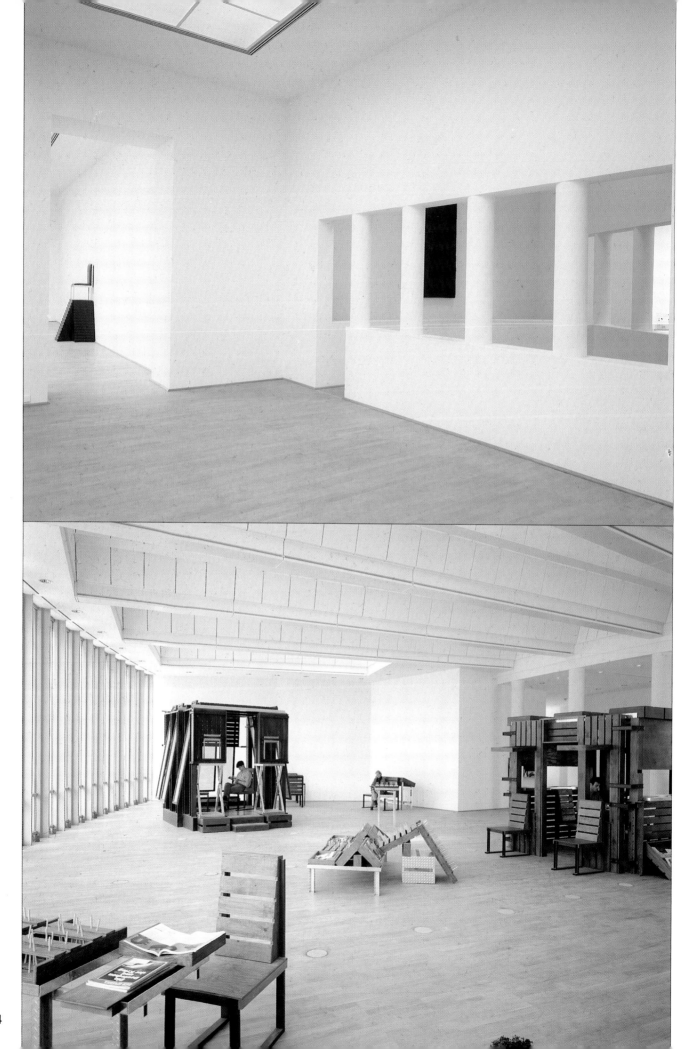

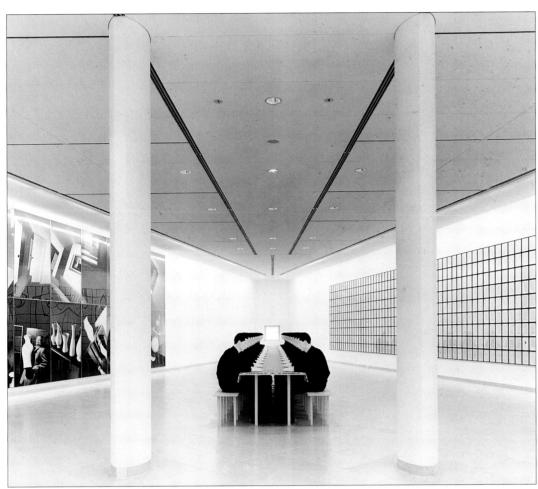

Interior view showing Walter de Maria,
Pyramid Chair, *1965 (photo Rudolf Nagel)*

Siah Armajani, Sacco and Vanzetti Reading
Room #3, *1988 (photo Rudolf Nagel)*

(left to right) Anna and Bernhard Blume,
Vasen Ekstasen, *1987, Katharina Fritsch,*
Tischgesellschaft (Company at table), *1988,*
Hanne Darboven, Ein Jahrhundert-J-W, von
Goethe gewidmet, *1971/82 (photo Rudolf*
Nagel)

Lothar Baumgarten, Frankfurter Brief,
1989-91 (photo Rudolf Nagel)

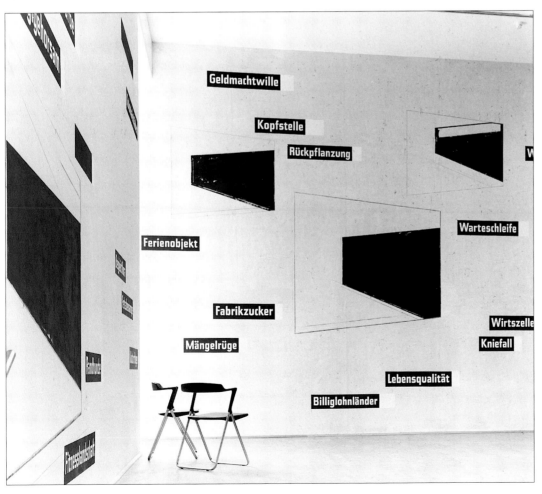

Franz Erhard Walther, view of installation showing Work Drawings, *1963-73, 44 of the 88 double-sided drawings and* First Work Series, *1963-69 (photo Rudolf Nagel)*

Walter de Maria, view of installation showing Pyramid Chair, *1965 and* 4-6-8-Series, *1966/91(photo Rudolf Nagel)*

Reiner Ruthenbeck, Verspannung II, *1969,* Keulen, *1967,* Löffel II, *1967,* Möbel III, *1968 (photo Rudolf Nagel)*

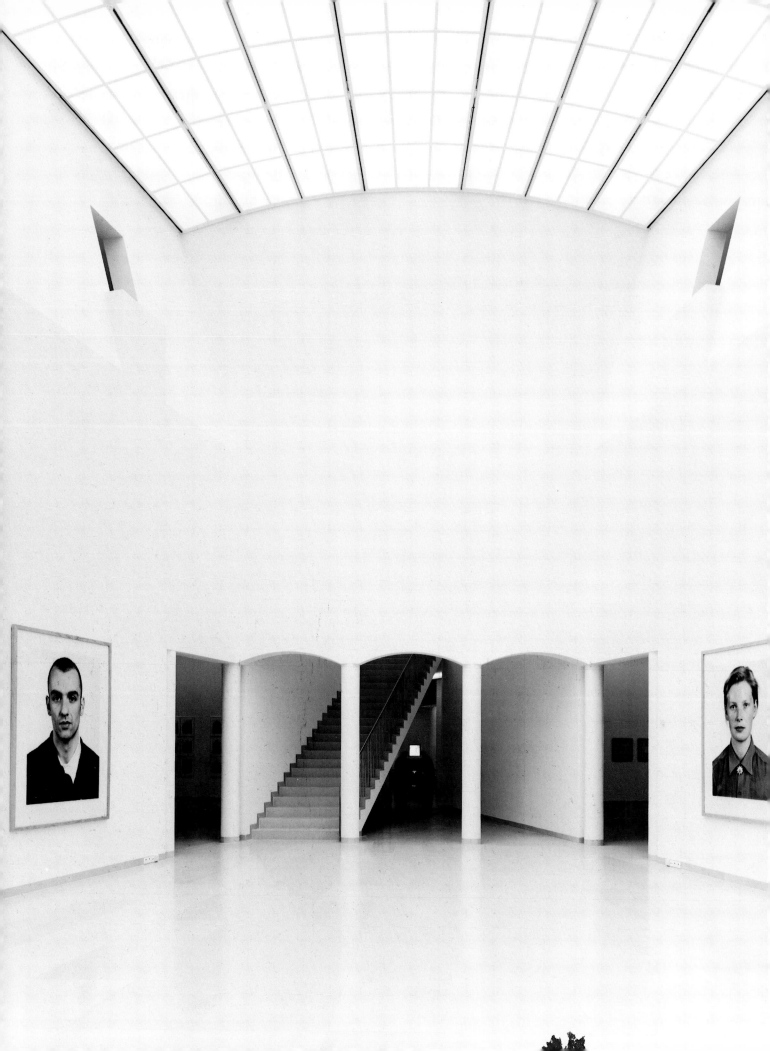

JEAN-CHRISTOPHE AMMANN
A POSITIVE EQUILIBRIUM

'That architecture might not encroach upon art and art not have to arm itself against architecture.' From the very beginning it was my particular concern to follow this maxim. Hollein's bold design for the Museum of Modern Art, Frankfurt – a building geared towards the greatest possible structural transparency within – is an enormous challenge to anyone wishing to 'play' this house.

It is not my intention to consider art on the one hand, architecture on the other. The subject can only be the equilibrium of two forces and not in the sense of stalemate. It is a question of the visitor's perceiving architecture via art and art by means of architecture. If it weren't so, it would be tantamount to failure.

Anyone who has anything to do with works of art in enclosed spaces, ie with exhibitions, knows that it is absolutely essential to have an intimate knowledge of those rooms if one is to create the prerequisites necessary for the works of art to reveal themselves in their essence. In the same way as works of art, rooms also have their individuality. It is only by experiencing rooms via art that its dwelling is manifested.

I lack this experience but two factors compensate to some extent. In 1980 the city of Frankfurt acquired 64 works of art from the Ströher Collection, primarily works by American and German artists of the 60s. These are for the most part high-calibre works: advised by Heiner Friedrich and Franz Dahlem, Karl Ströher – a Darmstadt entrepreneur who died in 1977 – had bought not single works by single artists but, if possible, whole series. In the municipal authorities' 1981 ruling on the founding of the museum, it was established that the museum should also contain installations. Installations, works of art created explicitly for rooms, are normally seen only in temporary exhibitions.

For 20 years these two parameters have shaped my exhibition work in the realm of contemporary art as I worked directly with the artists themselves. They will also decisively characterise the exhibition at the time of the opening. The fact that many artists install – or even create – their works on the spot means that they will lend to their rooms a definite physiognomy, a specific gravity.

The museum that Hans Hollein has built is very much a museum. It is well suited to accommodating series of works by individual artists or to promoting 'dialogue' between different works. The rooms are so diverse and so autonomous that, instead of an art-historical chronology, the 'event-someness' of the art comes to the fore. And that's how it should be. This is not to say, however, that a precise concept doesn't underlie the whole. But it doesn't become visible; at best we only feel it.

I should like to say a few words about this concept. It is characterised on the one hand by series of works and installations, on the other by two anchorages: 'the 60s' and 'the present day'. These anchorages, which I term bridgeheads, are linked by three 'bridges': the rooms devoted to Bernd and Hilla Becher and On Kawara, each with works dating from 1966 to 1990, and the Gerhard Richter room with the cycle *18 Oktober 1977* dating from 1988. This series by Richter is in line with the early works of the 60s from the former Ströher Collection.

Another decisive factor in the realisation of the concept was the building itself. It was a question of finding out, often together with the artists, which rooms were best suited to which works, always according to the maxim which I quoted at the beginning. Furthermore, the vicinity of other works was important – above all in cases when spheres interconnect, thus creating a kind of 'climatic zone' (eg Armajani/Wall/Zaugg or Schnabel/Clemente/Trockel/Balkenhol).

We are often asked if we are also going to hold temporary exhibitions and whether such a painstakingly devised concept won't lack the dynamic of change. In answer to this: the museum contains rooms laid out for the long and medium term and others which will change after a year. But the possibilities are not so great, simply on the strength of the complexity of the rooms, which in turn is defined by the interior design.

Change, alteration, dynamic are imperative. Yet I assume that before a change takes place, everything has been done so precisely that subsequently one can recognise what kind of changes would be meaningful at what point in time, with what means and in what context.

View of main hall showing Thomas Ruff, Porträt Manfred Hermes, 1987, Porträt Pia Stadtbäumer, 1988

Hans Hollein, sketches of main hall

BEYOND THE FRAME
AN INTERVIEW WITH GIUSEPPE PANZA

In 1956, Count Giuseppe Panza di Biumo came upon a photograph in an industrial magazine of a canvas by Franz Kline, contacted the dealer in New York and bought a painting for $500. So began one of the most outstanding collections of American art of the late 50s, 60s and 70s, numbering some 500 works: a logical progression from the Abstract Expressionism of Kline and Rothko, through the 'combines' of Rauschenberg and the Pop art of Lichtenstein, Rosenquist and Oldenburg, to the minimal, conceptual and environmental art of, among others, Robert Ryman, Dan Flavin, Robert Morris, Carl Andre, Alan Charlton, Bruce Nauman, Sol LeWitt, Richard Serra and James Turrell. While a number of these works were installed in Panza's 18th-century villa and converted stables in Varese, about 30 miles from Milan, hundreds more remained hidden in storage, or in the form of unrealised projects on paper. Following the sale in 1984 of around 80 works (among them the Klines, Rothkos, Rauschenbergs and Lichtensteins) to MOCA in Los Angeles, Panza began an investigation to find a museum with both the space to exhibit and the commitment to realise the remaining part of the collection. A solution was finally found on 16 February 1990 when Thomas Krens, director of the Solomon R Guggenheim in New York, announced the acquisition of 211 minimal works from the Panza Collection, to be followed in five years time by the gift of a further 105 works, together with the Villa Litta in Varese. In this interview with Clare Farrow, conducted in London on 16 June 1991, Giuseppe Panza discusses his thinking and beliefs as a collector.

– In an interview at the Musée d'Art Moderne in Paris, published in 1990 to coincide with un choix minimal dans la collection Panza, *you voiced your concept of a museum as being 'a place of thought ... where one can live through an experience which develops secretly in one's memory, like a hidden treasure.' I believe you are interested in the notion of a 'decentralised' museum. Can you explain the thinking behind this?*

I believe that the idea of a decentralised museum is important because of the increased demand for space. Art made in the last 30 years needs far more space than before because, especially in the case of minimal and environmental art, the works tend to be very large. Often a single work demands an entire room. It is difficult to have so much space in the centre of a city and this is why the idea of decentralisation is the first step

towards solving this problem. Another beautiful aspect of this philosophy is the possibility of having a space that is not crowded, that can be seen in a different mood from that experienced in a city. When we have to spend hours travelling in order to see something, we do so only when we have a special interest, a special reason to go. We are more willing to spend the time that is necessary to experience the full potential of the works we have gone to see, and we are ready for a different approach to the art. The visit becomes a real life experience and, by spending perhaps a full day on site, we try to understand, in the maximum way possible, what the artists are doing. This is a completely different approach to that of the museum in the city, where we tend to go when we have other commitments.

– While this notion implies a commitment from the viewer in terms of time and interest, would you say that this kind of art also demands a commitment from the museum in practical terms?

Of course. To show this kind of art, in particular minimal and environmental art, demands a special interest on the part of the museum. The minimal paintings, the Rymans and the Mardens, demand more attention than other paintings because the materials are so delicate. The large minimal sculptures, on the other hand, pose a different problem, in that they often weigh tons and are very difficult to move. Beyond these considerations, the installation of an environment presents the museum with an even greater problem in that, to have the light and sound effects that the project demands, it is necessary to construct a new space inside an existing room. In this case there are not only the problems of transportation and installation, but also the cost of building a new space. For this reason, a certain degree of permanence is demanded, not least because of the effort and time involved in dismantling a work. These objects cannot be put together or taken apart in one day. So it is important that the museum should have a long-term programme, involving some permanent installations, and other projects lasting from six months to one year. Unfortunately, the spatial demand is always the most limiting factor. There are always more works to show than there is space in which to install them.

– Would you say that these forms of art also demand an intellectual commitment from the viewer, in terms of reading critical texts and in

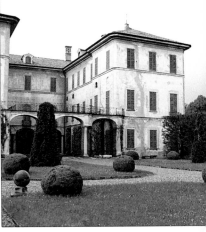

Bruce Nauman, Parallax Corridor, *1969-70, wallboard, 244x366x5cm, viewed through the stable doors, Villa Litta, Varese*

Villa Menafoglio Litta Panza Biumo Superiore, Varese, Italy

Count Giuseppe Panza di Biumo, London 1991

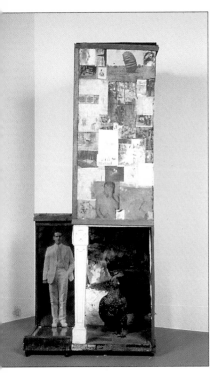

Robert Rauschenberg, Untitled, *1955, combine painting, 220x94x67cm*

Franz Kline, Alva, *1958, oil on canvas, 102x92cm*

Sol LeWitt, Wall Drawing no 146, *blue crayon, September 1972, Varese*

learning to concentrate the mind on a minimum of materials and visual differentiation?

The intellectual commitment is very useful, because we tend to understand what we know. If we don't know what we are looking at, our attention may not be properly focused. But I do not believe that it is a necessity to have special preparation and knowledge in order to understand minimal art. It is only essential to have an open mind, because this art deals not only with an intellectual vision but with sensations and perceptions that belong intuitively to our minds. Perception is an innate factor at the basis of every kind of existence, an instinct that places our consciousness in relation to the immediate reality which we touch and see. For this reason we don't need a special intellectual attitude. We need only to realise that this intuitive perception is to be understood as it is. There is no need to search for something behind it. We tend to judge art by habits, intellectual habits. We tend to look at what is inside the frame. In this case, we have to forget the frame. We have to deal with life, with direct experience.

– I believe that Robert Rauschenberg was instrumental in opening your mind to new things?

Yes. I met Rauschenberg in 1959, having been informed about his work by John Cage. Cage was working with electronic music at the radio studio in Milan in 1959. He knew I was collecting American artists such as Franz Kline and Mark Rothko, and for this reason he wanted to meet me. He came to lunch and spoke about his friends Jasper Johns and Robert Rauschenberg. In this way I became interested in Rauschenberg. I wrote a letter to Leo Castelli in New York, asking him to send me photographs of Rauschenberg's work, in order to start a collection. But he didn't answer my letter. So the first Rauschenberg I bought was not from Castelli but from a dealer who offered it to me after I had seen the work at *Documenta* in Kassel in 1959. I paid a very low price because nobody else was buying Rauschenberg at that moment. Later on, Leo Castelli told me that he didn't respond at first because he did not believe it was possible for an Italian collector to be interested in Rauschenberg. We met some months later in Milan. Castelli came to Varese to see the works installed and so I began an extensive collection of Rauschenberg.

– As an Italian collector, what drew you to American art?

I first became interested in American art because I was interested in looking for something new. I made a long trip to the United States in 1954 and was above all impressed by the energy and openness of mind I found there; the strength of will to make new things, to look to the future. I was impressed by the imposing structures and the vast open spaces, by the bridges and the huge factories, producing steel or chemical products, that form such powerful elements in the industrial landscape. I felt that this was the

moment when a new intellectual structure could be developed, in a society so different from that of Europe which was still shaped by social class and tradition. America seemed free. There was the possibility, or so it seemed, for everybody to build his own future, with his own hands, regardless of class or contacts. I believe it was this idea that led me to be interested in American art.

– Do you see your collection in terms of a logical progression?

Yes. I believe that every movement is new, but at the same time related to what has gone before. In the recent development of American art, there are logical connections and for me to follow this development was a logical process. Abstract Expressionism was concerned with inner energy and was related to society in emotional terms. Pop art was the result of a critical, intellectual attitude to the development of the economy and to a consumerist society. Minimal art was also an intellectual attitude, but very different to that of Pop art which was related to external happenings. Minimal art looked inside, to the process of the mind which shapes reality and art. Conceptual art is a more radical development of this essential idea; while environmental art is even more extreme in that it reaches the end of this process. It focuses on perception and on how the mind exists because of perception.

– The experience of Varese is one of coming upon works of space and light as if by chance, as if forgotten behind the old wooden stable doors. And standing alone in the silence of the white space, with the coloured lights of Dan Flavin or the blue-crayon wall drawings of Sol LeWitt, seemingly permanent in the simple, uncluttered rooms, one experiences a new sense of time, a new perception of light, colour and space. What was the thinking behind the transformation of the stables?

The transformation happened slowly. There was no need to ask for advice from an architect because I didn't change anything in the basic structure. I simply made well-finished walls which were flat, even and painted white, and in some cases I restored the original material to the floors. Some changes were made by James Turrell, Robert Irwin and Maria Nordman, who were invited to use some rooms in order to make the transformations necessary for realising their works. All the other work, for example the Dan Flavin, was installed without any modification to the original structure. And the artists' changes were very simple.

– The installation at Varese is very minimal, with a single artist in a single space. There are no captions or texts on the walls, nothing to act as a mediator or a barrier between the artist and the viewer. The art speaks for itself and breathes freely. Is this your philosophy behind installation techniques, that there should be minimal intrusion?

I believe that it is very important to show art in the best possible way, to help the viewer to understand the works and to avoid confusion. If we put different artists in the same room, artists whose meanings are very different, it becomes difficult for the viewer to understand, because one is seeing opposing realities. For this reason it is much better to show only the work of a single artist in each room. Also, each work of art needs to have a free space around it in order to see the work in itself, without any intrusion. This is very important because we need the right balance between the object and the empty space. If empty spaces do not exist, the attention of the viewer cannot be focused.

– The art in the stables seems to transcend the distinct categories of art, architecture and philosophy, and to exist on an intellectual plane of perception, manipulating space, light and colour. Is this an important notion for you – the interaction of disciplines?

Yes. Art is the result of a cultural situation that is made not only by art, but also by poetry, philosophy, mathematics . . . Art is a synthesis of different forms of knowledge; it is not independent from life, it is something that is essential, in my opinion, in order to have a complete understanding of the reason why we are alive. This understanding can be attained only if we have a wide knowledge in all directions. Art is important because it gives an intuitive knowledge of reality. Literature provides knowledge through reading, but reading takes time. The vision of art can be immediate and instinctive, although it also needs reflection and contemplation.

– You have said that minimal art is 'linked to the practice of science and philosophy'. Can you comment on this?

I believe that art and science are parallel processes: one leads to knowledge about physical reality, the other leads to knowledge about perception and intuition. Just as artists make new things, so scientists discover new laws. Both art and science are creative processes. Science of course is an analytical process, but one that would be impossible without new ideas, and new ideas depend on creativity. Without it, knowledge cannot develop and we cannot discover new laws. In every artistic process, what is important is the idea. The object that makes the work is only the medium, it's not the beginning, it's simply the tool of communication. Without the idea, the object is simply an object, a material thing. I believe that the interaction of disciplines is a very important concept. Both art and science have limitations – science as an analytical medium, art as an intuitive medium – so it is important to merge these two kinds of knowledge.

In California there is a group of artists who have scientific backgrounds that have enabled them to develop something new. James Turrell, for instance, studied psychology and the techniques of flying. He is a very good craftsman and makes his living restoring old planes and selling them to collectors. He works alone, repairing old engines and rebuilding broken wings. At the same time, he likes to study scientific problems, and he's also a great artist – he has this vision of the beauty of the sky and the beauty of light. His work is about the control, the manipulation of light, which is the most immaterial medium for making art. In the work of Turrell, light is direct, pure energy from the sun, an energy that has the most secret means of existing as matter in that only at certain wavelengths does the energy become visible as light.

– Can you recall your first encounter with Turrell's work?

The first time I met Turrell was in 1973. I met him through Robert Irwin, whose work I had been collecting for some years. He was living in Santa Monica in a house which he had transformed. It was a white space, with nothing in it apart from maybe a chair and a table. The walls were almost disappearing in the whiteness of the space, which contained nothing but light. The first impression of this space was very strong, very beautiful. But the most extraordinary moment was when, towards sunset, Turrell led us into a smaller room where we sat down on the floor. Everything was white. There was only a small opening at the top of the wall, through which one could see the sky. The opening seemed to be a part of the wall painted blue. But when we looked with closer attention we realised that this surface was not painted, it was just the emptiness of the sky. As the sun was setting the surface was continually changing colour: it became orange, yellow, violet, green, deep violet and finally black. It was a moving experience in time, both material and immaterial.

– So within the disciplined logic of a white space, Turrell focuses the mind on the 'invisible' factors of space, energy and light. Were you also interested in the thinking of Beuys?

Turrell is looking to light, and light is energy, and energy could be matter, because from Einstein's equivalence between energy and matter, energy could be transformed into matter and matter into energy. This kind of ambivalent possibility, this transformation, is one of the secrets of reality. The great quality of Beuys was to reveal the hidden psychological reality which is deep inside our minds, something which we have no notion of. In my opinion he is the first surrealist artist. The Surrealism of the 20s was a great discovery but there was still a very visual relationship to the inner reality of the mind. Beuys was able to establish a very different, more direct relationship with this hidden reality so that it became visible through the symbolic meaning of the object. This was the great operation carried out by Beuys, made possible by the precedence of Duchamp, whose ready-mades demonstrated how an object could perform a catalytic operation on the mind.

When I first saw the work of Beuys in 1968, I was at Eindhoven to see an exhibition by Robert Morris which was being shown together with the

James Turrell, Sky Space I, *Varese 1976*

James Turrell, Sky Window I, *Varese 1976*

Bruce Nauman, Diagonal Sound Wall, February 1970, Varese, wallboard and acoustic material, 244x1067cm

Bruce Nauman, Live-Taped Video Corridor, 1969-70, Varese, wallboard, camera, videotape and 2 monitors, ceiling high, 975x51cm

one of Beuys. I had never seen his work before and for me it was a revelation. I tried to get information on the work in order to start a collection, but unfortunately Ströher, the great German collector, was buying all the work that Beuys was making at this time. So I lost the opportunity to have many works by Beuys.

– Can you describe the works by Turrell which you commissioned for the stables in Varese?

There are two works by James Turrell installed in Varese. The first is a long corridor with a semi-circular opening near the ceiling from which we see the sky. Because of the position, facing north west, there are no direct lights from the sun coming inside the room, there are only the lights from the north. So there is a possibility of seeing the colours of the sunset. Inside the corridor there are neon lights so there is a balance between the strong light coming from the opening and the light inside. This balance gives a different perception of the opening, with the colour that we see through the opening giving us the feeling that it is a visible reality, painted matter, a painted surface. But when we focus our attention we realise that it is not material colour, it is a void. There are often these sensations in Varese, between the feeling of solidity and the feeling of emptiness. It is a beautiful quality of the work. Often we see clouds and a different perception of the sky. But it is at sunset that one experiences the true beauty of the work.

Another work is a room which has an opening only in the ceiling through which we see the direct, zenithal point of the sky. This is a beautiful work because it is always different: at every hour, in all kinds of weather, it is different because the sky is always changing. In winter, when the sky is cloudy or there are fogs, it is even more beautiful. We have then a completely different perception of light.

– The work of Bruce Nauman cannot be confined to categories: his art encompasses installations, constructed spaces, video, performance, neon language, etc. Can you explain the thinking behind the works by Nauman installed in Varese?

I believe that the most interesting aspect in the work of Bruce Nauman is the relationship of the body to space. It's a kind of art which is always dealing with the perceptions of the body. We are cultural animals but we work almost exclusively with our minds, to the extent that we almost lose the perception of our bodies, we almost believe that we don't exist in physical terms. Nauman's work gives us evidence of our material existence, of how we are inside a body that exists in time, that changes, that has limitations. We realise that this strong physical limitation is a means to discover reality from a different point of view and to become aware of our bodies, but at the same time we have the need to go beyond the limits of the body. There is this strong opposition between the physical and the metaphysical. There is the opposition of the mind,

the desire to be inside physical reality and at the same time to go beyond it. This strong opposition is increased by the operations that Nauman makes in his works at Varese.

– How would you define minimal art, based as it is on the principle of material reduction?

Minimal art deals with the most immaterial part of the body which is the mind, and the possibility for the mind to be free from physical limitations. This art is realised with geometrical forms because geometry is a construction of the intellect. The mind is able to construct an alternative reality from the circle and the straight line; an artificial reality that is at the same time linked to actual reality within which we discover a regularity of laws that can be defined by means of mathematical formulae. Minimal art is the relationship between the operation of the mind, which works through simplification, and the complexity of nature, which at the same time contains a simple scheme behind every kind of difference.

– Can you comment on the possible analogies between this interpretation of minimalism and oriental philosophies in which the reduction of material things, the contemplation of nothingness, frees the mind to go beyond physical limitations?

I believe that a number of artists from California, including James Turrell and Douglas Wheeler, have been strongly influenced by oriental philosophies – they have spent time in Japan and in Buddhist monasteries and have learned a lot about this form of culture. We live in a time in which things of interest tend to be transient, in a society that is always moving, always changing. Nothing is permanent. But the mind needs something that goes beyond this, that will retain its value for the future, that will not disappear. This search for something that will be forever, for the foundations of being, beyond this perpetual change, is the great quality of this kind of art. Western culture is mostly working for the improvement of external reality, while oriental philosophies are more concerned with the improvement of the mind. We must try to reach a balance, between living in reality and striving to go beyond it.

– When artists such as Robert Ryman, Donald Judd and Robert Morris talk about their work, the emphasis is invariably on the process and the materials. Ryman has said, 'There is no mysticism involved', and Carl Andre has said, 'I work with material things . . . I don't really work with ideas. I deal with desires.'

I believe that artists often want to hide the real intention of their work, they want to be simply what they are: artists working with materials, with objects. What is behind the object is something that must be perceived by the viewer, not explained by the artist. The viewer must look for the interpretation and in a good work there are many possible interpretations. In the work of Ryman,

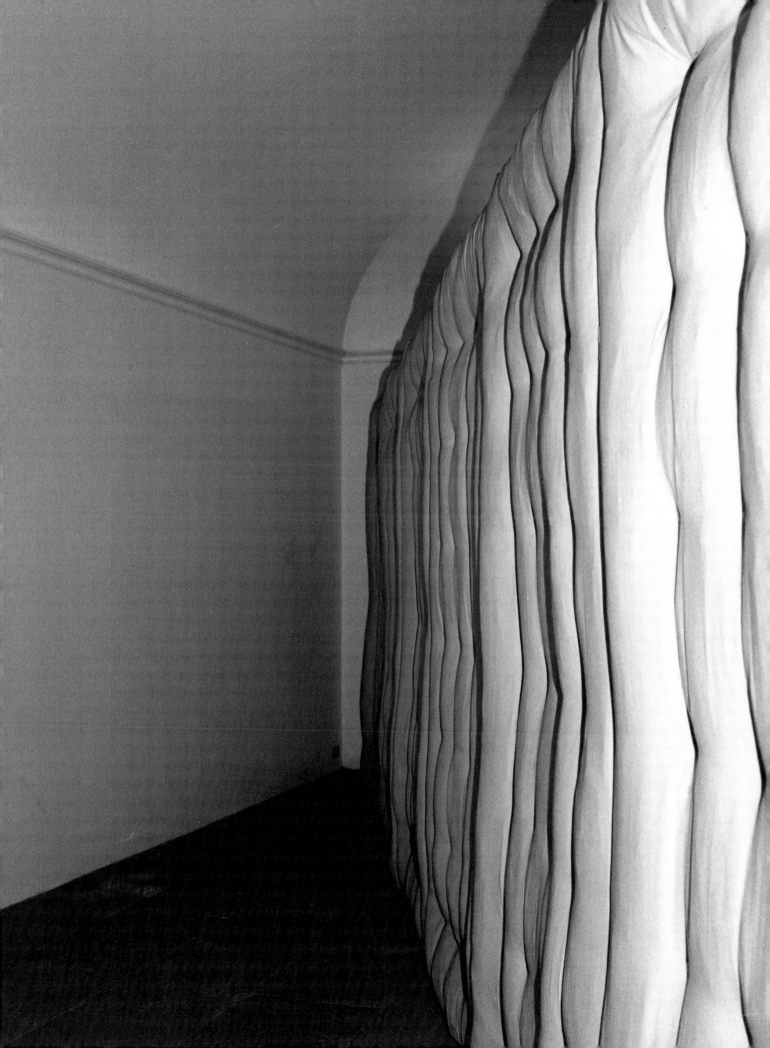

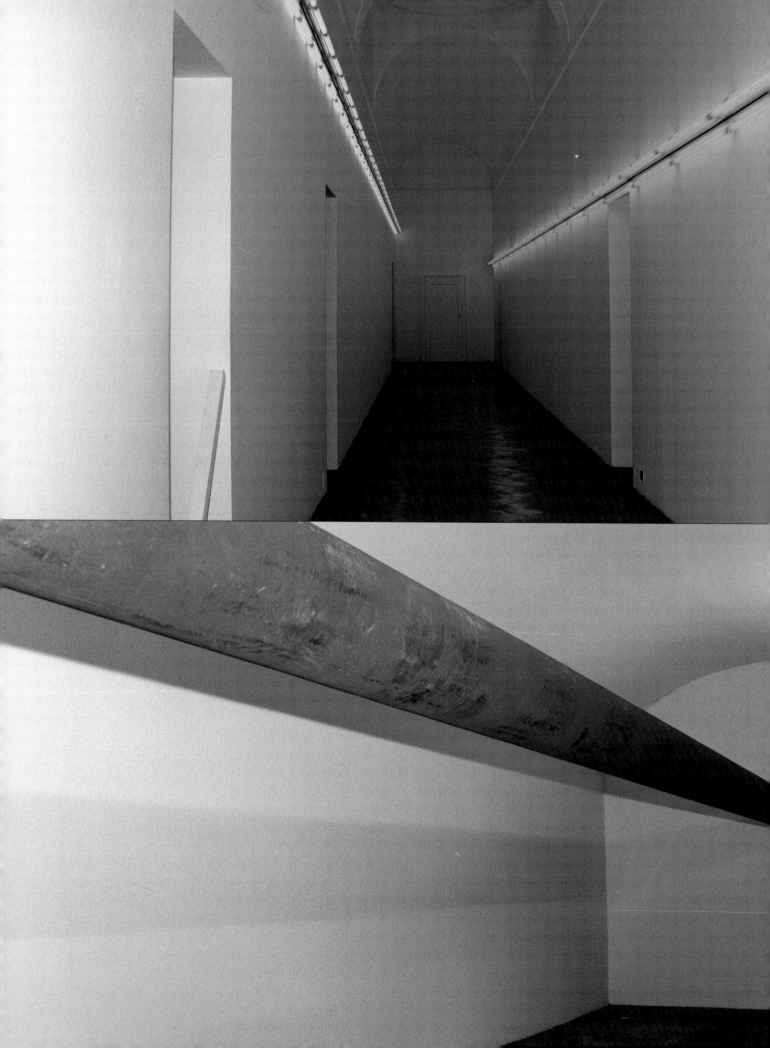

for example, there are both physical and spiritual interpretations. Sometimes the artist is willing to give only the physical interpretation, because the metaphysical one is free and open to the mind of the viewer. For this reason there are these kinds of statements. I believe that the artist expresses the real meaning through the work, not through the word. I would never ask an artist what a work means. The answer is in the work. If I am not able to look at the work and to understand it's language, it means that I am not able to see it. The artist cannot give a better explanation of the work than the work itself. For this reason many artists are unwilling to make statements.

– What terms would you use to distinguish between minimal and conceptual art?

The difference between minimal and conceptual art is that conceptual art came soon after minimal art – it's a development of minimal art. Minimal art is a reflection of the way the mind acts through shapes, showing this process with geometrical shapes. Conceptual art signifies a further step because it looks to the origin of the shapes, that is the idea, the concept, how the mind has developed a process, how the mind is able to make a structure that could have meaning. For this reason Lawrence Weiner, for example, uses words because words are the elements of speech. Through speech we give meaning to everything we refer to. This happens because the word has always existed in relation to reality, the word can give a definition, not only one but several definitions. This ambiguity of the word renders it useful to the artist, because it is an ambiguous way to have meaning. For this reason Lawrence Weiner's work is art because the word in itself can have this multiplicity of meaning. We have only to look at a vocabulary to see how many meanings a word can have, how rich are the possibilities in just one word.

Weiner works like a poet. The poet is able to force the meaning of a word because he is able to introduce it into a new context in which it can have some kind of different meaning. Weiner undertakes a similar process because, by removing the word from its normal context of speech, it takes on a multiplicity of meaning. It's like the ready-made of Duchamp. Duchamp used the object. Weiner uses the word. The word has the same capacity to suggest different meanings.

Joseph Kosuth's main interest lies in the tautological processes of speech. Through Kosuth's words we realise that there are differences that we are not aware of between the mental process of knowledge and reality. They are in fact two independent realities. The meeting point is invaluable, but we cannot realise where it is because the process of learning is in its own way autonomous, detached from its relation to reality. This bridge with reality, constructed by our minds, is something that philosophy has always sought to explain.

– The experience of Dan Flavin's lines of pure, fluorescent colour installed in Varese is quite magi-

cal: the narrow white linear space, initially opening onto a sequence of intense reds, blues and greens emanating from the adjacent fluorescent light rooms, is instantaneously transformed into a corridor outlined in pink, green and yellow light. There is something almost alchemical in this transformation of industrial tubing into pure coloured light.

I know that Duchamp was very interested in the alchemical idea as an investigation into the mystery of existence. Flavin's work brings the mind into direct contact with light which, as immaterial matter, is certainly mysterious. So in this sense his work might be interpreted in alchemical terms. I began to collect Flavin's work in 1966 when he had an exhibition at the Sperone Gallery in Milan. The works in Varese were mostly from gallery exhibitions, so it's possible to show them in any space that is right to contain them. Only the work in the corridor was made for this space and cannot be moved.

– Many of the projects in the Panza Collection were bought in the form of ideas existing only on paper. Can you outline the conditions of such a purchase, the issues involved and the circumstances under which these projects might be realised?

When we buy a work by Turrell, we buy the project that describes how the room is to be constructed, where the lighting systems go, what amount of light must be available in order to see the work, and other specifications essential to its realisation. There are also statements and agreements in which the artist gives the collector the right to realise the work, following exactly the specifications contained in the project. The collector is under no obligation to realise the project, because this kind of work can be realised only when there is the right space. In the case of Turrell and Irwin we need a lot of space and for this reason we do the work only when the space becomes available. Unfortunately large spaces are difficult to find. The artist has the right to supervise and control the construction, to check that everything is right and to ask for modifications if any changes must be made.

– So the role of artists such as Turrell and Irwin is comparable to that of an architect, conceiving a structure in terms of space, materials and light which is visualised in the form of working drawings and models, and supervising builders and technicians in the construction of the work?

Yes. The work of the minimal and the environmental artist is similar to that of an architect and also to that of an engineer who makes drawings for a project that is then made in a factory, which has the tools to work the steel or aluminium. The same principle applies to this kind of art, which is too large to be made by the artist. The demand is for prefabricated industrial material which a factory can cut into the right size for making the work. This process, like that of an engineer or architect, is essentially an intellectual

Dan Flavin, Varese Corridor, *1976, green, pink and yellow fluorescent light*

Jene Highstein, Untitled, *1974, seamless steel pipe, 1229cm long, 32cm inside diameter*

Dan Flavin, Ursula's One and Two Picture 1/3, *1964, ultra violet fluorescent light, 126x81x16cm*

Robert Irwin, Varese Portal Room, *1973, room dimensions 500x1000cm*

Robert Ryman, Classico IV, *1968, acrylic on paper, 231x231cm (photo Attilio Maranzano)*

Robert Mangold, Ellipse Within a Square (Grey), *1972, acrylic on canvas, 183x183cm (photo Cathy Carver)*

one because the realisation of the object is achieved by following the instructions outlined in the project. The tool for realising the idea is the factory, not the artist. These drawings have no interest as works of art, because they are just engineering drawings, working drawings made in order to give instructions. The end of the process is the object, not the drawing. These projects on paper can only be understood by an experienced collector who is able to visualise the end of the process, to see in his mind the finished work.

– How many unrealised projects do you have in the form of drawings and instructions, and how many of these will be realised by the Guggenheim?

There are many works by Robert Morris, Donald Judd, Robert Irwin, Sol LeWitt, Carl Andre, Richard Serra and Bruce Nauman which exist only as projects. These were realised for a temporary exhibition and afterwards destroyed because it was too costly to ship tons of steel. It was cheaper to buy the steel and to realise the works again. For this reason they no longer exist. They have to be remade. But in order to be made they need to have space around them and this task now belongs to the Guggenheim.

Because of the great potential for space in the MASS MOCA project in North Adams, Massachusetts, it will now be possible to realise these projects. Each work will take one room. There is a huge amount of space but with these works it will be easy to fill the space. I submitted a proposal on how to use the space but this now depends on the Guggenheim. Most of the works will be realised under the supervision of the artists because to have the collaboration of the artists is important. Artists will share, with the museum, the responsibility of realising each work.

– The conversion of the factories in Massachusetts will provide a vast white space, free from architectural limitations and in contrast to the spiralling space of the Guggenheim in New York. Can you outline your thoughts on this?

It's very important to have a good space for showing art. If the space is not good, it's not possible to see the art properly. And for this reason it is important to have a good architect to supervise the realisation of the museum. Old factories often provide the best opportunity for showing contemporary art because they are neutral spaces but at the same time they have personality. Technology demands a clear structure and this gives shapes to the space inside. So the factory is a form of architecture, even if it has come about because of technological needs, rather than as a means of artistic expression.

The factory building is always a beautiful space because it is large, the ceilings are high, the columns are a long way apart and there is a freedom for the works inside. The size of individual rooms for showing different works of art is also important. The flexibility of a factory space means that we can build walls and rooms of whatever size we want. Also the space is always the same, the

ceiling is not differentiated, it is made with beams of steel or wood which are always similar. In this way it is a neutral space because there are always the same shapes. So the factory is a very good space. Technology is something that has some intellectual conditions in common with minimal art because it is made through the calculation of the resistance of material, size and space: there is an intellectual relationship between different elements of reality in order to have a variety of spaces for making an operation. Inside, the intellectual product is art. This is a beautiful possibility for old factories. But another possibility is the use of an old building. Old buildings have their own characters and personalities, and in order to use them in the best way possible we must have the freedom to choose the right work for each room, for each space. Only in this way do we have the best chance to use the space and to merge the work with the space, because old buildings are not good for everything. For instance, in some old buildings there might be a contradiction between the art and the temperament of the building, so that the art becomes less good because we see such a strong difference. But usually, when the art is of a high quality, the merge is possible, and almost always beautiful.

The Guggenheim of Frank Lloyd Wright is an impossible museum because it is very difficult to show paintings there: big paintings just don't fit inside. But I have seen beautiful exhibitions there because the artist was able to use the space, making a work for the space. For instance, Dan Flavin, Joseph Beuys and Carl Andre all made wonderful exhibitions because they chose the right works for the space and because they were not using the walls. The walls in the Wright building are not vertical, they're sloping!

– You have mentioned Leonardo and Piero della Francesca in conversations on minimal and conceptual art, emphasising the notion of continuity.

Yes. This continuity consists in the fact that Leonardo was not only a painter, not only an artist, but a man who studied science, a man who wanted to understand reality, to look for the laws behind nature. This is very important because the attitude of Leonardo marked the beginning of modern science. Piero della Francesca is also important as an artist who was looking beyond the geometrical shapes in his works to reveal a philosophical vision of reality. These shapes refer to an ideal reality that is behind the forms. It is a neo-Platonic vision that stresses the importance of the idea behind everything that we can see. This attitude is very close to that of conceptual art because it is the manifestation of the idea as the origin of every kind of art. Both Leonardo and Piero were greatly interested in science and mathematics, in making relationships that deal with the intellectual simplification of reality, and geometry was a main interest for both artists. In fact, at one time there was a project to install the collection in the Vigevano castle near Milan where Leonardo and Bramante lived and

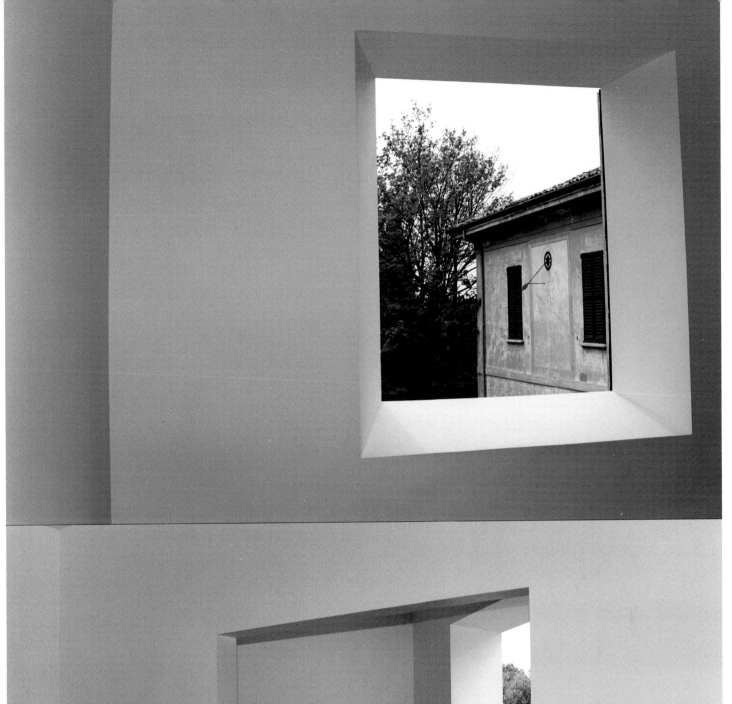
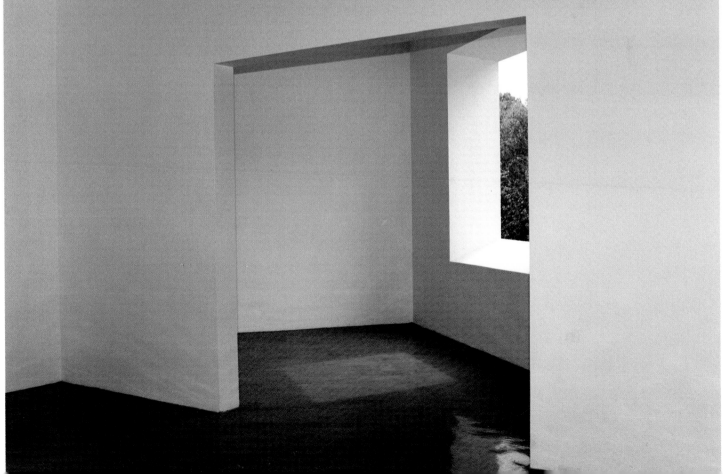

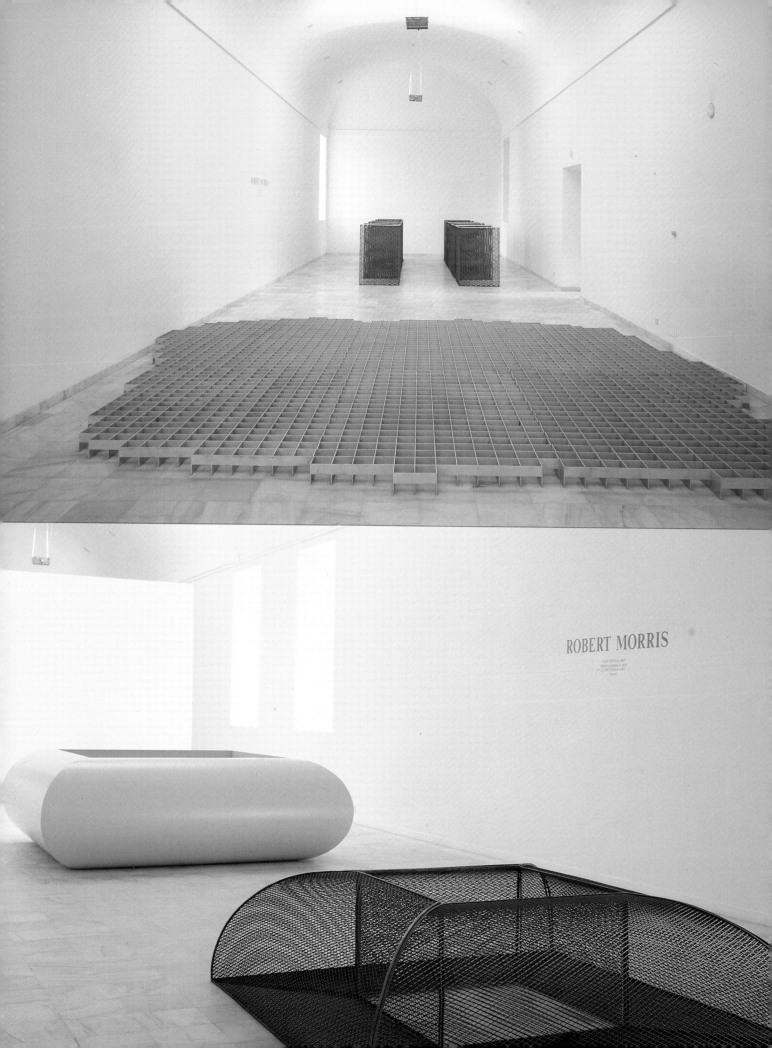

ROBERT MORRIS

worked. But unfortunately this project had to be abandoned.

– *What did you think of the Guggenheim's installation in Venice of works by a number of minimal artists from your collection (Donald Judd, Robert Morris, Robert Ryman and Richard Serra) in the context of modern art from the Peggy Guggenheim Collection (Georges Vantongerloo, Joseph Cornell, Piet Mondrian and Jackson Pollock)?*

I approved of this installation very much, because to show the relationship between an artist such as Robert Ryman and the early work of Piet Mondrian is very important: it allows one to see the processes involved. The process of Mondrian leads to a geometrical simplification. The simplification of Ryman leads to the white paint on a white surface which directly links the emotional reality of one's being to the work itself.

– *Do you see the arrival of your collection in New York as a continuation of the abstract philosophy of the Guggenheim, which was founded in 1937 as the Museum of Non-Objective Art?*

Yes. I have no doubt that this kind of art is the continuation of a process begun by artists such as Kandinsky and Mondrian, of abstract values that have dominated the 20th century.

– *Why did you decide to place your private collection in a public museum?*

I believe that a collector who has made something good has something in his hands which is no longer an individual possession. The collector has a responsibility to others, to make the works available to a museum and to future generations. This is extremely important. These works must be kept together in order to have the greatest impact. This must be the first priority. The museum has a very important role in keeping art for the future. Just as we enjoy seeing works of art made 500 years ago, I hope that in 500 years time these works will be similarly enjoyed.

– *It is becoming increasingly difficult for museums to compete financially in the commercial art world. The Guggenheim has purchased your collection at a figure that is lower than the commercial value. Can you comment on this?*

Yes. I believe that it is important for the collector to give up the economic interest in order to help the museum to acquire the collection. A museum can only buy an entire collection if the economic conditions are so good that it can convince people to donate money and if the collector is willing to give up part of the capital to help the museum. For this reason the negotiation with the Guggenheim is part sale and part donation.

– *What do you think about the Guggenheim's sale of a Kandinsky, Modigliani and Chagall to fund the purchase of the Panza Collection?*

The Guggenheim sold three masterpieces but it bought 300 very important works of art. I would be happy if, 60 years from now, three works from the Panza Collection were sold to buy 300 beautiful new works made in the next century.

– *Do you think a museum should exercise a critical, selective eye in purchasing contemporary art, rather than simply following the trends of the market?*

Yes, it's very important for the museum to be detached from the trends of the market, because these trends have very little to do with the quality of the art. The market for contemporary art is an erratic one because fashionable attitudes prevail. So there are artists whose works reach a very high price but after 10 or 20 years they are completely forgotten. Also the market value can completely collapse because people realise that this kind of work is not art. This is common in the contemporary market. The good artists who challenge the conventions of intellectual judgement are not immediately understood. It takes 20 or 30 years for their work to become fully intelligible and the market does not follow these works for a long time. So the museum must exercise a judgement that is independent from the market.

Unfortunately for the museum, however, it is difficult to collect contemporary art because there are only a few artists who are good enough to be kept for the future. And the museum must buy only these few. But when a museum buys 30 paintings by a single artist many people are against this kind of acquisition, this kind of preference. This raises many political problems and for this reason it is very difficult for a museum to build a collection of contemporary art. The collector, however, is free to buy 30 works from only 20 artists, to make a limited selection.

– *What role has collecting played in your life, and are you still buying new works of art?*

I am buying a lot of work because I now have the economic means to do so. It is a very beautiful activity and it is my life, to look for new things. I am collecting young artists who have yet to become well known and older artists who have not had the chance to become known or who are making new forms of art in just the last few years. This is important. I am buying Kiecol and Schütte in Germany, Vercruysse in Belgium, Grenville Davey in London and many in America, including Meg Webster, Peter Shelton, Bob Therrien, Roy Thurston, Susan Kaiser Vogel, Michael Brewster, Robert Tieman, Allan Graham, David Simpson, Daniel Levine and Carol Seborovski. I am confident that they are very good artists.

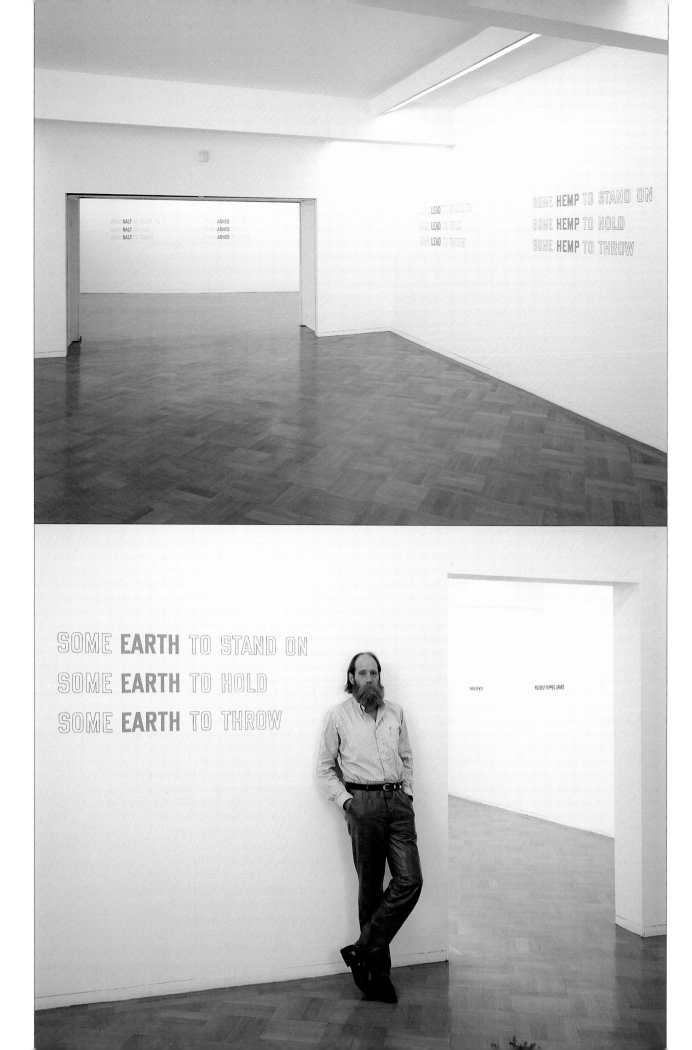

LAWRENCE WEINER
THE CONVERSATION OF ACCOMMODATION
The New Museology

THE FUNCTION OF THE MUSEUM IS IN THE FACT THAT:
(THE HOUSE TO HOUSE THE MUSE)

ART IS MADE BY THOSE WHO ARE NOT CONTENT WITH THE CONFIGURATION
OF HUMAN RELATIONS TO OBJECTS AND PHENOMENA AS PRESENTED.
ART PRESENTS AN ALTERNATIVE TO THE CONFIGURATION AS IT STANDS.
THE CONCEPT OF A CONVERSATION WITH AN ARCHITECT AS TO THE FUTURE
OF NEEDS PRECLUDES THE CONCEPT OF ART PRESENTING AND THE SOCIETY
DEALING WITH WHAT IS PRESENTED.
THE CONCEPT OF A CONVERSATION WITH AN ARCHITECT AS TO WHAT ART
IS TO BE AND HOW THAT ART SHALL BE PRESENTED IS NOT THE REASON FOR
NOR THE FUNCTION OF ART.

AS TO THE HOUSING OF THAT WHICH HAS BEEN MADE (THE HISTORY OF
ART) THAT IS A PRACTICAL CONVERSATION BETWEEN THE ARCHITECT AND
THE ART.

IF AND WHEN A PRESENTATIONAL SITUATION CANNOT ACCOMMODATE A WORK
OF ART – IT (THE WORK OF ART) MUST THEN ERECT A STRUCTURE CAPABLE
OF SUPPORTING ITSELF
WHATSOEVER SUPPORT THAT IS FOUND CAPABLE BECOMES IN EFFECT
LEGITIMIZED
THE DIALECTIC (CONVERSATION) CONCLUDES AS THE SYSTEM OF SUPPORT
CHANGES
PROLONGED NEGOTIATIONS WITH A STRUCTURE (EITHER ACCOMMODATING OR
NON-ACCOMMODATING) IS NOT THE ROLE AND OR USE OF THE ART OR THE
ARTIST

CONSTANT PLACATION OF PREVIOUS AESTHETICS CONSUMES PRESENT
RESOURCES TO THE EXTENT THAT AS THE NEEDS AND DESIRES OF A
PRESENT AESTHETIC MAKE THEMSELVES FELT THE RESOURCES HAVE
BEEN EXHAUSTED.

NEW YORK CITY 1991

SOMETHING TO STAND ON SOMETHING TO HOLD SOMETHING TO THROW,
installation view, Anthony d'Offay Gallery, London, 1 December 1988 to 6 January 1989

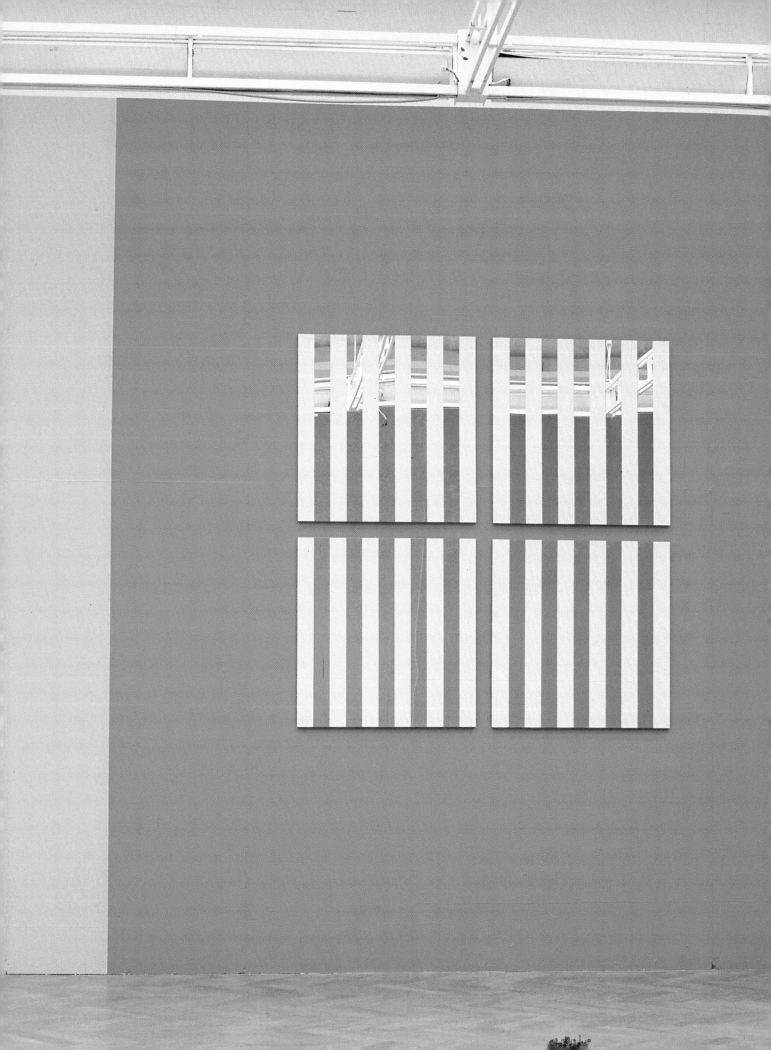

JEAN-FRANÇOIS LYOTARD
CONSERVATION AND COLOUR

I shall speak only about the museum of painting. Of what is called painting. Or: *pigmenta* as *picta*. Colour, posed, disposed, proposed, exposed. And, in the museum, re-posed, or posed one for all times, already and still posed and to be posed. Conserved, we say. With this connotation from the Latin *servare*: to keep up [*entre-tenir*: literally, to hold between], to maintain, to remain and cause to remain. Conservation as an *entretien infini.*[1]

It's a strange obstination or destination, to maintain and entertain posed paint. It has a relationship to time. The posed paint will not 'pass', it will always be now. That's the principle.

One might think that this condition (more demand than situation), is common to every enterprise of conservation, that it is the presumption, not of any memory (which, as we know, overflows both broadly and insidiously – I mean from the outside, but from the inside too – the programme of intentions to remember), but one might think that this remained common at least to any voluntary, intentional memorisation. Which cannot happen without the inscription of the thing to be maintained outside forgetting.

'Inscription' means that the thing can pass, cannot not pass, but that the signs which signal that it was then remain there. And when we say 'remain there' we presuppose, with that 'there', the salvation that every memorisation expects from space. This is the very argument which supports the supposed 'Refutation' of idealism in Kant's first *Critique*. We presuppose that *servare*, that *salvare* of the inscription, or we imply it. Graphy, engraving makes a trace, whatever it may be, that the thing has been. The picture in the museum is of course no longer the 'picture itself', as one says the 'thing itself': so we think, so we all think, enemies *and* friends of the museum. It is the trace of its past presence, and it makes a sign, mnesic sign in the direction of its supposed initial state, let's say of appearing.

The whole space of exhibition becomes the remains of a time; all the places, here, indices for other, past times, the olden days; the look, now, of the looker, the visitor, on the paint makes it into the sign of the paint it was, in its position or pose at the beginning of the work, at the moment of the opus' operation. And that can be said, so it seems, of any work, a house, a town, a landscape too, a book. The exhibition, says J-L Déotte, submerges every position. The worked space is a memorandum, the coloured space included.

You will remember that it is upon this presupposition or this implication, according to which space conserves, but conserves only by converting the thing into its sign, or by replacing it with its archive, that Plato's condemnation of writing in the *Phaedrus* rests. Graphy is a mnemotechnique. It transcribes for us what was said and thought then. It maintains and entertains the dialogue with self that is thought, it allows it to reach posterity, but it disarms it, blunts its living point. Writing delivers to readers, to their minds, a thought deprived of the faculty or rather of the actuality of that faculty to bounce back, to start

Daniel Buren, Buren-Parmentier, *installation, Palais des Beaux-Arts, Brussels, June-July 1991 (photo Philippe de Gobert)*

again, to ask again, to accept the question raw, to make room for the void of what is not yet thought. Through inscription, tradition betrays what it conserves. The time of transmission is a dead time, that of a repetition of the same through moments not distinguished by the event. It is still this presupposition, scarcely displaced, that orders Bergson's opposition of spatialised time with living duration.

Many of the accusations levelled at the museum proceed from this presupposition. It is only, they say, a mnemotechnic device. The works exhibited in it are emptied, bloodless. They are no longer valid for themselves, in their presence, but as signs of a lost life, and again, and perhaps above all, as testimony to the power – very current and present – to conserve. The power of the curators. And finally, according to this logic, the museum exhibits itself as a work of conservation. A work of the conservation of works. The 'colour' of an art museum, its timbre, its tone, its own atmosphere exercise its hegemony over the colours posed and composed in the painted works. The first is obtained by a composition of the second. The artists pass over into subservience to the curators. Even here, in our workshop, the absence of artists, as Buren pointed out to me when he had read our programme, testifies in favour of this necrosis. The dead grips the living.

It would be possible to think that this is 'merely', so to speak, a question of a change of frame, or scale, what Buren himself has been criticising for 15 years (I'm thinking of one of his first texts, *Critical Limits*, which dates from 1970). The museum of painting is itself a work of painting. But it is not a simple enlargement of the frame or the scale, it is also a decisive transformation of the destination of the work, at least in Buren's view. For the museum-work has as its end the conservation, upkeep [*entretien*] and maintenance, and therefore mnemotechnics alone. Whereas this is not true at all, at least if one follows Buren's initial hypothesis, of the painted work. It is living, one-off, ie situated and momentary. I'd say that in this approach it is essentially expenditure rather than reserve, and that if exhibited or exposed, it is rather to the uncertainty of its future than to its perpetual right to a place in the cultural heritage.

There is, or was, in Buren's polemic with conservation, a recurrence of the properly Platonic motif of the life of works. The term *entretien*, which is understood as *maintien*, maintaining, mnemotechnics, also means its opposite, a holding of meaning ceaselessly exposed to the event, to the question, to the taking up again, to the re-working of the maintenance of the theme, as Blanchot's Entretien infini.

And if we push a little in this direction, we will not be able to rest content with the principle of the so-called 'open' work, for it is the very notion of a work at all, as gathering and pose, for example of the painting as position and finished composition of colours, which needs to be questioned. In such a problematic, which rests, I repeat and stress, on the presupposition that the first gesture, live, 'presence', can only be damaged and pass or fade, as a colour fades when it is retained, reserved and conserved – and because of this very reserve – in this problematic, the institution of the museum seems as though it ought to be condemned without appeal. Simply because it is *par excellence* the finished work, the work in which works are finished.

If we want to confirm that this problematic, which is Platonic and entirely metaphysical, is still active and alive, it is enough to read the reflections inspired by photographic art (it keeps the thing alive by killing it), or to observe the media's penchant for 'live' transmission and recording (the words are revealing) on records: recording, ie what is deferred.

We philosophers have been in the habit of ignoring this prejudice for years. Of doing the critique of the 'first draft', of the origin, of life, and this is also a critique of the act, of pure actuality, and of the now . . . By showing that one is always and everywhere dealing with differing/deferring. This critique is called 'grammatology' when it emphasises that nothing is that is not inscribed, 'written' in the sense

Derrida gives to this writing. Or, following Deleuze's path, that there is no difference that does not presuppose repetition. An ontology of differing/deferring necessarily involves the avowal of inscription always already there, of a pre-inscription revealed after the event and a mourning of presence.

Every *voice*, *vox*, inasmuch as, since the *Bible*, this has been the name borne by the pure actuality of the event, comes to us recorded, phenomenalised, formed and informed, if only in the tissue of spatio-temporal agencies, in the 'forms of sensibility', here and over there, not yet and already no longer, etc. Not to mention the meanings pre-inscribed in the 'language' spoken by the voice.

Plato wrote his dialogues in the trivial sense of writing. But even if a work of language had remained unwritten, it would nonetheless have been inscribed even in the oral tradition of the bards, story-tellers, which involves no less technique, even if it is a different technique, than graphy. The universalisation of the idea of writing prevents any separation of the act from its placing in reserve, of the living and the dead, the work and its conservation, genius and technique. In his research at the Collège International de Philosophie, on the so-called new technologies and their relation to so-called culture, Bernard Stiegler takes the critique of the prejudice hostile to archiving in the other direction. There is no culture, even so-called archaic culture, which is not sustained by a technique, because culture is always transmission (whether it operates through tradition, institutions or media) and because transmission demands inscription. A thing is cultural because it is exhibited, ie inscribed or 'written'. Conversely, Stiegler is able to show that any technique, insofar as it is inscription, memorisation or conservation, far from being a means that would come as an extra to be applied to spontaneous works to ensure their transmission and conservation. And of course he does mean thereby to run together every kind of technology. But he does at least demand that the new kinds, or 'new technologies', should stop being considered, as they most often are, as new means, applied to works unchanged in their essence.

On the contrary – and I think I can say this in his name – it is the very relation of the mind to time and to space which is displaced by them, from the moment of the operation, of the *opus*. Following this orientation, one must consent without disgust to the institution of the museum, since the upkeep [*entretien*] in the sense of maintaining is no longer to be ascribed solely to deliberate memorisation. There is nothing alarming in the fact that archiving of works should take *place* (and moment), especially not painted works, if it is true that any work is already necessarily an archive, a spatio-temporal organisation, 'blocked', in some sense, to permit repetition and transmission. Deleuze says 'territorialised'. But you know that territoriality can 'engage a movement of absolute deterritorialisation', and 'stop being terrestrial and become cosmic'.[2]

What we can be alarmed about is that the museum might neglect the modes of inscription and organisation of space and time that the new technologies are, at the very moment when, in today's version of humanity, they are in the process of replacing the 'old' technology of writing-graphics.

And what we can also be alarmed about is that, whatever technical mode the museum satisfies, the aspect of archiving and blocking, what I'd call the 'apparatus' in the exhibiting of works might, in their perception and reception, take precedence over the aspect of differing/deferring, of putting back into play, of 'bouncing back', as Buren says. I would say of welcoming the event, and, in our case, that ontological event that colour can be.

That there should necessarily be spatial inscription, trace and conservation in no way entails that the mind is doomed to repetition, and that there is nothing else to inscribe which has not already been inscribed. A despair that is nowadays often adorned with the name of 'new' or 'neo'. I won't develop

this fear any further here, and the demand it brings as to the conception and function of the museum. The point is not to collapse them back onto the prejudice I've just denounced, the implication that only the 'live' is any good, or, as the public authorities put it, 'creation'.

I would prefer to end by saying a couple of things about what in my view is the important point. It may seem to contradict what I have just said. I do not think that it does.

You will remember that in trying to make the reader of the 1767 Salon see the landscapes painted by Vernet, Diderot pretends in his writing that he is strolling in them with his friend the Abbé. Through writing, he opens the surfaces of the pictures like the doors of an exhibition. As in the museum, it is not just eyes, but whole bodies that come to move, and no longer *in front of* the disposition of colours, but *amidst* them. Each landscape fictively traversed in this way is the exhibition of a 'nature'. Through this feature, Diderot abolishes – I'd like to say 'abridges' – the opposition of nature to culture (nature is a museum of colours), of reality and the image, of volume and surface.

There would be a lot to say about this procedure. Here I wish only to take it as witness to what I believe to be at stake in painting, and perhaps more so today than recently or long ago. By pointing out that landscapes are exhibitions, Diderot also suggests the opposite, namely that exhibitions are landscapes. It is enough, perhaps, to take the situation of works in museums in itself and for itself, *without referring it* to their supposed initial situation, in the studio, at the moment of the 'first' sketch, or even what might have been the artist's 'first' imagination of them. It is enough to convince oneself that there is not *one* originary freshness, but as many states of freshness as what we might call disarmed gazes. As many times of presence as there is soul (Kant uses the word in the third *Critique*).

It was in order to support this really quite trivial – too trivial – idea that I started with colour. As opposed to forms, and still more figures, colour appears to be withdrawn, at least through its 'effect', through its potential for affecting feeling, from the circumstance of context, conjuncture, and, in general, from any plot [*intrigue*]. This is why it is usually classified, in aesthetic theory, on the side of matter or material. Form (or figure) can always, from near or far, be referred to an intelligible disposition and can thus, in principle, be dominated by the mind. But colour, in its being-there, appears to challenge any deduction. Like the timbre in music, it appears to challenge, and in fact it undoes it. It is this undoing of the capacity for plot that I should like to call *soul*. Far from being mystical, it is, rather, material. It gives rise to an aesthetic 'before' forms. An aesthetic of material presence which is imponderable.

I know very well that colour changes with light, lighting, the weather, and the passing of time. But it is because we have given it a name, a place in the table of samples, and because this designator inspires the principle that it is and must always remain the same. But it is its very mutability that makes it propitious for the disarming of the gaze. Everything is changed in the timbre (to keep the musical metaphor), or the fragrance, in olfactory terms, according to whether you open the curtains of the choir of San Francesco d'Arezzo, whose walls bear Piero's frescoes, or whether you direct spotlights onto them. But it cannot be demonstrated that one of these is more 'beautiful' than the other – let's say less 'present' than the other.

I saw in Montreal little landscapes by Vernet himself, under glass and lit by neon, whose livid quality thus obtained had an immediate force of interruption or forbidding of the mind.

The painter is seized or made to let go by a shade. Cézanne in front of his mountain. He tries to transport it onto his support. He knows that he will not be faithful. But what is he attempting at least? To get the looker to feel (let's use this word, for want of a better) the same letting go when faced with the

colour posed and composed in the picture. It is not a question of authenticity, which is a market value.

It seems to me that the aim of painting, beyond and by means of all the plots with which it is armed, including the museum, is to render presence, to demand the disarming of the mind. And this has nothing to do with representation. Painting multiplies technical and theoretical plots to outplay or play with representation. It belongs to voluntary memory, to the intelligence, to the mind, to what questions and concludes. But it happens that a yellow, the yellow in Vermeer's view of Delft, can suspend the will and the plot of a Marcel. It is this suspension that I should like to call soul: when the mind breaks into shards (letting go) under the 'effect' of a colour (but is it an effect?). And then one writes 20 or 100 pages to pick up the pieces, and one puts together the plot again.

Now I see no reason at all why this aim, this unique aim of painting, this material presence, should necessarily fail from the fact that the yellow of the wall is hung up in a museum rather than elsewhere, if it is true that chromatic matter owes nothing to the place it can take (and which in a sense it never takes) in the intrication of sensory positions and intelligible meanings. And this is how the case of a museum of painting is different from others, from many others. Through the fact that it exhibits chromatic matter, which makes an appeal to presence beyond representation. All one can expect from it is for it not to prevent the state of letting go by making itself too prominent.

And finally, so as to avoid confusion, I want to make it clear that when I say colour, I mean any pictural matter, beginning with the line. In the old Japanese calligraphies, the stroke of the brush does not make a line in the sense that a draughtsman's pen does. And what should one say about Yves Klein's imprints?

Notes

1 *Entretien* has the sense both of 'conversation' or interview', and that of 'maintenance' and 'upkeep': the immediate allusion here is to Maurice Blanchot, *L'entretien infini*, Gallimard, Paris, as referred to a little later.

2 G Deleuze and F Guattari, *Mille plateaux*, Minuit, Paris, 1980, pp341-433.

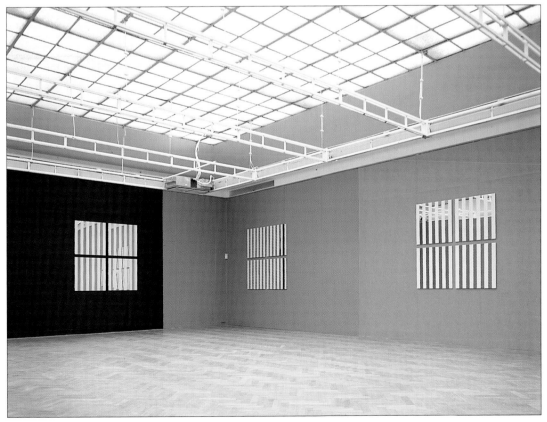

Daniel Buren, Buren-Parmentier, *installation detail, Palais des Beaux Arts, Brussels (photo Philippe de Gobert)*

AN ABSTRACT DEFINITION OF SPACE
CAPC MUSEUM OF CONTEMPORARY ART, BORDEAUX

Opened in 1984, the capc Museum of Contemporary Art in Bordeaux has added another layer to the history of the Entrepôt Réel with a project that aims to communicate to a public audience the visible manifestations of contemporary artistic thought. Conceived and realised by director Jean-Louis Froment, with the support of the City of Bordeaux, the project has brought the museum into direct contact with many contemporary artists, and has initiated a programme of temporary exhibitions. The extension of the museum into the surroundings of the Entrepôt in 1990, in addition to the restoration of the old warehouses by architects Denis Valode and Jean Pistre, has brought about the opening of new exhibition spaces and has given a new impetus to educational and scientific activities related to art.

Built in 1824 by the engineer Pierre Deschamps, L'Entrepôt Réel des Denrées Coloniales was constructed on the banks of the Garonne to house and guard the precious foodstuffs imported daily by ships trading with the West Indies, Africa and India. The uncompromising rigour of its conception perfectly harmonises with the use of only three materials – stone, brick and wood. This austere character has found a certain compatibility with the spirit of numerous contemporary artists who concern themselves with simple visual and spatial effects.

Contemporary art in this building, on the decision of capc and by its own nature, is more than just a matter of exhibiting to the public. It requires a notion of museology that includes not only conventional gallery spaces, but also creative artists' spaces, conference and consultation rooms for artistic and critical discourse, and a well-stocked research library, as well as opportunities for meetings among artists and between artists and viewers. It is a continually evolving process: one does not know the development or outcome of the route taken by the artist in realising the work. Confronted by the need to take into account both programmatic coherence and the creativity of the artist, the architectural objective has been to propose redefinable places, as much in the exhibition spaces as elsewhere in the building.

Even while functional or technical constraints might prove to be problematic, the aim is to communicate, by means of a certain detachment between the new arrangement and the original building, the notion that other situations might exist, that everything might conceivably disappear but the Entrepôt would always remain. This concept naturally leads to the anticipation of a space for architectural debate, an exhibition gallery for architecture and places of learning that encourage the heightening

of perception, particularly among children.

The exhibition space is of course the most essential part of the museum. The rooms which we have at our disposal, a sequence of partitions measuring 6.5 by 13 metres, are too small for exhibiting works of a large format. There is both a lack of proper perspective and insufficient wall surface: more than half the walls are composed of empty arches. But this is the charm of the place, indeed its spirit resides in this sequence of successive arches. It is therefore essential that these structures are not hidden while exhibiting the works, and it is important to offer the public a sufficient distance in order to appreciate them.

Our intervention consists of encasing within the architecture of the warehouse another architecture, that of museum spaces formed by walls – vertical and horizontal panels, which demarcate, divide, articulate and define the exhibition space. The composition consists of a system of planes, centred and modelled on the dimensions of the building and dispersed according to a common rule. The panels of greater dimensions, for receiving the large formats, cover the brick arches to half their height and, thanks to their thickness (the thickness of a wall) and their displacement in relation to the stone masonry, the reading of the Entrepôt's architecture remains, in a sense, an independent one. The spectator continually perceives the wide perspectives and retains a memory of the brick arches in their entirety.

In order to have the necessary perspective, the pictures have to be seen at an angle in relation to the viewer, since the preceding panel is, so to speak, across the preceding arch. Therefore the viewer understands his relation to the works by involving himself in the enclosed composition of the two architectures.

If we have searched for clarity in the relationship between the abstract definition of spaces and the restoration of the Entrepôt, we have sought readily to maintain the ambiguity between painting and architecture. As H Damish said, 'I have never been able to consider works of a large format such as those by Jackson Pollock or Barnett Newman without recognising in them the wish that haunts painting, which is to substitute the wall to the point of suppressing all notion of hanging.' It is this wish which we have wanted to integrate: to forget the idea of architecture in order to present paintings, to permit the painting to become the only presence, or to be perceived as such. These are no longer walls on which paintings are hung, these are spaces defined by the walls which are thus able to become paintings.

Interior view of the museum showing one of the free-standing panels that divide, articulate and define the exhibition space, at the same time maintaining an independent reading of the original warehouse structure. (photo Christophe Kicherer)

Richard Serra, Threats of Hell, *installation view, May 1990. For the inaugural exhibition, the capc Musée invited Richard Serra to make an installation in the great naves of the Entrepôt. He proposed to install three immense steel planes of 43 tonnes each, looking as though they had fallen out of the sky and been driven into the earth. These structures define the spaces anew and were conceived both in relation to, and for, the great naves. At the same time, they can be perceived and read independently from the Entrepôt. In this way Richard Serra's preoccupations seemed to overlap with our own at the moment of the presentation of the museum to the public. (photo Frederic Delpech)*

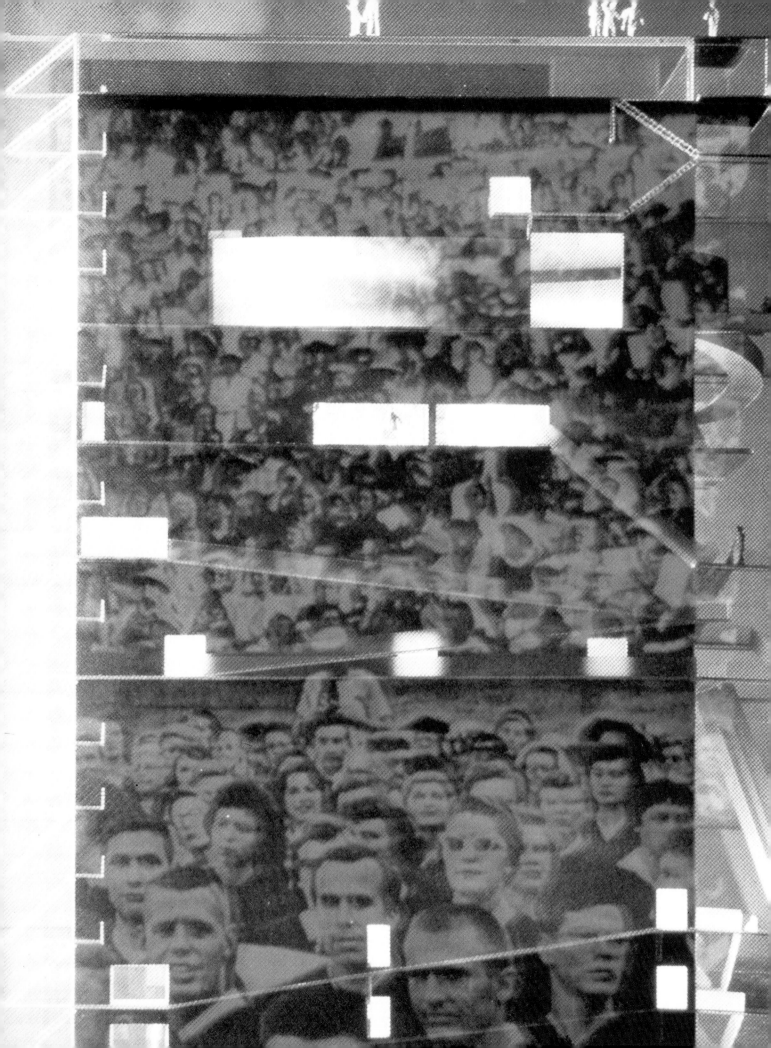

HEINRICH KLOTZ
CENTRE FOR ART AND MEDIA TECHNOLOGY, KARLSRUHE

The container for Zentrum für Kunst und Medientechnologie (ZKM), the Centre for Art and Media Technology in Karlsruhe, conceived by Heinrich Klotz early in 1989 and designed by Rem Koolhaas towards the end of 1989, has yet to be constructed. The complex space devised to contain computer research laboratories, experimental studios, a media museum, theatre and museum of contemporary art, as yet exists only in the form of written texts, drawings, models and dramatic computer simulations. However, even without a permanent structure, which will not be realised until 1992, ZKM is already gaining international recognition as an active and influential centre, gathering together new art from commercial galleries and artists' studios, and recently installing an exhibition of media art in an old factory in Karlsruhe, where the accompanying photographs were taken. Emphasis at ZKM is on the temporary and the immaterial, on the notion of a museum as an 'experimental stage' for new art, accepting the risks that accompany such a venture and extending the limits of conventional museology. In the following text, director Heinrich Klotz explains the thinking behind his conception.

Bringing together the arts and new media technologies in theory as well as in practice, the main objective at ZKM is to foster the creative possibilities of a connection between the two, in order to gain insights and anticipate the needs of the coming century. The goal is to enrich the arts, not to amputate them technologically. Therefore, the great potential in the traditional arts and the potential to be reaped in the media technologies must measure up mutually; both of these areas, individually and in collaboration, will be promoted and supported.

The models for this undertaking were Bauhaus in Dessau and the former School of Design in Ulm. Bauhaus was the first attempt to remove handicraftsmanship from art and to orient art towards the machine; the School of Design in Ulm continued by creating a connection between art and industrial products. Appropriately for the present state of technology now nearing the end of the 20th century, ZKM will be applying digital techniques to the arts, yet just as Bauhaus avoided replacing artistic creation with machine production, ZKM will also emphasise the importance of maintaining the artist's creativity when he is confronted with technological processes. Just as painting has not been made redundant since the arrival of computer graphics, the grand piano, too, need not be disposed of simply because the synthesiser is now readily available.

In order to fulfil these requirements, the Centre will have to pave new ground in terms of its substance and organisational structure. A space must be established in the Federal Republic in which the attempt is made to advance artistic and media technological issues and to anticipate for the future – a place where the goal is a synthesis of the best creative forces in the arts and media technologies. Priority will be given to the creation of multi-media *Gesamtkunstwerks* as well as to the development of special technologies, the promotion of the new, and also the critique of a society partially blinded by media euphoria. The artist and the scientist, and also the interested general public, will have access to the facilities and equipment at ZKM, in order to achieve the goals in mind. Especially promising results are expected in the combination of various kinds of visual and acoustic media, as can arise from a coupling of electronic music, laser, video and video animation. Furthermore, the creations in new media must relate to those in the traditional arts, in order to provide a desirable amount of friction between production methods of consumer articles or pieces of art which have been made using media technology and those produced using conventional methods.

Decisive steps must still be taken in regard to a critical combination of art produced by media technology and traditional techniques. A few selected examples of the issues to be explored include: the confrontation of traditional ballet with an immaterial stage-set designed using holography; the merger of standard design techniques with the CAD possibilities for custom-designed products for mass consumption; the fusion of hand-drawn architectural designs under the control of multi-perspective views; or, more broadly, the confluence of illusionary artificiality with simulated 'substitutes for reality'. In the field of video art and animation, to cite just one example, the potential for broadening the horizons in experimentation and research are immense. And lastly, the tenacity of traditional notions of art must be re-examined. An institutionalised solution must be found for the possibilities and issues presented here. Establishing the Centre for Art and Media Technology in Karlsruhe will, for the first time, provide a physical space which can enable the study and creative coming-to-grips with new media as an artistic and scientific discipline. To this end a School of Design will be established in Karlsruhe which will make it possible to offer the knowledge gained to future generations and to set up a binding basis for augmentation and practice.

The central area of ZKM is the computer laboratory. This is the area for experimentation and

Rem Koolhaas, ZKM, Centre for Art and Media Technology (west facade), 1990, computer simulation

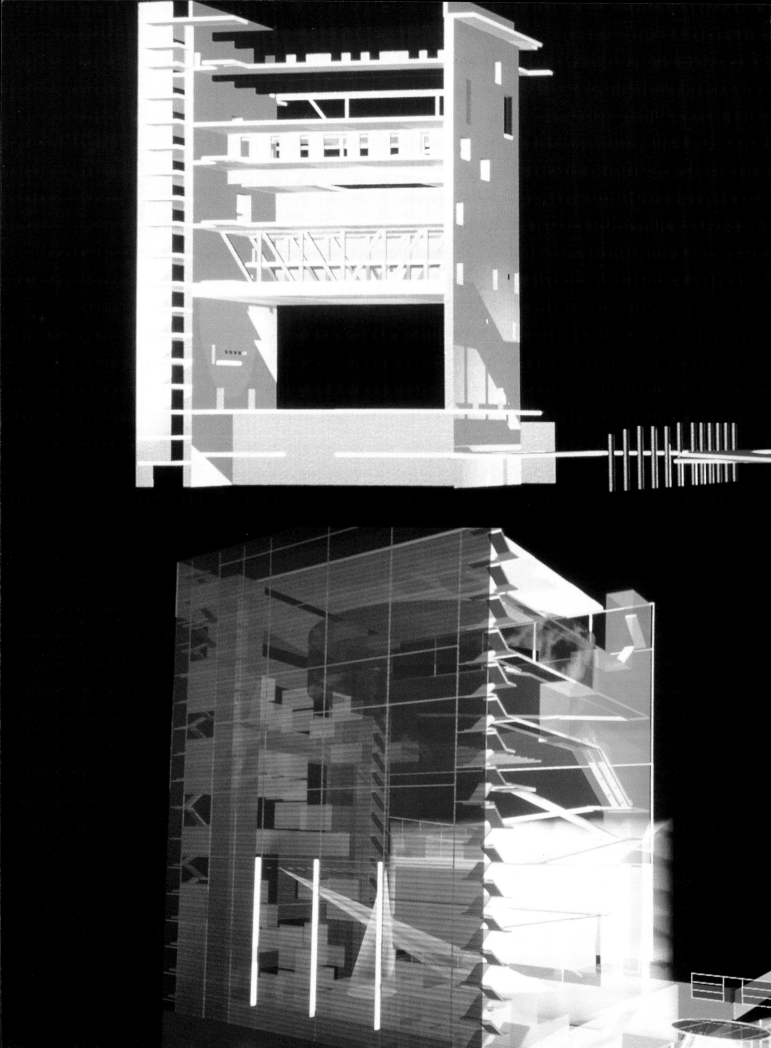

*Rem Koolhaas, ZKM, 1989, computer
simulations realised at the Office of
Metropolitan Architecture (OMA),
Amsterdam, and in the studios of ZKM*

Nam June Paik, Arche Noah, *1989, mixed media video installation*

Nam June Paik, Passage, *1986, mixed media video installation*

Wolf Vostell, Beton TV-Paris, *1974-91, mixed media installation*

research, in which artists and scientists have the necessary equipment at their disposal in order to apply new technology to aesthetic practice. Collaboration with experienced engineers and computer scientists will lay the groundwork for practical artistic work.

Studios will be necessary (for long-term installations) to serve in producing videos, laser installations, holograms, etc, and also in preparing for presentations (performances, multi-media operas, etc). These studios will have to exceed the standard size which artists normally have at their disposal, in order to facilitate the production of installations and experiments with light, laser and acoustics which are of a large format and/or extend over a wide area.

Results arrived at in the laboratories and studios will be exhibited and tested publicly in the Media Theatre which will contain the specialised production and performance equipment lacking in conventional performance spaces. Opportunities should be provided to showcase in-house productions, as well as 'guest-productions' in order to present results drawn in other places and, when the occasion arises, to combine these with ZKM productions. The international scene of events in media technology and media aesthetics must be reflected jointly to allow a wealth of exchanges of experience across national borders.

ZKM libraries for videos, audio cassettes and slides, as well as the art and media libraries, are all open to the public. These collections additionally serve as archives, not only for media produced at ZKM, but also for a comprehensive collection of documentation regarding video art and electronic music. Setting up a video library is especially desirable, since videos are not necessarily durable and must therefore be replaced regularly. The various techniques available today enable us to maintain important video documents for posterity. Unfortunately, each year many video recordings of artistic events get lost, for example videos of happenings, performances, multi-media events. Art videos and video animation, too, suffer from a rapid aging process. Since public broadcasting stations do not always keep art-related programmes in their archives, these should be taped and kept in a central video library. Such facilities do not yet exist in the Federal Republic of Germany.

Media Museum

The Media Museum, the most important point of departure for ZKM, is closely tied to the computer laboratory and studios. The history of media and the potential for individual kinds of new media will be brought into full public view using exemplary models and exhibits. Individual hands-on areas encourage the visitor to cross over from passive observation to active participation. Adjacent areas will include laboratories for the public and seminar rooms. Before the interested public can venture into the laboratory area in order to turn their knowledge and artistic intentions into a piece of work, they need the stimulation, the basic information and subsequently the educational opportunities provided by the Centre.

A permanent exhibition must offer the visitor the opportunity to be led along a carefully planned and pedagogically sound path, starting with a harmonious selection of examples of media technology, going on to a less spectacular conventional area of classical media, continuing into the area of possibilities for media technology and media aesthetics today, and finally ending up in the sector of research and development, in order to gain insight into practical work in the laboratory.

A concept for the Media Museum could include the following collections:

Printing methods

Classic media include book-printing and other printing processes. The initial topic in a permanent exhibit should be the reproduction of the word and illustration. Displayed here could be specific samples out of the history of early book-printing (incunabula, a facsimile of the Gutenberg Bible, etc) and also especially impressive examples of books from more recent eras.

The public could be given the chance to set type on their own, experiment with different fonts, and print their texts by hand on a printing press kept in operation by the Centre. As a means of comparison, the equipment necessary for printing using computerised type-setting should also be made available and the printing process using computers should at least be illustrated.

Printmaking

The earliest form of the reproduction of pictures is the woodcut. A small collection of such woodcut incunabula, and also the first copper etchings, could illustrate the historical process of reproduction started in the 15th century. A working press could provide live presentations of this process.

Handbills, caricatures, comic strips

During the Reformation, the first instances of the media being used to influence public opinion appeared in the form of the handbill. For example, the historical conflict between papistry and Lutheranism could be illustrated through an exhibition of handbills, with detailed explanations. As a means of comparison, adjacent exhibits should be of modern photojournalism, enhanced by classic examples (picture series of Parliament elections, natural disasters, etc). Election posters, too, should at least be referred to, together with a presentation of the role of political caricatures starting in the 16th century. Historical and contemporary examples ought to confront each other.

Pictorial illustration leads from the single picture to the narrative sequence. Popular pictorial representation can be traced back to its roots using examples from Hogarth, Wilhelm Busch and others. From its inception in the Baroque period as word banderoles up to the cartoon bubble, the interaction of word and picture can be presented in its historical development.

Other media

The essential aspects concerning the history of photography and film will be sketched using con-

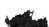

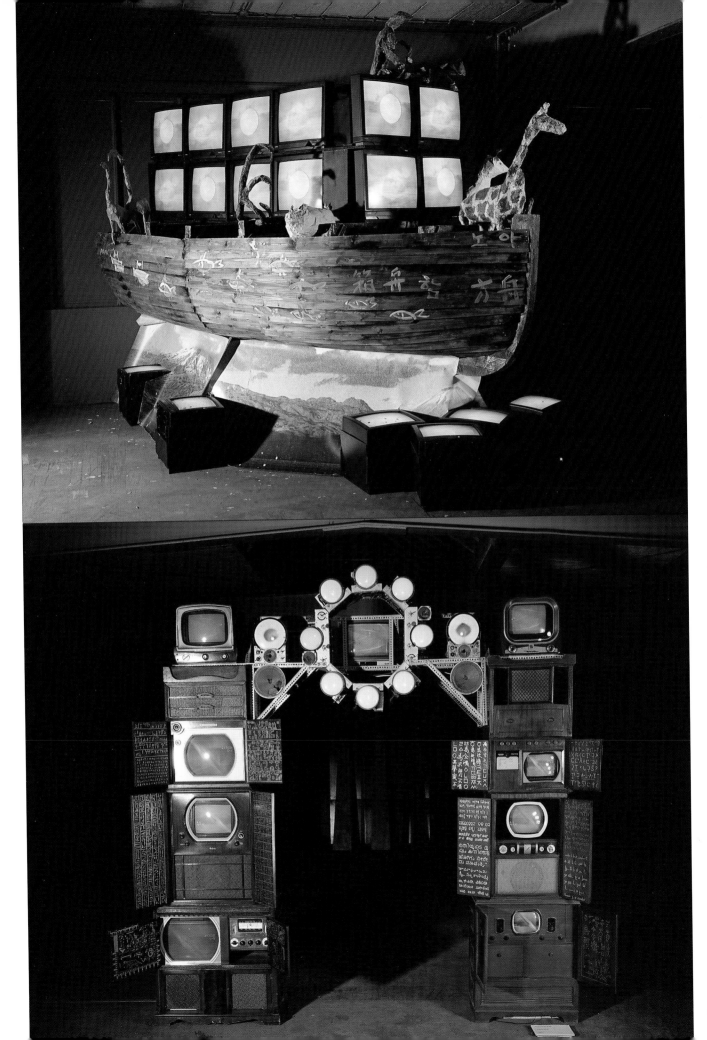

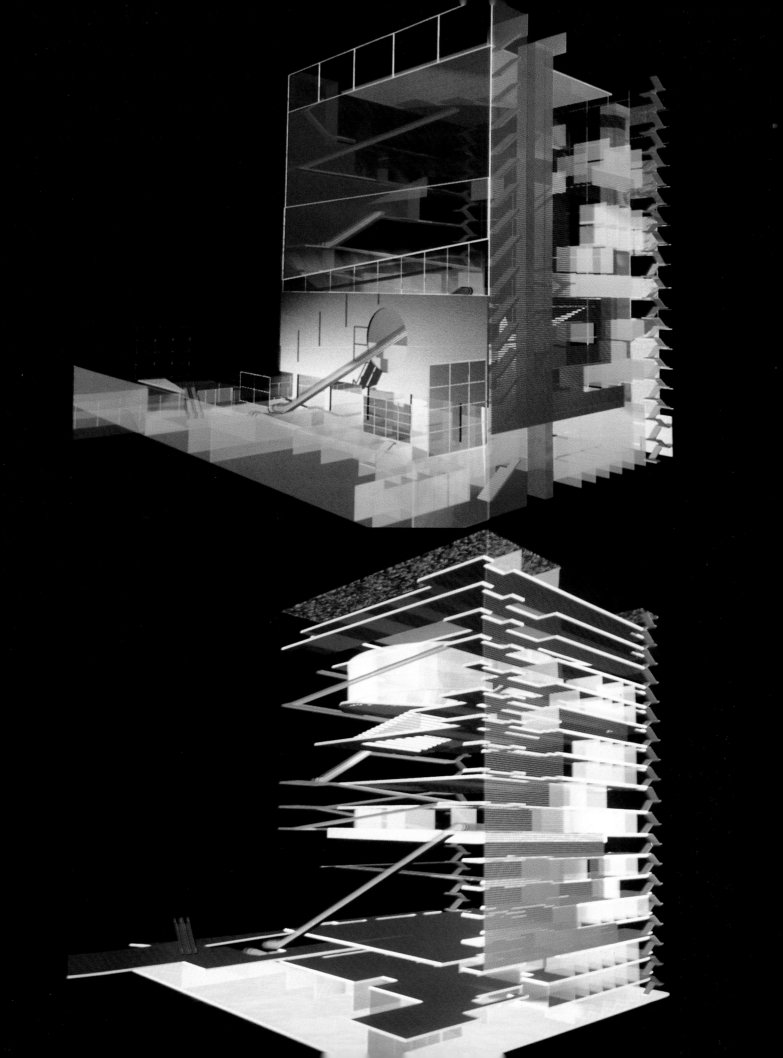

Rem Koolhaas, ZKM, 1989, computer simulations realised at the Office of Metropolitan Architecture (OMA), Amsterdam, and in the studios of ZKM

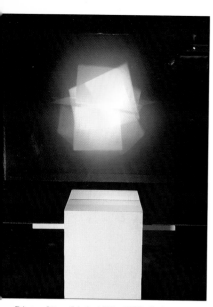

Dieter Jüng, Light Mill, 1989, holographic tryptychon

Multimediale 2, 28 May to 7 July, a festival organised by the Centre for Art and Media Technology, including mixed media video installations from the Museum of Contemporary Art, ZKM and coinciding with a number of performances, symposia and concerts

cise and striking examples. The wealth of various ways to convey a message by word or picture, in technical as well as aesthetic dimensions, should be illustrated in its entirety in a media museum. The exhibition must present the parallels between historical and modern media, but also the blatant break between the two.

Modern media

Following the historical comparison, the exhibition should culminate in the presentation of the potentials of modern media: video, computer graphics and computer animation, holography and laser.

On one hand, the video and holography exhibits can be experienced by the visitor in a purely passive way, and are therefore not directly influenced by the visitor. Computer aided design, on the other hand, and perhaps laser installations, can be offered as instruments to be manipulated by the visitor.

Using computer aided design similar to that already applied in architectural studios, the visitor can draw groundplans, isometric sketches and perspective drawings of his ideal living situation on the basis of data he has entered. A myriad of vastly differing ground plans and spatial arrangements can be made evident using the constant variables entered. Another computer aided design programme could be utilised to show the multitude of possible positions for the furniture in a given room. Thereby the scope of functional and object relationships is demonstrated in constant volume. The computer provides the user with the freedom to 'furnish' the space in a completely new way.

The computer in the permanent exhibit can, furthermore, offer an introduction into the possibilities of computer graphics. The visitor can experience his first 'findings' in practical media aesthetics, from the production of simple patterns to that of more sophisticated examples, ranging from geometric to free-form.

The *Gesamtkunstwerk* of contemporary media is the media environment. The permanent exhibit should culminate in a large space in which various kinds of media interact to create a total experience. Electronic music, laser, light and video can be installed here as an analogue process (controlled by computer). The existing precursor to the media environment can be found in the hi-tech media discos in metropolitan areas. These could serve as a model for a still-sublimated form of the media environment (compare Otto Piene's experiments at MIT). Shin Takamatsu's media disco in Kyoto can almost be considered a media environment.

Should new media be utilised simply as 'exhibition pieces' and limited to a presentation of aesthetic objects, such as a collection of holograms? Or should we restrict ourselves purely to demonstrating the usefulness of a graphics programme or a video library which enables the visitor to view a specific video? If these are the goals, then the new potential for the world of media will be only partially exploited. The new media environment, on the contrary, fully transforms the human environment as a media-aesthetic artefact. While the traditional relationship of discovery and aesthetic experience is characterised by the detached opposition between the observer and the observed, new media, on the other hand, confronts the observer head-on and he finds himself within it.

'Moving pictures' in film have already brought the observer closer to the object. Total involvement in the story increases the psychic proximity (loss of self). And the simulation methods used in 3-D films have practically done away with the distance between viewer and image. The degree of illusion has even reached the point of a complete identification with the movement of images and the viewer's sense of movement (mountain and valley train effects). It has become possible, by the use of modern simulation methods, to create the illusion of the ocean waves, a plane taking off, or a ride down Fifth Avenue, as immediate environments. The process of simulation takes the place of the illusion. In this vein, the 'small environment' of a simulation capsule, for example, similar to those used for training pilots, could serve to immerse the visitor in different environments in the Media Museum (a flight through the Grand Canyon, a trip through an African village, etc).

All the possibilities presented in this concept for setting up a media museum should serve as a range of examples which will necessitate expansion and grounding. It goes without saying that the aspects of a museum as a place for learning and discovery should not be neglected; neither should the aspect of aesthetic enjoyment. But above all, we need to break out of the rigid opposition of observer and exhibited object. The museum should also be a place for experiences. Unconventional means ought to be implemented and a stiff setting of priorities, such as the definition of so-called 'high culture', should be disposed of.

Museum of Contemporary Art

There will be a Museum of Contemporary Art incorporated into ZKM. This will present works of traditional art in comparison to media art, the focus not being the history and analysis of media technology, but rather the art itself, free from any specific methods. A museum displaying all sorts of art and contemporary media, which does not shy away from technical innovations, does not yet exist.

The Museum of Contemporary Art should not be obliged to exhibit so-called 'Modern art' in a retrospective manner, but rather a continually renewed cross-section of the most recent developments should be exposed. In this way a permanent collection, in which the works displayed slowly age and gradually transmute into 'classic works' or end up in storage, can be dispensed with. This means that the Museum of Contemporary Art must be a museum for temporary exhibits. The entire exhibition must be replaced in yearly rotations and focused towards the latest developments in the field of traditional art as well as media arts. Changing exhibits need not depend only on the presentation of in-house creations; loans from private collections, galleries, also from the artists themselves, will insure that the exhibits remain up-to-date.

After the Museum of Contemporary Art has been established, it will need financial means for the

acquisition of works of art; furthermore it must be capable of commissioning its own works, especially media installations and environments created specifically for the museum. The collection will thus be able to grow slowly, without being forced to do without certain exhibitions.

The exhibits on loan, as well as the museum acquisitions, could mainly be comprised of pieces acquired at a calculated risk. An acquisition budget of about DM500,000 is sufficient to acquire works of most younger artists, although media installations could be more costly because of the higher production expenses. A Museum of Contemporary Art should be an 'experimental stage' for the arts, so that risks will be undertaken to support new artists, not only to confirm already recognised and established artists. Risk or venture art can be acquired relatively economically, but it must be expected that a considerable percentage of the acquisitions and commissioned works will not prove themselves over the long run. On the other hand, works of art which were acquired early on for minimal sums and subsequently gain general recognition can serve as guarantees for a noteworthy increase in value. Loss of assets in regard to some of the venture art can therefore be compensated for (with the expertise of the museum curator). Finally, the novel working character of media art must be taken into consideration; since it is often immaterial and exists only for the duration of the exhibit, this art disappears after dismantling or is reduced to its technical equipment. In this way the material value is practically lost after the exhibition is over.

A Museum of Contemporary Art must consider the most recent phase of the history of artistic production over the last 20 to 30 years in its exhibitions and collections. Adjusting for the latest 'has-beens' and the newest avant-garde implies a retrospective covering a short period. This comparison of styles and directions in the arts is an essential premise for setting up a collection. As soon as single pieces of venture art are recognised and become classics, they should no longer be exhibited and could be given to other state or municipal museums. It cannot be the objective of a Museum of Contemporary Art to earn itself a reputation by accumulating a collection of classics. The opening of the new annual exhibition of the Museum of Contemporary Art could be more than a purely local event; a symposium of art critics, art theoreticians and artists should be established for the occasion. Up to now, the Federal Republic has not had a forum offering the possibility to discuss newly emerging tendencies in the field of art at regular intervals.

Integrating a Museum of Contemporary Art into ZKM will also mean presenting the results from the laboratories to the general public. Similarly to the Media Theatre, this area will provide the necessary experimental stage for appropriate kinds of art and media in order to prevent the work and artists at ZKM from remaining introverted and in order to counter the risk of becoming a private 'crystal palace'. Presentation to the public is the ultimate proof of achievement.

Marie-Jo Lafontaine, Les larmes d'acier (Tears of Steel), *1987, video installation*

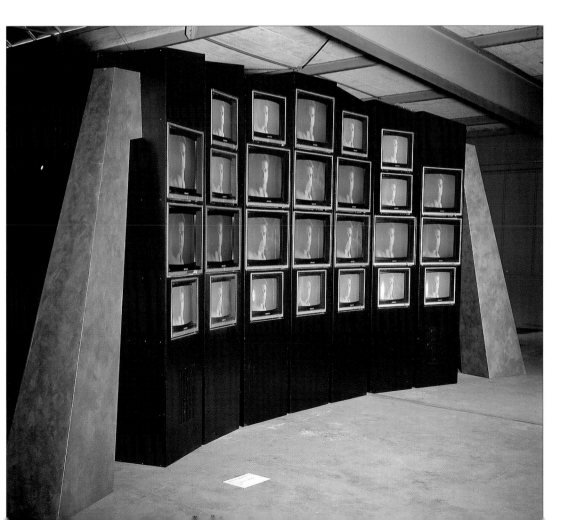

ANDREW BENJAMIN
ON DISPLAY

Judith Barry, Adam's Wish, *1990. Barry's electronic* trompe l'oeil *ceiling features a worker, Adam, who is swept up into a vertiginous fast edit journey through architectural spaces and symbols, some iconographically jumbled, others rigid and codified. Barry asks, 'If architecture refers to a sense of shared community and to a public vision and responsibility, why is the loss of iconography not more keenly felt and desired?'*

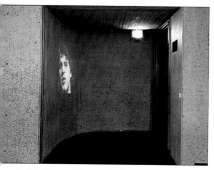

Judith Barry, First and Third, *1987. In a series of talking portraits, actors narrate stories collected by the artist from people whose roots lie in South American, Asian or Afro-Carribean cultures. Their everyday, yet invisible histories are writ large; through projection they are transient but flexible, able to appear anywhere in the city, whether welcome or forbidden.*

6 Here the question of the event – object as event and as event never reducible to pure objectivity – will pertain to what is on display. And yet the pertinency in question is difficult. An apparent reflexivity is involved since expressing display brings with it the very complexity that must come to be addressed. Expressing display already entails a form of display. On display – being on display – is a state that is 'itself' being displayed. (It goes without saying that the nature of this 'itself' is far from straightforward.) The doubling of display allows for a response to be made to the question of what conditions would pertain for the evaluation of any display.

7 Admitting complexity opens up the question of the event. Complexity is present. Its presence is anoriginal. Consequently it will even be present at that precise moment when simplicity – even elegant simplicity – is thought to have done without the complications of complexity. Accepting such a possibility, let alone working or *interpreting on the basis* of its enactment, is itself based on neglecting, perhaps forgetting, the display of display. Exhibited in this doubling is the presentation of politics. Any reduction to the simple, to an unproblematic 'there is', effaces this presentation. However the political is reinscribed and complexity reintroduced by the mark, the remainder, left by the positing of simplicity. Forgetting leaves its mark.

8 Even the elemental can be confounded by showing that it resists the elementary. The white cube entails a certain conception of the object of display and is of course entailed by it. It involves a specific determination of the site of art, including the relationship between subject and object. This relation is not just phenomenological – the locus of experience – since it is also the location of meaning and thus the domain where the conditions of possibility for meaning and understanding come to be played out. It is in the playing out that strategic chance – the chance effect – may introduce an incision.

9 There is no simple move from experience to meaning and then to understanding as though they formed a linked continuum, one where each was an addition that either built on or supplemented the other. *Experience*, meaning and understanding are interarticulated. They mark the object with their expectations; accepting that they are, in addition, the site of expectations. The expectations – projections incorporating identifications – are also implicated in the object, its being as object and thus with its display in its being on display. Expecta-

tions allow for a move beyond pure objectivity. A move enjoining complexity.

10 The complex marked by expectation introduces tradition and repetition. Tradition, a determination in advance operating within and as the interarticulation of experience, meaning and understanding, becomes the source of a repetition taking place within, and as, the Same. The work of repetition militates against the positing of absolute alterity. (The new). However, it is the ineliminable presence of tradition – its repetition – that occasions its own new; the site of its effective abeyance. (The avant-garde.) It is in this repetition that the question of display's display can be best approached.

11 There is an expectation pertaining to the viewer/viewed relation. It is an expectation maintaining a certain conception of the subject/object relation. The effectivity of the repetition of these relations depends upon the specificity of the object and the nature of its display and thus with the possible presentation of an intended homological relation existing between them. Homology as that which provides the unity of the site.

12 It is the site of repetition that comes to be displayed; displayed by being repeated. A recognition of this display – the construal of the site in terms of repetition – is a recognition of doubling and hence the inherent presence of the political. It is thus the site – its complexity – that lends itself to a reworking of repetition. A repetition in which something occurs again for the first time.

13 Occurrence, the display of that which occurs, will either be constrained by forgetting and the work of the Same and thus sustain its own complacency, or in taking its own display – the site of the subject/object relation – into relation resist the necessity of homology and open display up to the chance effect. What appears as a choice, a simple either/or, is, in its incorporation of tradition and hence the constraint to repeat it, neither simple nor a choice. Again complexity appears working to open display, thereby presenting a display of contestation.

19 The neon lights – Jenny Holzer's city lights – convey a message. They present their content, words spell. In presenting, in displaying it they present, display, at the same time their presentation. Here the presentation involves a relation involving neither parasitism nor dependence. Central to the relation will be components of mass culture. Refer-

ences to advertising, to the poster, to the bill board mark the work. And yet the references are neither allusions nor citations. The components are the display of the work. In being the display of the work, the occurrence is not reducible to that display. The site of irreducibility, of one and another, involves a specific relation. The words, spelling, the lines to be read, only employ the means of mass culture, only become a part of them to the extent that they are at the time apart from them.

20 The presence of a logic of a part/apart – a repetition of distance and presence – means that the display becomes the site of a spacing. The message, the words spelt out, are not written into the spacing. They enact it, enacted by it. The work of this logic displaces the presence of irony. It moves the object beyond the site of negativity.

24 What seems to be an igloo stands on a wooden floor. The walls of metal, glass, wood and straw are incomplete. Some are lit. Light passes the walls. An entry cannot easily be made. The ineffectual walls effect a distance that brings habitation to the fore precisely because entry is impossible. Here, however, there is more than gesture. Something other than a presentation of synecdoche. The question of the whole and the part and thus the conventional strategies of naming have been checked.

25 Again negativity is supplanted. Merz's metal frames work to frame. Lights attracting attention. They site housing. Citing it. It is of course not an impossible housing. Questions of function are left to one side. Here, however, this other side is not outside. Function and all that pertains to it are rehoused in a form that brings dwelling into consideration. Bringing it in by being a consideration of habitation.

26 The singularity of 'form' is simply strategic.

There is no singularity, there is only the re-placing – the placing elsewhere – of prediction.

30 Here spacing, to the extent that it lends itself to generality, takes on a particular form. Spacing in this specific sense becomes the precondition for spatial relations. The object's being in space is not given as a singularity – as isolated – even though it may be posited as such. The siting of spacing – its citation here – opens up an approach to Judith Barry's exhibition. The implausibility yet necessity of the word – 'exhibition' – is itself revealing.

31 Writing in the catalogue for *Damaged Goods* Barry states that:

Minimalism allowed for the spatialisation of experience. Numerous other contemporary discourses produce different subjects within spaces that are ideologically coded. In exhibition and museum design, it is precisely these relations that need further elaboration. Given these preconditions, the exhibition becomes the set for a play with objects describing various possible subject positions and making the viewer spatially as well as visually aware.

Here the act of the display's display is presented in another form. In spite of its acuity the question that must nonetheless still be posed to this formulation concerns how the objects manage to sustain all the possibilities, be they actual or potential, that are being attributed to them? What is an object?

32 In approaching the problem of relation, the envisaged stand between viewer and viewed is 'envisaged' in terms of the object as well as the view. The relation that is dis-placed, brought into conflict, involves considering the object.

These paragraphs have been selected by the author from a work in progress.

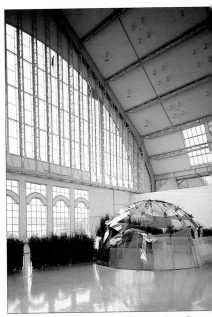

Judith Barry, Maelstrom: Max Laughs, *1990, installation from the exhibition* Public Fantasy, *ICA, London, June-July 1991. The impact of information and computer technologies on public space is explored in this work. The installation literally immerses the viewer in an argument of the senses. No longer stationary observers in control of what we see, motion control graphics, perfected by cinema and television, sweep us along an exhilerating journey – but where to?*

Mario Merz, Labyrinth, *1989, mixed-media installation (photo Detlev Bonn)*

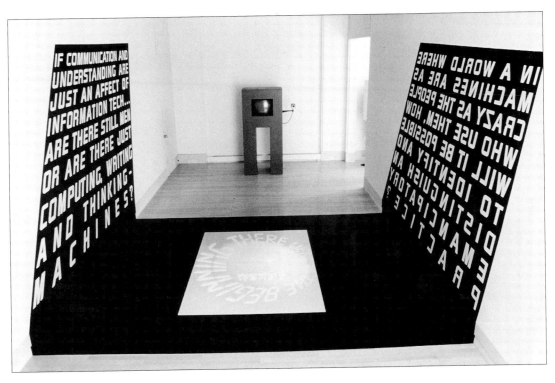

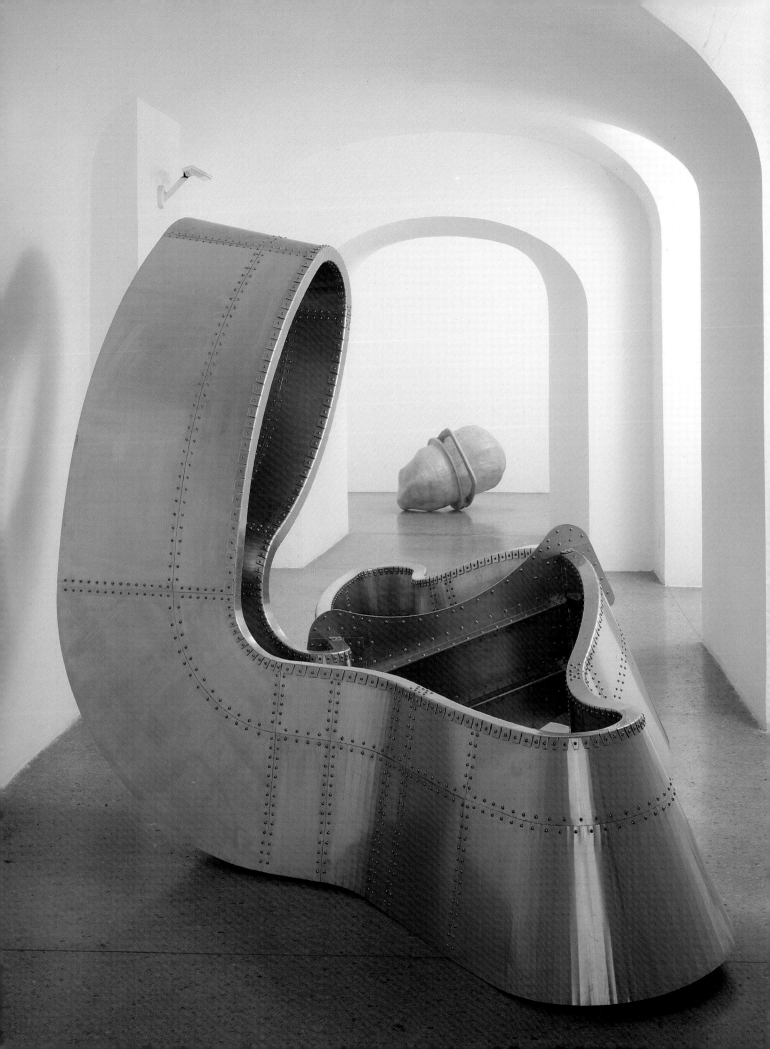

ACHILLE BONITO OLIVA
ART TOWARDS THE YEAR 2000

To discuss contemporary art means also highlighting the problem of the museum, or temporary exhibition space. In many examples the spaces are created taking into consideration the characteristics of the works, whilst in others we see interventions that tend to reinstate architectures of the past or to apply modern solutions.

The Royal Academy and the Tate Gallery in London have both expanded their exhibition spaces, with different results. In the first example we have a happy reintegration of the old with the new, a good lighting system and a well-balanced architectural solution. In the second, everything seems to be more temporary and less integrated.

In any case, the problem of contemporary art museums requires solutions that also depend on the homologation of the artistic product, which moves freely within the international art system.

Today a predictable homologation governs the sides of the two systems: on the Western side, the transition to a post-industrial civilisation and a post-modern culture from the simple production optimism that has governed the economy during the last few decades; on the Eastern side, a soft ideological demobilisation that can work the same way and is able to knock down abstract models of behaviour.

In both cases we see being questioned the values of projectuality, of the culture of forecasts held by an investment of faith in the future, and the flat development of history towards a trite ideal of progress. In both cases the complexity of a present that requires solutions to be given in the tight schedules of contemporary history is evident.

In this way, a sort of homologation is created; the transition even for culture and art from the condition of *positive Utopia*, as a reversible blueprint on the world, to the condition of *negative Utopia*, limited to the obvious value of the elaborated thought and the created work, moving away from the hope for a mythical elsewhere where culture and art should push mankind.

The neo-objectivity of intellectual artists accepts the need to establish itself within the paths of the art system, trying to develop a language capable of inciting processes of penetration into the daily inertia, rather than subject it to impossible modifications.

The peacefulness of this widespread attitude highlights the condition of today's artist, who doesn't want to give up his present, but would rather establish a dialogue with it, using materials, behaviours and languages that are not isolating but understandable and readable, not alarming and negative but affirmative and corroborating his own

soft approach. This is actually possible because the artist feels legitimised by the super-objectivity of his work, by the hyperreality of a linguistic order that doesn't destroy the object but respects its daily inertia. Such a condition determines the super-objective representation of the subject, which thus bears witness to his capacity to face his relationship with the world on the aspect of specific production (Bertrand Lavier, Gerhard Merz, Gianni Piacentino, Reinhard Mucha, Julian Opie, Thomas Schütte, Rosemarie Trockel, Jan Vercruysse, Richard Deacon).

Cold trans-avantgarde, after the hot one of the 80s, means then defending the status of art and of the super-objective subjectivity of the artist, capable of elevating himself, and exalting his own role through the formulation of a language within art's history and within history in general, where it is affirmed that 'Art is what it is'.

Whereas Nietzsche prophesied the transformation of the world into a fairytale and of truth into narration without foundation, Heidegger confirmed the inevitability of such a fate.

In fact, we live in times of rhetoric: a strengthening of the artistic discourse accepting the continuity with daily life through the *language of the showcase*, the power of persuasion of the frame, implicating exposure and protection, offer and reservation, use and contemplation.

Before Warhol, the noble ancestor remains Baudelaire and the starting date that of 1855, the year of the *Exposition Universale* in Paris. Here the poet acknowledges the new objectivation of art, which acquires the character of indifference and the equivalence to merchandise. Baudelaire's proposal is to turn art into an absolute commodity. From 1855 to today, we have seen the enhancement of the ritual of transparency of an art able to cross its own system by means of a status of super-objectivity; absolute commodity that benefits from the privilege of a symbolic centrality within a market now transformed from poetry to prose, without nostalgia and with a terrible lucidity.

Art, with its ability to prophesy even the past through re-reading history, has already foretold the fall of the Berlin Wall, and therefore the superseding of ideology and the underlying project-orientated mentality.

Just as in the erudite world of the 'finis austriae', the subject lost itself in the great tale of the world, weakening its voice from historical exhaustion, so in the present world of the 'finis russiae' a sort of posthumous subject, thanks to its chamber narcissism, has spoken through the *hot trans-avantgarde* and now continues to express its own identity

Richard Deacon, Under my Skin *(foreground)*, Band of Gold *(background), installation from Galleria Locus Solus, Genova, 28 May to 20 July 1990 (photo Attilio Maranzano)*

Achille Bonito Oliva at the New Museology Forum, London 1991

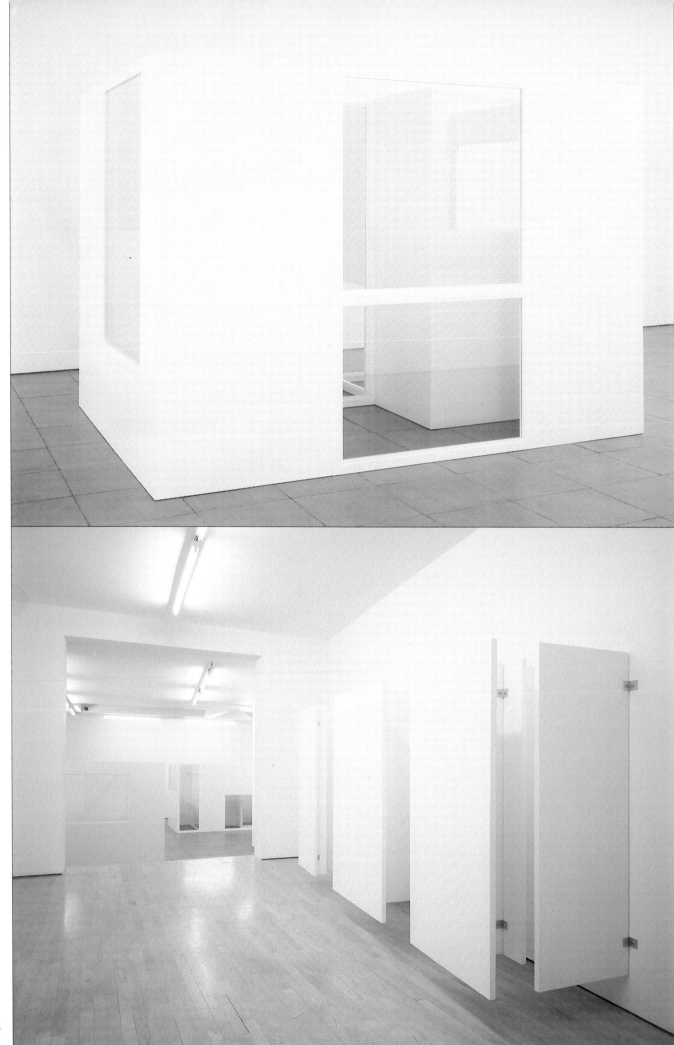

through the *cold trans-avantgarde* and its pictorial and sculptural neo-objectivity.

At the end of this century the artist quite rightly moves loosely, and so individually, with an intent that is not hedonistic but accompanied by a little constructive ethic. This does not mean the resumption of an abstract optimism towards history but rather the wish to preserve the *difference* between art and other productive practices.

Art is productive when it manages to produce a measure of its own territory, to declare its own internal order.

Artists of the 90s generation assume the value of *negative Utopia* in its positive sense. The ability of forms to represent the possibilities of an *ordinate strictness* within the linguistic frame of the work, without the further presumption of reversing it onto the chaos of the world.

'Finis russiae' returns artistic production to a central position as the only form able to represent the detachment and the positive nomadism of thought. As in the 'finis austriae', we have an extremely broad panorama, on an international level, which interacts with the historical situation.

Within this panorama the artists produce linguistic systems pervaded by an idea of de-structuralisation, recycling, nomadism, contamination, eclecticism – the same dualities that denote the spectacular use of video technology – a synthesis of languages purified by the utopian tension of the avant-garde.

To hide the subject behind the work's objectivity doesn't mean the performance of a removal operation. Compared to the end of the last century, we have the advantage of an acquired lucidity that allows us to look at the future with stoical attention, without nostalgia for an exciting past to be glorified.

The last decade of the 20th century opens, then, on a scenario that no longer vacillates on the dichotomies between art and life, capitalism and communism, creativity and ideology, nature and history. Instead, a new conflict emerges, that of the north and south, wealth and poverty. The old contrapositions are now absorbed by the cultural anthropology of post-modern man.

Even this term is now read in a less hysterical manner and no longer in opposition to the modern. Rather, it designates the position of a culture that, through computerised memory, can move on to an expanded territory, without spatial and temporal boundaries.

Here, two-dimensional and three-dimensional images are formed, bringing together the abstract and the figurative. Surely the *international generation of the 90s* towards the year 2000 entrusts to art's neo-objectivity its creative sense, intended as the possibility of joining together memory and linguistic style, experimentation and representation, ornamentation and communication, the collective poetry of art history and the personal prose of the medium. *The irony of neutrality* seems to pervade the works of these artists which are now intercontinental, and convinced to be viewed by society with the photographic eye in preference to the naked eye and obliged to run their works, airport style, under the 'Caudine Forks' of the metal detector.

Art towards the year 2000 tends to recognise, as its own context, a sort of *world state* already existing on a technical level, as Ernst Junger affirms, where there isn't a centre but rather an area constantly forced by the periphery: a constellation world, as the definition by Norbert Elias, well represented in art by the dual polarity of the *hot* and *cold trans-avantgarde*. Creativity no longer expresses itself under the hegemony of a strong language or the prevailing influence of a single market. Geographically, art will tend to follow an ambiguous strategy of movement and homologation, following the physical law of the *continental drift*, by which the distance between the continents is reduced until catastrophe is reached, by the collision of land masses still separated by the oceans; art *against* the year 2000.

The movement will probably lead to the growth of a common process of visual alphabetisation between peoples far apart but telematically brought close by satellites.

At the same time such alphabetisation of images, as far as art is concerned, will short-circuit local and international codes. Contamination constitutes the prevailing characteristic of art that goes *against* the year 2000, fostered by the speed of propagation of the various visual codes between the continents of Europe, America, Africa, Asia and Oceania. An array of styles present and functioning in a unique context, into which artists act and interact. Artists such as the aborigine Joseph Surra Tiapaltajarry (Australia), Samba (Zimbabwe), Kuicka (Argentina), Gevas (Israel), Galan (Mexico), Macinado, Leonilson, Tenga (Brazil), Cattani, Caropreso, Fogli, Sarra, Fermariello, Brandizzi, Werner, Bresciani (Italy), Bontin, Leccia (France), Resende, Sanchez (Portugal), Kirchoff (Denmark), Barclay (Norway), Zalopany, Stainl, Mike and Doug Starn (USA), Endo, Wakabayashi, Haraguci, Yamamoto, Aski (Japan), Chen-Zhen, Chen-Qi-Gang, Yang-Ye-Chang (China), Orlov, Prigov, Raiter, Filipov (Russia), Rivka Rinn (Germany), Paneque (Spain), Fast Worms (Canada), Bassiri (Iran), Magdalena Yetelova (Poland), Diohandi (Greece), Lim (Malaya), Douglas Abdel (Lebanon), Lubaina Himid (Tanzania), Rob Sholte (Netherlands), Adong (Uganda), Gotine (Congo), Obbeice, Ei Anarsu (Nigeria), Trogreje (Senegal), Caur (India) and Ahn Sungkeum (Korea).

In this sense art preserves its characteristic of producing expressive forms capable of documenting mankind's condition at the end of the 20th century, a condition that by necessity is moulded after a kind of neo-austerity, the only possible one in the elementary north-south, east-west divides. It also acquires the involuntary attribute of alarm on the homologation resulting from the circulation of artistic objectivity. It is art's destiny, on the other hand, to be ambiguous and problematic. The acceleration imparted by the system signals its wearing out and, implicitly, the danger of the end, but also an elasticity that constantly postpones its death. In this last decade of the 20th century, the problems of art find a planetary scenario scored by connotations capable of making a mark in the collective imagery; the birth, perversely humanising, of biodegradable advertising in America; of television, in Japan's case, deceptively suited to the consumer

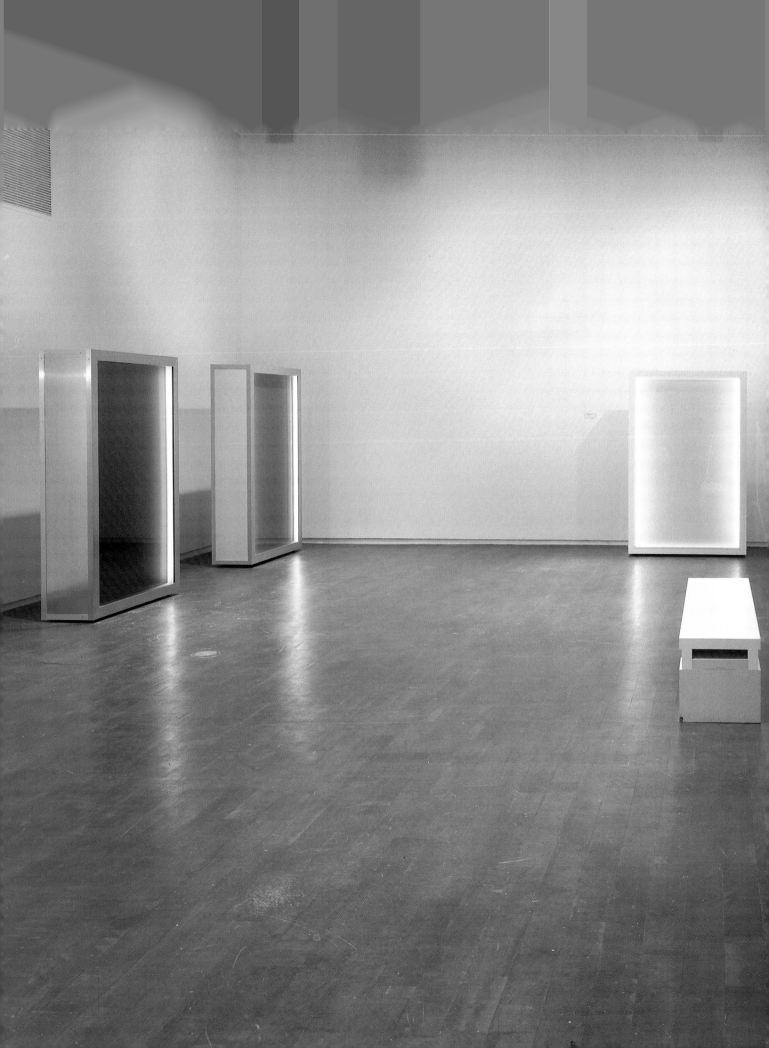

and with a production preference for fashion, architecture and design; of the possibility of using an art model in real scale, like that broadcasted via satellite of the French peasants invading the Champs Elysées with their wheat and transforming the monumental space of Paris into a rural and natural space. As Einstein wrote:

> Where the world ceases to be the stage of our hopes and our desires and becomes the object of free curiosity and contemplation, there art and science begins. If we try to describe our experience within the frame of logic, we enter the world of science; if, on the other hand, the relationships that exist within the forms of our representations escape our rational understanding but still manifest intuitively their meaning, we enter the world of artistic creativity. What there is in common between the two worlds is the aspiration for something universal and non-arbitrary.

In an electronically replicated universe, technology, the spectacular extension of science, domesticates all reality, natural and artificial, transforming it into its own *objective correlation*. Art, with its linguistic pluralism, sets itself as a problematic and creative stimulus, capable of infiltrating a world now permanently inhabited by shadows.

Even the typology of art-show writing, the critical perspective of the exhibition and the setting of art works in space have crossed the border from avant-garde to *trans-avantgarde*, from a blueprint of linguistic unrest to one of pro-positive peacefulness. Wright's Guggenheim Museum and Richard Roger's and Renzo Piano's Centre Pompidou represent the notion of an art museum as a bastion in defence of purism and modernity, art workshop or cathedral spire, but always at the service of the experimental work and far removed from the social context.

In fact, the public is always viewed as an outside observer of the architectural work, bizarre and original, and not as an inside observer, where the artwork is installed. Even the exhibitions themselves have often respected the pre-eminence of their container, with the installation of works viewed as urban furnishing or as a European comment on American space, with criticism in its abstract role of guarantor.

In the more mature climate since the 70s, we find the museum proposals of Hans Hollein, James Stirling, Richard Meier, Michael Graves, OM Ungers and Arata Isozaki with architectures that accept cultural industry and the rules of communication.

In a situation like the approach to the year 2000, no longer ideological, as in *cold war* (East-West), but healthily conflictual, as in *cold peace* (North-South), communication becomes the holding value of art and its ways of displaying itself.

In this context *Contemporania* (1973), a contextual and multi-media presentation of various expressions in the underground garage designed by Luigi Moretti in Rome, is capable of reaching the new social and interracial subject, which lives and moves in the new urban reality.

He/she meets art without chasing it, art that now has become, in the aspects of the *cold trans-avantgarde*, a tendency bound to the operativity of merchandise and product in the post-industrial civilisation.

Art, then, remains a protected presence, a fragment, a fragment of which paradoxically nothing is missing, and part of the great jigsaw puzzle of the world. The epigraph could be these words by Goethe: 'What is difficult and what is good is what art is made of. To see the difficult easily dealt with, gives us an idea of the impossible.'

Julian Opie, OBJECTives: The New Sculpture, *installation at Newport Harbour Art Museum, 8 April to 24 June 1990*

Richard Deacon, Pipe, *1991, aluminium, installation at Haus Lange, Krefeld (photo Volker Doehne)*

THE LAST PICTURE SHOW
THOUGHTS ON SCREEN

'*What is today's museum? A place for spiritual enrichment or a tourist checklist? Communion with the infinite or a photo opportunity? A learning experience or a shopping mall?*' So questioned The Last Picture Show, *written and narrated by Lesile Megahey and produced by Charles Chabot as part of the recent and highly successful BBC television series* Relative Values, *which focused public attention on aspects of the contemporary art world, from the commercial market of dealers, auction houses and international collectors, to the notion of artistic genius. Filmed in New York, London, Paris, Tokyo and on the site of Mass MOCA in North Adams, Massachusetts, the programme took the form of interviews conducted mainly with museum directors, responding to questions posed by Chabot. A number of these statements are presented here, together with extracts from the narrative text and images photographed on screen.*

plane. Art is man expressing himself at the highest point of his consciousness and you don't want to step off the street into something that is ordinary.

The Metropolitan was founded in the late 19th century by a group of clergymen, social benefactors and unionist politicians.

Philippe de Montebello: This was the period following the Civil War in the United States, post the industrial revolution – a sense of the corruption of society – and the trustees saw art as being able to elevate the viewer. I really don't believe in this. Art fulfils a lot of things, it has enrichment value but it does not make a person better, not in the way that the trustees wanted. It does not redress social ills.

The founders of the National Gallery in London rather hoped it might.

IM Pei, extension to the Louvre, Paris, 1989

The site for the future Mass MOCA, North Adams, Massachusetts

Philippe de Montebello

Neil MacGregor

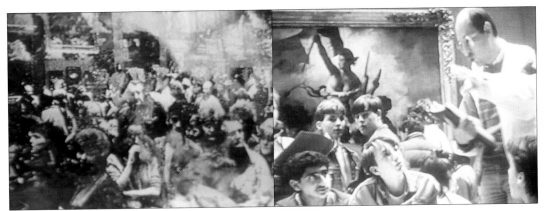

Milton Glaser, designer: The museum is a kind of spiritual experience, a test of your sincerity and goodness. In a museum you know you are encountering the most sublime works of the species and that requires a special kind of attitude and experience to be able to deeply appreciate it.

The concept of a museum as a place of worship came in at the beginning. The first public art galleries adopted the form of the classical temple.

Philippe de Montebello, Metropolitan Museum of Art, New York: The key to a museum is that it's a paradox. I think one should look enquiringly, searchingly, even with a sense of scepticism, certainly in front of modern art and indeed in front of all art, but I do believe in a museum as a temple. I like to be able to walk up the grand staircase to a museum. I think art should be displayed in an environment that is suited as much as possible to it and that gives a sense of grandeur. Art is on a high

Neil MacGregor, National Gallery, London: The British Museum didn't allow children, but from the beginning of the National Gallery, the Prime Minister, Lord Liverpool, said that babes in arms must be allowed in, otherwise the poor wouldn't be able to come at all. So from the beginning the museum was seen very much as belonging to the whole population and the admission was free.

Once inside the National Gallery, the marble pillars and floor mosaics, the dark damask wall coverings and heavy gilt frames, all help to create the required atmosphere of reverent silence that accompanies spiritual enlightenment. But is this sanctified aura destroyed if you strip away the decor? The white cube concept started at the Museum of Modern Art in New York. It was founded in 1929 largely through the enthusiasm of a group of wealthy New York women, including Mrs John D Rockefeller.

Kirk Varnedoe, Museum of Modern Art, New York:

Kirk Varnedoe

Gerard Regnier

Our white cube galleries are in a sense the ghosts of former private apartments in which these paintings were hung. We think these paintings were made for individual viewers, for private dialogue, and are not suited to grand spaces. My predecessor, William Rubin, tried to institute a uniform framing policy to take away some of the distraction of the large ormolu ornament that came on many collectors' frames. So there is a certain urge towards what you might call purification or simplification, to make the pictures speak on their own terms.

The white walls aspire to a neutrality that somehow

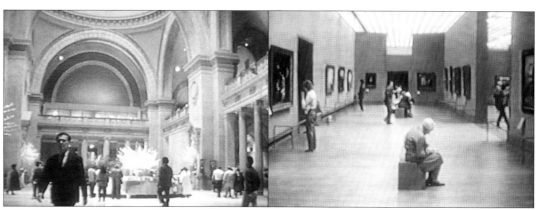

manages to declare all their contents to be art, no matter how uncrafted they seem, no matter how mundane. This process began with Marcel Duchamp in 1917 when he sent a urinal signed R Mutt to a public exhibition. As Duchamp stated in a television interview, when defining the ready-made: 'the choice of the artist is enough to transfer it from a functional or industrial form into what's supposed to be aesthetic.'

Gerard Regnier, Musée Picasso, Paris: Now artists

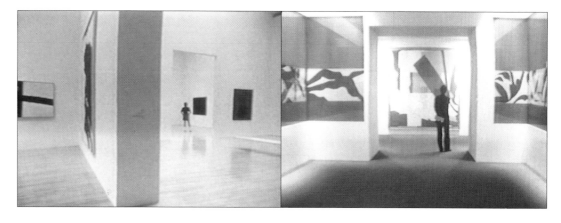

are making works directly for the museum so they are working for a kind of abstraction; they are working for a place the status of which becomes vaguer day by day. They are not working for one person, for one taste or one sensitivity, they are working for a kind of abstract power which is the power of the museum and the directors.

Several of the founders of MoMA were big collectors in their own right. They recognised and ac-

quired the very best in contemporary art long before other American buyers caught up. Given this head-start, the museum's first curator, Alfred Barr, was able to lay down the law on 20th-century art, developing his own individual and authoritative account.

Kirk Varnedoe: I suppose one of the most particular things about our institution is that we feel that at any given moment visitors to the museum should be able to walk in at the front of our gallery and come out at the other end with a sinoptic overview of the history of modern art since about 1880. We therefore feel an obligation to cover a lot of bases: Dada, Surrealism, Abstract Expressionism, etc.

Nicholas Serota, Tate Gallery, London: For many years there has effectively been a single reading of the development of modern art from Cézanne and Picasso, through to the present day. I think that is a view which was formulated largely by Alfred Barr and promulgated through the Museum of Modern Art in its displays. The main thing I wanted to achieve in the rehanging of the Tate was the recognition that there are many different readings both of modern and contemporary art and also the art of the past. I think that our public is an increasingly sophisticated one, it sees more art on television, it visits galleries more regularly than it did 10 or 15 years ago, and therefore it expects more from a public gallery such as the Tate. I think it expects to be more informed, it expects to actually see juxtapositions of pictures, to be more excited, stimulated and engaged by what it sees. It is

important that when you come to the Tate and look at the 20th century art you should be conscious of the fact that you are in London and not in Paris or New York; that is to say I think people come hoping that they will see how British art plays a part in the broad story of international 20th-century art. I think that the re-hanging has helped to reinforce the part that British artists have played, not so much in the sense of coming third in the race, but in the sense of the interchange of ideas across the Channel or across the Atlantic, or now back across the Channel. We are an island and it is very interesting to see how artists have reacted to what is happening

(left to right, top to bottom) The Tate Gallery, London, interior; Musée d'Orsay, Paris, exterior; Musée d'Orsay, interior; IM Pei extension to the Louvre, Paris

Alfred Barr

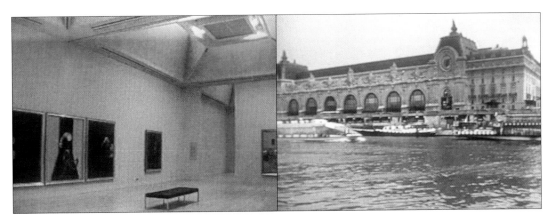

in continental Europe and America.

Neil MacGregor: The whole task, I think, of the museum director at the moment is to persuade people to stop and sit down in front of one picture. All our policy I think can be summed up in that aim. But it is a very difficult thing to achieve because all the incentives and the hype is to get around as much as you can, to fit in as much as you can. During the war the entire collection was evacuated to Wales and one picture was brought back every

the banks of the River Seine. It lay empty for many years, and was finally selected to house the formidable Impressionist collections, formerly in the Jeu de Paume. During the conversion the galleries had to be fitted around the building's original structure, and displaying the building itself is the underlying principle of the d'Orsay's central space, the concourse of the original station. Galleries are created in cubicles beneath the stone walkway and the whole design leaves uninterrupted the 103-foot-high steel and glass barrel vault.

Kirk Varnedoe: I regret an institution in which the architecture takes priority over the pictures. I really believe that a museum ought to be a vessel for art. What I regret about a lot of recent museums, and I think that the d'Orsay has some of this problem, is that they are arranged first and foremost as theatrical spaces for visitation and the art is then positioned in the corners with whatever is left over. I think there has been a tendency in recent years to think about the notion of the museum building as a monument from the outside and a grand tourist space inside and let's fit the art in the spaces that

Nicholas Serota

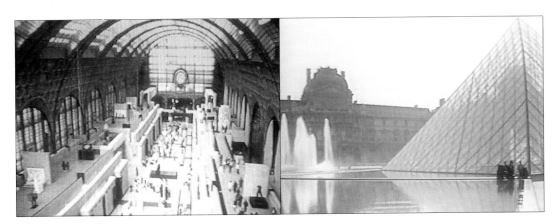

month and presented to the public. It is quite hard to imagine the impact of this whole building empty, with just one picture, but what it clearly did was to set up a habit on the part of the public, of coming to look at just one picture and then coming back to look at a different picture.

At the other end of the scale is the concept of the museum as spectacle. The Musée d'Orsay, formerly a railway station, occupies a prime site on

are left once those functions are fulfilled. This seems to me absolutely backwards.

The Musée d'Orsay was part of a coordinated and hugely ambitious government masterplan begun 15 years ago under Georges Pompidou. The aim was to make Paris the museum capital of the world. The celebrated Pompidou Centre has become the most visited tourist destination in France, eclipsing even the Eiffel Tower and now there is the Pyramid of IM

Michel LaClotte

IM Pei

Pei, a sophisticated piece of crowd management in the heart of the Louvre complex. There's a network of walkways, escalators and corridors with the latest visual display equipment. It's a radical approach, bound to upset the traditional Parisians and, worst of all, imported by an American modernist!

Michel LaClotte, Louvre, Paris: To begin with, the museum was created well before the Revolution. The idea of the museum comes from the Age of Enlightenment. Under Louis XVI, a precise museographic study was begun, both to enlarge the royal collection, to complete it and to present it

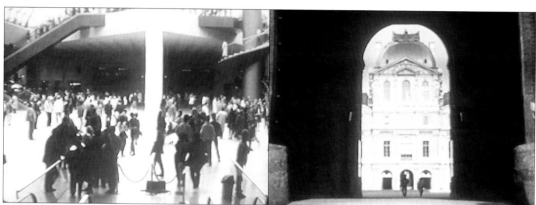

in a museographic way. We have the layouts and the plans for arranging the Grande Galerie with overhead lighting. Hubert Robert did a series of paintings which were imaginary but precise schemes, particularly for the Grande Galerie. The Louvre was a laboratory for museography.

During the construction of the Pyramid, the contractors unearthed whole sections of the walls of the original medieval moated castle. They were immediately added to the tourist circuit; the build-

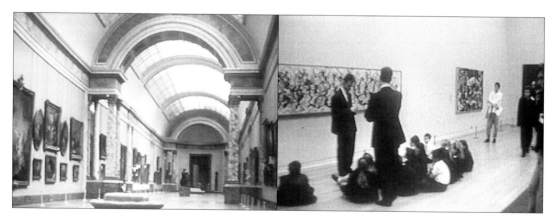

ing itself becoming part of the museum experience. The concept of the museum as tourist attraction is, however, rejected by some museum directors.

Gerard Regnier: When I first arrived at the Museum of Modern Art in Paris in 1966, the museum was a place for the amateur and the connoisseur: a Max Ernst exhibition, for instance, got no more than 5,000 visitors, but now we are coping with hundreds of thousands of visitors for any exhibition,

whatever the subject, whatever the works, whatever the seriousness, whatever the quality of the exhibition. So we are dealing with a social phenomenon, no longer with an aesthetic phenomenon.

The block-buster exhibition has become an essential part of the strategy of today's museums. Yet even with such huge takes at the box office, big museums still have to struggle with one major problem, the massively spiralling cost of buying art. In the 70s and 80s, this seemed uncontrollable.

Nicholas Serota: I think we went through a period in the 80s when there is no doubt that the collectors were making the running in terms of being able to acquire work ahead of museums and sometimes, as far as dealers and even artists were concerned, in preference to museums because they could pay higher prices, more quickly. Now we are experiencing a drop in the market, or at least a halt in the market. I think the climate is changing generally and this is drawing people's attention back to the museums. Obviously it will only stay there if the museums themselves are active and put forward propositions and ideas, and indeed manage to acquire work which seems to contribute to the dialogue and the discussion about contemporary art. I don't think we can simply sit back and hope that people will come to this great spectacle.

But it's still to the big collectors that museums have to pay court. The massive National Gallery in Washington, with its own orchestra, a staff of more than a thousand, as well as generous state sub-

94

sidy, is an example of what benefaction and endowment can do when taken to its ultimate limits. Andrew Mellon, Secretary of the Treasury under three presidents, bequeathed his private collection to the National Gallery in Washington and persuaded other collectors and benefactors to do the same, in return for a little immortality. The National Gallery in London was the model for Mellon's museum although, for its recent additions, Washington has aimed at a modern, futuristic approach. The architect for the new East Wing extension was IM Pei.

IM Pei: This building is not a monument, it's a place

in a museum in a way that is so utterly different would serve no purpose.

There's certainly no lack of drama in Philippe de Montebello's displays at the Metropolitan. Objects are picked out by a single spotlight as if they were on stage or perhaps in a Harrods window display.

Philippe de Montebello: There is something about pin-pointing an object with light that in a sense promotes it and, if we have chosen it as something exceptional, I see no reason, so long as it is within the boundaries of taste, not to promote it, to make

to engage, not to intimidate the people; it's intended to make the public want to stay longer. The building has to be designed in such a way that young people will find it interesting to go there. Otherwise the whole purpose is lost; they will spend five minutes here and then go on to the Air and Space Museum to look at the moon rocket. That is our problem, you have to think in terms of the public.

Another major element in the Pei redesign is the

it look as good as one can.

In the last 30 years museums have borrowed very successfully from department store windows, and many of the early American designers of exhibition installations came out of that world.

The Metropolitan offers only the most elevated kind of commerce. It features limited edition lithographs by Roy Lichtenstein at a special members' price. In other parts of the shop the confusion between exhibited art objects and shop goods is actively

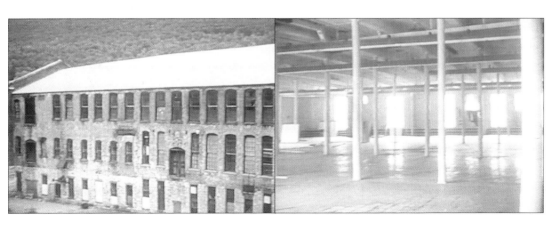

merchandising area of more than 3,000 square feet. Are they targeting a new kind of art lover, one who feels more comfortable with the a shopping-type experience?

Philippe de Montebello: We are dealing with a generation that is accustomed to the great shopwindow displays of Fifth Avenue, the Faubourg St Honoré and Bond Street, of having things presented in a certain way and to present works of art

encouraged. A few feet from the gallery of medieval pewter and silverware, similar objects are on display on the shop counter and even use the museum's uniform identification label and typography.

Philippe de Montebello: We have occasionally fallen into excesses. I remember when we did an exhibition of Van Gogh in Arles, we did not leave enough room at the end of the exhibition, after the great self portrait with the mutilated ear which is a very

*(left to right) The Tate Gallery, London;
The Louvre, Paris*

Joseph Thompson

moving moment, before arriving at the cash registers. Since then we have always put a decompression chamber at the end, so you are not immediately confronted by the commercial side of things.

Commercial viability is the underlying factor in the Mass MOCA project in the small town of North Adams in Massachusetts. Having grown up around one huge electronics factory, when that closed North Adams looked as if it would die too. The extraordinary scheme hatched up to save the town involves turning the derelict factory into the biggest contemporary art museum in the world.

Joseph Thompson, Massachusetts Museum of Contemporary Art: Mass MOCA is a museum unlike any other. We are consciously integrating cultural and commercial functions at points throughout the museum in a way that I think goes beyond what has been done before. We are not trying to create a cultural bubble, it's not going to be an art ghetto at one end of the site, away from the commerce. There will hopefully be a natural flow of visitor traffic, to increase circulation and cash flow for the commercial components of the project, which are important for the museum's bottom line after all.

Richard Bonz, Leggat McCall Advisors: This study is politically sensitive because the state is to fund about 30 million dollars of it and the questions are going to be hard questions: is it really going to work, who will come, why will they come and, more importantly, will it have an economic impact on the region? We carried out surveys on what would attract people to this location and listed what effect contemporary art would have, as opposed to something that tends to attract a broader mass. It would attract fewer visitors than different types of art, but it would still attract a substantial number.

In spite of the massive costs involved, there is no purchasing budget for a permanent collection. Mass MOCA hopes to attract big collectors. Maybe one attraction would be user-friendly buildings. One of the architects commissioned here is Robert Venturi.

Robert Venturi: This is a rambling complex of noble, in their way very lovable buildings, but they don't symbolically, or in terms of scale, say 'I am a museum'.

Venturi's partner, Denise Scott Brown, has taken

particular responsibility for the shops integrated into Mass MOCA's layout.

Denise Scott Brown: Retail makes the connection with the town an ambiguous one; there is a different kind of relationship with the art. Retail must be in places where a lot of people will pass by and in that sense the planning for the retail cannot be very different from planning a shopping mall. You really have to put the retail where people will buy.

Even designer hotel suites form part of the project. Again, big name architectural designers like David Childs and Frank Gehry have been enlisted.

Richard Bonz: The hotel is so connected to the art that it is like having the museu as part of your own quarters and there will be art in the hotel itself.

Robert Venturi: The hotel component is not unusual in the sense that museums are combining and integrating more and more in the commercial dimension. I think it is a good idea not to make art into something that is to be worshipped.

Philippe de Montebello: The notion of museum as temple is a perfectly acceptable one. People have said for years that the museums in America are the cathedrals and in a sense that is true. I do not want museums to become shopping malls and I think the commercialisation of museums is something that does bother me a great deal.

Kirk Varnedoe: I think that any museum is, in a sense, a place apart. It doesn't want to be a movie theatre or a playing field. It has a special place.

Nicholas Serota: The important thing is that art should be accessible. I certainly don't want to introduce barriers to people looking at work and drawing from that work something that affects their lives. At the moment you have walk up steps to get into the Tate. I think it would be more in the spirit of a public institution if you were to enter on ground level: you would feel as though the art were not something contained in a temple. The museum should actually be the place where you go to have many different kinds of experience: sometimes those experiences will be quiet, peaceful and contemplative, at other times those experiences will be noisy, brash and loud. We need to provide both kinds of experience in the institution.

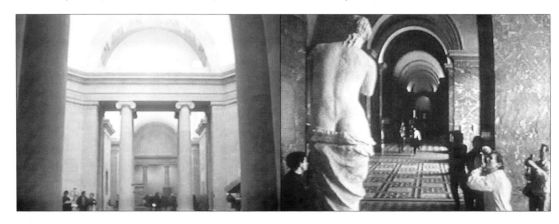

•CReATive KiDs•

Busy Bodies, Active Minds

Activities to Grow Happy, Healthy Kids

Ages 5-9

Written by Dara Coan, M.P.H. and Dana Petersen, M.A., M.P.H.

Illustrations by Ken Tunell

Cover by Denise Bauer

Teacher Created Materials, Inc.

TCM 2599

Teacher Created Materials, Inc.

6421 Industry Way

Westminster, CA 92683

©2000 Teacher Created Materials, Inc.

Made in U.S.A.

www.teachercreated.com

ISBN #1-57690-599-3

Library of Congress Catalog Card Number: 96-061507

Editor:

Michelle Combs

Table of Contents

Table of Contents *(cont.)*

Table of Contents *(cont.)*

Introduction

Busy Bodies, Active Minds provides you (children, parents, and teachers) with a wide variety of entertaining and educational activities related to personal, environmental, and community health. Developing healthful habits and a healthy perspective is important when building the foundation necessary for a long and healthy life. Health encompasses more than simply practicing healthy habits and proper hygiene (although these things are important). Health is also how communities and neighborhoods work together to create an environment in which you (and everyone else) are provided with an opportunity to reach your full potential.

Objectives of This Book

The activities in this book are designed to help you learn. You will develop the skills and knowledge necessary to lead a healthy life and to become an active and contributing member of your community. You will learn to share with others what you have learned. Most of all, you will have fun!

How This Book Is Organized

The first six chapters of this book are composed of specific activities related to the different areas of personal health. These chapters focus on individual, health-related skills that affect your well-being. The seventh chapter brings health to your family, providing healthy activities to do during holidays. The final two chapters of this book include activities and ideas directed at learning about and improving your environment and community. These sections are included because individual good health is dependent upon healthy surroundings. A resource list that includes fiction and non-fiction books and Internet Web sites is provided at the end of this book to assist you with the activities and for further reference.

© *Teacher Created Materials, Inc.*

Body Basics

Bodies In Motion

Fancy That It's a Fact!

Your body is made up of a number of very special parts with very special jobs. Together, these parts allow you to move, jump, run, eat, and play. Joints are places in your body where separate bones come together, allowing your body to bend. Examples of joints are your elbows and knees. There are many different types of joints in your body such as hinge joints, ball-and-socket joints, and gliding joints. A *hinge joint* is a place where two bones come together opening and closing like the hinge of a door. Notice that a door with hinges usually opens in only one direction. *Ball-and-socket joints* allow you to move your body parts in circular motions. A ball-and-socket joint moves in a way similar to the way a baseball rolls around in an empty cup. *Gliding joints* allow your bones to slip and slide against each other.

Materials

- butcher paper
- 30 paper fasteners
- scissors
- colored marker
- pencil

Let's Do It!

1. Unroll a sheet of butcher paper and place it on the floor. The piece of paper should be slightly longer than you are tall.

2. Lie on your back on top of the paper and have a friend draw an outline of your body with a pencil.

3. Cut out the outline of your body with scissors.

4. On your body cutout, mark each of the following of your joints: shoulders, elbows, wrists, hips, knees, and ankles.

5. Cut your body outline into pieces at each joint.

6. Using a marker, make a dot about one finger's width from the edge of where you just cut the body pieces apart.

7. Lay the body pieces together on a table so that they fit back together in the shape of your body. The dots you made should overlap. Now join the pieces back together again by pushing a paper fastener through each overlapping dot. The paper fasteners act as joints, allowing you to move the various parts of the body.

8. Read the descriptions of joint types given in the "Fancy That It's a Fact!" section again. Try to find a hinge joint, a ball-and-socket joint, and a gliding joint in your body. You will probably have to move around and test your joints to see how they move. Use the table provided to check your answers.

9. After you have found an example of each, label it on your body cutout.

 8

Bodies in Motion *(cont.)*

Examples of Types of Joints

Hinge Joints
Elbows
Knees

Ball-and-Socket Joints
Shoulders
Hips

Gliding Joints
Ankles
Wrists

Chain of Command

Fancy That It's a Fact!

The *nervous system* is the part of your body that acts as the communication center. It is like a series of telephone wires which send messages and talk to your body parts, commanding them to react and move. The nervous system is made up of nerve cells. A *nerve cell* has both a small cell body, like a head, and a very long, thin tail (called the *axon*). The tail of one nerve touches the head of another nerve, forming a long chain. Messages pass along the chain from one nerve to the next. In this way, messages can travel from your big toe to your brain in less than a second. Messages sent along the nerve chain are made of electricity. This tiny bit of electricity commands your muscles to move and makes us see, hear, smell, touch, and do the things that we do. In this activity, you will create a nerve chain in which cotton balls represent nerve cell bodies and string represents nerve tails.

Materials

- 12 cotton balls
- glue
- string
- scissors

Let's Do It!

1. Use your scissors to cut 12 pieces of string. Each piece of string should be about as long as the distance from the tip of your thumbnail to your wrist.

2. Using glue, attach one tail (piece of string) to each nerve head (cotton ball). Let the glue dry for five minutes before moving on to the next step.

3. Now that you have made 12 nerves, connect them in a nerve chain so that they can talk to one another and send electric messages throughout the body. To connect your nerves, glue the string (tail) of one nerve to the cotton ball (head) of another. Let the entire chain dry for five minutes. At the end, you should have one long line of alternating cotton balls and string.

4. Play gently with your newly made nerve chain by wiggling it on a table. How many cotton balls and string pieces would you need to send a message from your toe to your brain? The chains inside your body are often that long. Notice how careful you must be with your string chain to keep the glue from coming apart. The chain inside your body is also fragile. This is why we need to protect important nerve centers in our body, like the brain and spinal cord, from accidents and injury.

Chain of Command *(cont.)*

Your Nerves

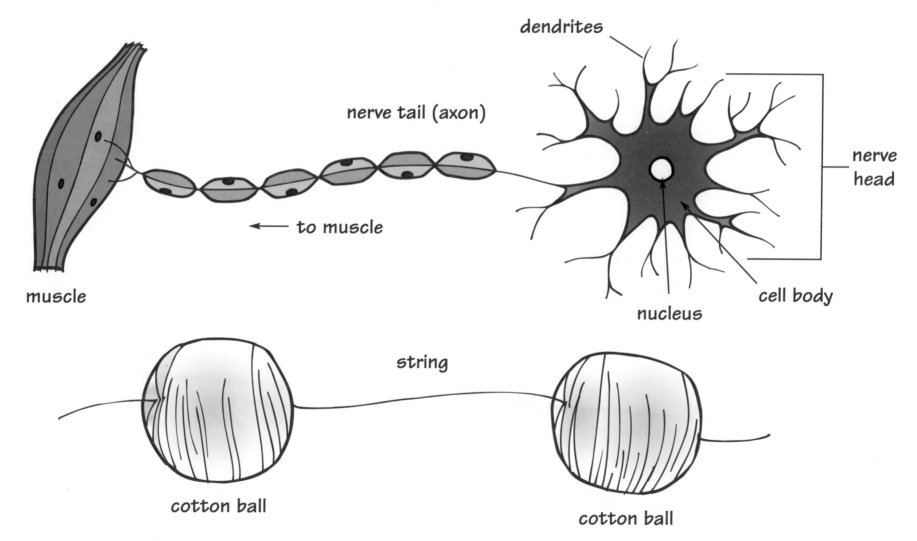

dendrites

nerve tail (axon)

← to muscle

muscle

nerve head

cell body

nucleus

string

cotton ball

cotton ball

Listen to Your Heart

Fancy That It's A Fact!

Your *heart* is the muscle in the left side of your chest responsible for pumping blood throughout your body. This is a very important task because blood not only delivers super-important oxygen and nutrients to your body but also helps to take away unwanted waste. In order to pump blood through your body, the heart must squeeze and push the blood. You can hear this squeezing and pumping in your own body. It is the sound of your heart beating. The beating sound comes from the opening and closing of the valves (like doors) in your heart through which blood is being pushed. When you are resting, your heartbeat usually beats around 70 times per minute. When you are exercising or moving around a lot, your body needs extra blood. This means that your heart must beat faster. This exercise allows you to count and hear the beating of your heart.

Materials

- cardboard tube (e.g., inside of a paper-towel roll)
- clock or watch with a second hand
- blindfold or handkerchief
- partner
- scrap paper

Let's Do It!

1. Pair up with a friend and listen to his or her heartbeat by placing one end of the cardboard tube over your partner's heart (a little to the left of the center of the person's chest). Then put your ear to the open end of the cardboard tube.

2. Have your partner time 15 seconds on a clock or stopwatch while you count the number of heartbeats you can hear in his or her chest.

3. Add this number together four times to find out how many times your partner's heart beats each minute (60 seconds). Write this number down on a piece of scrap paper.

4. Have your partner run in place for one minute.

5. Listen to his or her heart again. Count the number of beats in 15 seconds and again add the number four times to find the total number of beats per minute. Write this number down on the same piece of scrap paper. Is this number higher than the number you wrote down in Step 3? Why does your heart beat faster after running in place?

Touchy Feely

Fancy That It's a Fact!

Your *skin* is an organ, just like your heart or brain. In fact, it's the biggest organ that you have! Like your eyes, nose, and tongue, your skin is a sensory organ. These organs help you to "sense the world" and interact with it. Your skin not only protects your insides from infection and injury, but it also allows you to touch things and to feel them. For example, with your skin, you can determine hot from cold, smooth from rough, and soft from hard. You can do this because your skin is full of *receptors* that trigger and send nerve messages to the brain.

Materials

- pillowcase
- glove (e.g., plastic dish glove, garden glove, or winter glove)
- random objects that will not hurt you (examples: marbles, coins, flowers, pencils, leaves, rocks, bottle caps)
- blindfold or handkerchief
- partner

Let's Do It!

1. Fill the pillowcase with five random objects. Try to choose objects that feel interesting. For example, choose objects that are smooth, rough, soft, or gritty, but make sure they won't break when they rub against each other. Do not let your partner know what objects you are putting in the pillowcase.

2. Blindfold your partner. (If your partner does not want to be blindfolded, simply have your partner close his or her eyes during the activity.)

3. Have your partner put a glove on one of his or her hands. He or she should then reach into the pillowcase with the gloved hand and try to guess what each object is. Your partner should rely on the sense of touch through the glove and should not look at the object, smell it, or touch it on any other portion of the skin. See how many of the objects your partner gets right.

4. Keeping your partner blindfolded, take the objects back and return them to the pillowcase. Now have your partner take off the glove and try the activity again with the full use of his or her skin organ. Your partner will be able to touch and feel the objects as nerves send messages to the brain. How many of the objects does your partner get right this time?

Germ-Mania

Fancy That It's a Fact!

Unwanted germs entering our bodies cause most of the common infections that make us sick. Germs are tiny plants and animals—so tiny you cannot always see them. Two common kinds of germs are *bacteria* and *viruses*. One of your body's infection fighters is a white blood cell. In your white-cell army, you have two types of defenses. One type of white cell is called a *lymphocyte*. A *lymphocyte* fights off infections by removing them with chemicals called *antibodies*. The other type of white cell is called a *phagocyte*. Phagocytes fight off infections by eating unwanted germs. You can help your infection fighters win their battles by doing your best to remain healthy. Eating a good diet, exercising, and getting plenty of sleep are all ways to help your body fight off infection.

Materials

- cookie sheet with sides
- 10 mini-marshmallows or other small objects (examples: raisins, sunflower seeds, pennies)
- small amount of milk or juice
- sponge
- tweezers

Let's Do It!

1. Place the cookie sheet on a water-safe, flat surface such as a kitchen countertop. Pretend that the clean cookie sheet is a germ-free portion of the inside of your body.

2. Spread the mini-marshmallows out on top of the cookie sheet. The mini-marshmallows represent germs that white blood cells are trying to fight with antibodies.

3. Make 10 small puddles of milk or juice on the cookie sheet. These liquid drops also represent germs that have entered your body and that white blood cells will attempt to kill by eating them.

4. Use the sponge and the tweezers to remove these unwanted germs from your body. The sponge and tweezers represent your white blood cells.

5. Which of the infection-fighting tools that you used—the sponge or the tweezers—was better at getting rid of the mini-marshmallows? (Tweezers work better.) Were the tweezers or the sponge better at absorbing the drops of liquid? (The sponge works better.) Here, the sponge acts as a lymphocyte, removing infection. The tweezers act as a phagocyte, "eating" infection.

Germ-Mania (cont.)

phagocyte

lymphocyte

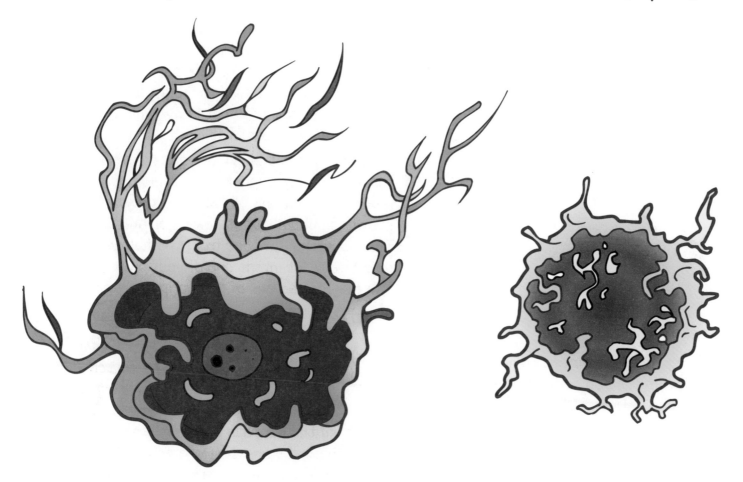

Body Talk

Fancy That It's a Fact!

It is very important to let other people know when you are not feeling well. No one can know how your body feels if you do not tell them. The way in which you explain how you feel is very important because your parents, teachers, or doctors make decisions about what they think may be troubling you based on your explanation. This activity allows you to practice your communication skills by putting on a puppet show.

Materials

- 2 old socks
- colored markers
- scrap-cloth material (if available)
- 3 rocks or other heavy objects
- colored yarn
- bedsheet

Let's Do It!

1. Make two puppets using the craft materials listed above. Use one old sock as the body of each puppet. Glue on colored yarn as hair. Use colored markers to draw the eyes, mouths, noses, and ears. Cut out and glue on scrap material for clothing, or color on clothing with markers. Create one puppet that looks like you and one that looks like your parent or guardian.

2. Borrow a bedsheet from one of your family members to make a puppet stage. Drape the sheet over a table and place rocks or other heavy objects (such as books) on top to hold it in place. You will be able to hide your body behind the sheet while holding your puppet up above the table. Your guests should only see the puppets, not your body (which will be hidden behind the sheet and table).

3. Perform a puppet show for your parents and/or friends. In your puppet show, the puppet that represents you should talk with the parent or guardian puppet about how he or she is feeling and what is wrong. Choose from the following sicknesses or problems or invent one of your own. Create your own play or use one of the scripts provided.

 a) sore throat
 b) stomachache
 c) headache
 d) toothache
 e) dizziness

4. Now, take the puppets off your hands and stand up from behind the sheet. (Don't forget to take a bow!) Ask the audience what they think is wrong with your puppet. Discuss with the audience what you could do to make your puppet feel better.

Body Talk *(cont.)*

Sample Script 1

Sample Script 2

"Sally's Sadness"

Sally: Mom, I don't feel so good.

Mom: What's wrong, Sally?

Sally: I feel funny.

Mom: Does something hurt?

Sally: My throat hurts.

Mom: Where does it hurt?

Sally: Right here on the left side of my throat.

Mom: Does it hurt all the time?

Sally: No, only when I swallow.

"Pat's Problem"

Pat: Dad, I feel yucky.

Dad: What's wrong, Pat?

Pat: I felt strange when I got out of bed this morning.

Dad: What do you mean, Pat?

Pat: The room was spinning when I sat up, and I couldn't see straight.

Dad: What did you do?

Pat: I lay back down and waited a minute.

Dad: That was a good idea. Did it happen again after that?

Pat: Yes, while I was eating breakfast.

Daily Diary

Fancy That It's a Fact!

When you are sick, your body works differently than when you are healthy. It is important to notice when things in your body happen differently than they usually do. For example, coughing, sneezing, hiccuping, and wheezing are ways of breathing that are different from how you normally breathe. A runny or stuffed-up nose is different from the way your nose usually works. Losing your voice, having a sore throat, and having diarrhea are all conditions that are different from normal. When your body acts differently than normal, it is said to be expressing symptoms. One symptom of sickness, or sign that your body is busy fighting off an infection, is an increase in your body temperature over its normal 98.6° F. The purpose of this exercise is to learn more about how your body functions when you are healthy so that you may be more easily able to notice symptoms when you are getting sick.

Materials

- 7 sheets of notebook paper
- 1 sheet of colored construction paper
- stapler
- crayons or colored markers
- pencil
- thermometer
- clock

Let's Do It!

1. Make a journal. Place the seven sheets of notebook paper together with the colored construction paper on top, like a book. Then, staple all eight pages together on the left side so that it opens like a book.

2. Decorate the front of your journal (the colored construction sheet) in any way you like. Title it "My Health Journal" or "Symptom Book" or any other title you like.

3. Label each of the inside pages of your journal to correspond to a day of the week. For example, write "Sunday" on the first page. Use the sample provided on page 19 to create each page in your journal.

4. Now, you are ready to fill your book in on a day-by-day basis. When you wake up tomorrow, fill in the answers to questions 1–7 in your journal. Answer questions 8 and 9 before you go to bed. Please use the help of an adult.

5. When your journal is full, look back through the pages for the healthy patterns of your body. Which things were almost the same every day? Look for things that may be symptoms or signs that your body is acting differently than normal. These are the types of things that you would want to tell an adult about when they happen.

Daily Diary (cont.)

Sample Diary Page

Day of the Week _____ Date _____

Dear Diary,

 1. I woke up at this time today: _____.

 2. My temperature is _____.

 3. My skin feels _____.

 4. My eyes look _____.

 5. My head feels _____.

 6. My stomach feels _____.

 7. These parts of my body feel different than usual:

 _____.

 Describe how they feel. _____

 8. I went to the bathroom this many times today: _____

 9. I went to sleep at this time today: _____.

Signed,

(Your Name)

Daily Diary (cont.)

Symptom Scroll

Headache

Stomachache

Sore throat

Runny nose

Earache

Aches and pains

Fever

Vomiting

Nausea

Diarrhea

Coughing

Phlegm

Bleeding

Sores

Swelling

Tiredness

Dizziness

Chills

Shivers

Shakiness

Loss of voice

Weakness

Cramps

Disrupted sleep

Sweatiness

Clammy hands or body

Glazed eyes

Itchy or runny eyes

Rashes

Nutrition

Building a Food-Group Pyramid

Fancy That It's a Fact!

Every day, your body needs nutrients—protein, carbohydrates, fats, vitamins, and minerals—to work properly and stay healthy and trim. The *food pyramid* is a general guide for how to eat; you don't have to follow it exactly every day. The main ideas to remember are that your diet should have a lot of breads, cereals, rice, and pasta; medium amounts of dairy products, protein sources (meat group), fruits, and vegetables; and only small amounts of sweets and fatty foods.

Materials

- large poster board
- colored markers
- magazines with pictures of food
- miscellaneous empty food cartons, containers, or packaging
- miscellaneous nonperishable food items such as rice, pasta, and eggshells
- glue

Let's Do It!

1. Draw a food pyramid on the poster board with colored markers. Label the number of servings in each section. (See sample on page 25.)

2. Collect several pictures of food that you have cut out of magazines, food items that won't rot (for example, uncooked macaroni, uncooked rice, and well-rinsed eggshells) and food packaging and labels such as a logo from a cereal box. For food that would rot, you can draw pictures or photocopy and cut out the patterns provided on page 24.

3. Using the sample, glue these items to the appropriate place in the pyramid. Make sure that the number of items you place in each section corresponds to how many servings you should eat of that food. For example, put between three and five different vegetable pictures or food labels in the vegetable section.

4. After the glue has dried, display your food pyramid in a place—such as on the refrigerator—where it will remind you to eat a balanced diet.

Building a Food-Group Pyramid *(cont.)*

What Makes Up One Serving?

Milk, Yogurt, and Cheese

- 1 cup (240 mL) milk
- 1 cup (240 mL) yogurt
- 1½–2 ounces (42–50 g) cheese

Meat, Poultry, Fish, Dry Beans, Eggs, and Nuts

- 2–3 ounces (100–150 g) cooked lean meat, poultry, or fish
- ½ cup (120 mL) cooked dry beans
- 1 egg
- 2 tablespoons (30 mL) peanut butter

Fruits and Vegetables

- 1 cup (240 mL) raw leafy vegetables
- ½ cup (120 mL) other vegetables, cooked or chopped raw
- ¾ cup (120 mL) vegetable juice
- 1 medium apple, banana, or orange
- ½ cup (120 mL) chopped, cooked, or canned fruit
- ¾ cup (180 mL) fruit juice

Breads, Cereals, Rice, and Pasta

- 1 slice of bread
- 1 ounce (28 g) cold cereal
- ½ cup (120 mL) of cooked cereal, rice, or pasta

Building a Food-Group Pyramid *(cont.)*

Food Patterns

Milk

Yogurt

Cheese

Lean Meat

Poultry

Fish

Apple

Banana

Orange

Orange Juice

Apple Juice

Bread

Building a Food-Group Pyramid *(cont.)*

The Food Pyramid

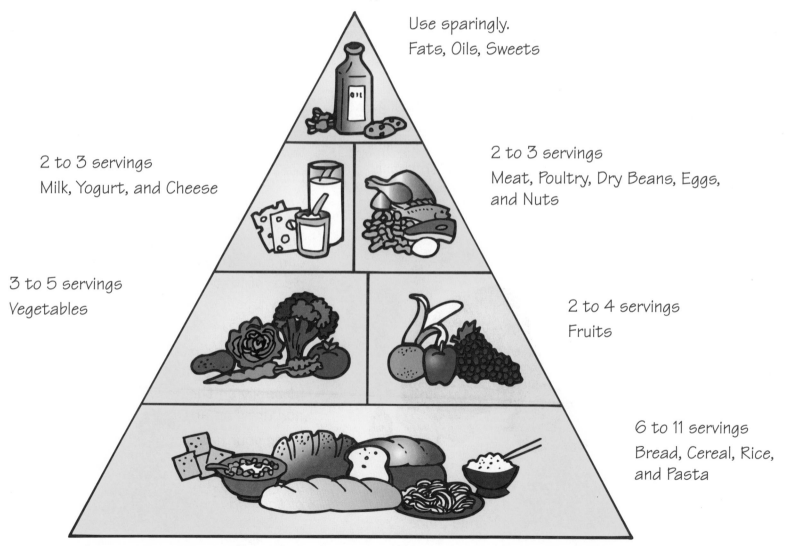

Use sparingly.
Fats, Oils, Sweets

2 to 3 servings
Milk, Yogurt, and Cheese

2 to 3 servings
Meat, Poultry, Dry Beans, Eggs, and Nuts

3 to 5 servings
Vegetables

2 to 4 servings
Fruits

6 to 11 servings
Bread, Cereal, Rice, and Pasta

Vital Vitamins and Mandatory Minerals

Fancy That It's a Fact!

Your body needs nutrients to survive. *Vitamins* and *minerals* are nutrients that help different parts of the body to work properly and stay strong. Some people take vitamin and mineral pills to make sure they get enough nutrients, but this is not a substitute for healthy eating. Foods like candy don't have very many nutrients, but fruits, vegetables, and other non-processed foods do. If you stock up on nutrients, your body will be sure to thank you for it.

Materials

- butcher paper
- old magazines with pictures of food (or you can draw your own)
- white paper
- scissors
- glue
- colored markers

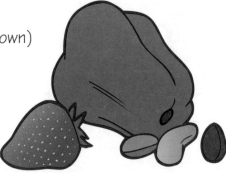

Let's Do It!

1. Lie down on the sheet of butcher paper and have someone trace the outline of your body.

2. Inside the outline of your body, draw the following with colored markers: bones, muscles, and veins in your arms and legs; your brain; nerves going from your brain down your spine; eyes; nose; mouth and teeth; ears; and hair. See page 28 for an example.

3. Using the chart on page 27, pick one food for each vitamin and each mineral, and cut it out of a magazine. (Some of the vitamins and minerals can also come from things besides food, like the sun. You can cut out pictures of these things as well.) On a piece of white paper, make a label with the name of the vitamin or mineral each food contains and glue it to the picture.

4. Glue the food picture to at least one part of the body that the vitamin or mineral helps. If it does not fit easily on the body part, glue it near the body part and draw an arrow.

5. Hang your healthy body on the wall or on your bedroom door. When you eat, imagine the nutrients going into your stomach and then out to the parts of the body that need them most.

Vital Vitamins and Mandatory Minerals _(cont.)_

Vitamins, Minerals, and You!

Vitamin	Part(s) of the Body It's Good For	Foods (or Other Sources) that Contain This Vitamin
Vitamin A	Eyes, bones	Milk, eggs, green leafy vegetables, orange and red fruits and vegetables
Vitamin B1	Nerves, brain	Beef, pork, legumes, fish, chicken, grains, pasta, nuts
Vitamin B2	Eyes, skin	Milk and dairy foods, dark green vegetables, eggs, yogurt, bread, cereal, meat
Vitamin B6	Blood	Meat, fish, green leafy vegetables, legumes, bananas, grains
Vitamin B12	Blood, nerves, brain	Meat, fish, chicken, milk, eggs, cheese
Vitamin C	Skin, gums	Citrus fruits, berries, mangos, papayas, melons, tomatoes, potatoes, green peppers, green leafy vegetables
Vitamin D	Bones	Milk, fish, eggs, the sun
Vitamin E	Blood	Nuts, wheat, grains, green leafy vegetables, vegetable oil

Vitamin	Part(s) of the Body It's Good For	Foods (or Other Sources) that Contain This Vitamin
Vitamin K	Blood	Dark green vegetables (such as spinach and broccoli)
Niacin	Nerves, skin, stomach	Meat, eggs, chicken, cereal, legumes, milk, green leafy vegetables, fish, nuts

Mineral	Part(s) of the Body It's Good For	Foods (or Other Sources) that Contain This Mineral
Calcium	Bones, teeth, muscles, nerves, blood	Dairy products, fish with bones, tofu, legumes, broccoli
Fluoride	Bones, teeth	Water, tea, seafood
Potassium	Muscles, nerves	Fruits, vegetables, dairy products, grains, legumes, beef
Iron	Blood, muscles	Beef, fish, chicken, shellfish, eggs, legumes, dried fruit, cereals
Zinc	Skin	Beef, fish, chicken, grains, vegetables

Source:
http://nutrition.miningco.com/library/blminerals.htm?pid=2756&cob=home

Vital Vitamins and Mandatory Minerals *(cont.)*

Body Outline

Fish

Brain

Milk

Bone

Nerve

Pork chop

Spinach

Blood vessels

Muscle

Chicken

Citrus fruit

Skin

Letter Soup

Fancy That It's a Fact!

People need lots of different kinds of fuel to stay healthy, just like a plant needs water, sunshine, soil, and the right temperature. As long as you eat foods from each of the four different food groups every day, you will be on the road to good nutrition. One way to get all of the four food groups into one meal is to make soup.

Materials

- 4 sheets of construction paper in 4 different colors
- scissors
- black marker
- soup bowl

Let's Do It!

1. Cut each piece of construction paper into eight rectangular pieces of about the same size. Separate the pieces into piles according to color.

2. Pick one pile of squares. On each square, write one of the following letters: M, E, R, C, A. On the pieces in another pile, write the letters: C, C, I, H, E, N, K. On the pieces in the third pile, write the letters: L, C, I, C, O, B, R, O. On the pieces in the last pile, write the letters: C, R, E, I. Set the extra blank pieces of construction paper aside.

3. Pretend you are a chef who is making a healthy soup. Put all of the squares with letters into a bowl and mix it up. Each color represents a food group.

4. Pull out all of the letters of one color. Unscramble the letters to form the name of a food. Which food group is this food from? Do this for each color until you have unscrambled all of the food names.

--

From the cereals and grains group: RICE
From the fruits and vegetables group: BROCCOLI
From the meat group: CHICKEN
From the dairy group: CREAM
Answers

Foods of the World

Fancy That It's A Fact!

People in different parts of the world eat different kinds and different combinations of food. But all people need to eat foods that come from the four food groups because that's the way our bodies are made. There are endless ways to put these foods together to make different dishes. Try a new food once in awhile, and add a little spice to your life!

Materials

- large sheet of poster board
- colored markers
- light-colored construction paper
- glue
- map of the world or globe
- information on foods from different parts of the world from the library or Internet (See Resource List on pages 156–160.)
- pictures from magazines of foods from different parts of the world

Let's Do It!

1. Using colored markers, draw your own map of the world on the poster board. Label each continent.

2. On small pieces of construction paper, write the name of a food dish from each part of the world. Underneath, write down which food groups the dish contains.

3. Glue each piece of construction paper to the appropriate part of the map. If you can find a picture of the food, glue it next to its description.

4. Pick a dish that you would like to try from a different part of the world. Look for a recipe on the Internet (See Resource List.), at the library, or at the bookstore. Buy the ingredients, and make a new and exciting dish!

Hopscotch for Health

Fancy That It's a Fact!

If you don't remember the important ideas about food and nutrition, how will you be able to eat a healthy, balanced diet? This activity will help you learn how to eat properly. When you play it with your friends, brothers, sisters, or parents, they will learn about healthy eating, too!

Materials

- paper
- pen or pencil
- coin or marker
- construction paper
- chalk
- scissors
- give

Let's Do It!

1. Make a list of 20 questions and answers related to food and nutrition, or use the list of 20 questions and answers provided (page 33). If you choose to make up some of your own questions, look at the other activities in this book, food labels, and the bibliography at the end of this book for more ideas.

2. Photocopy and cut out the questions and answers from the list or write your own on a sheet of paper and cut them out. Glue each question onto one side of a piece of construction paper and glue the corresponding answer to the back of that sheet. You should have 20 construction-paper cards with a question and answer on each.

3. Separate the cards into two piles of 10. Number the cards in each pile from 1 to 10.

4. In a safe place outside, use chalk to draw a hopscotch grid numbered 1 to 10.

5. Invite a friend, brother, sister, or parent to play the hopscotch game with you. If three people want to play, one person can be the one to ask the questions while the others play hopscotch. Take turns being the one to ask the question.

Hopscotch for Health *(cont.)*

Rules of the Game

1. Flip a coin to decide who will hopscotch first. This person should choose a pile of cards. The second player gets the other pile of cards.

2. The winner of the coin toss throws the coin or a marker onto square 1. The other player then asks question number 1 from his or her pile of cards. If the player gets the answer right, continue with step 3.

3. The player then hops on one foot over square 1 to square 2, landing on the same foot; then, the player hops onto square 3. The player then lands on two feet, with one foot in square 4 and the other in square 5. He or she then hops again and lands on one foot in square 6. With another jump, the player lands on two feet, with one foot in square 7 and the other in square 8. The player must continue hopping and jumping up to squares 9 and 10. At this point, the player should turn around and jump back down the grid in the same fashion. When the player gets back to square 2, he or she should bend down and pick up the marker from square 1. From there, it's a single hop onto square 1 and out.

4. If the first player continues to answer questions correctly, he or she can continue moving up through the hopscotch grid. For example, for the second turn, the player throws the marker onto square 2 and answers question 2. He or she then hops through the grid, skipping square 2 on the way up and picking up the marker on the way back.

5. It becomes the other player's turn when any of the following happens:

 a. The marker does not land in the right square.

 b. The player does not hop within the squares (touches the lines of a square with his or her foot, for example).

 c. The player gives a wrong answer to the question. (If a wrong answer is given, the player must try again on the next turn until he or she answers correctly.)

6. The winner of the game is the person who gets to 10 first and successfully hops through the hopscotch grid and back.

Hopscotch for Health *(cont.)*

Sample Questions

Q: What are the four food groups? **A:** Meat, fish, poultry; milk, yogurt, cheese (or dairy); fruits and vegetables; grains, pasta, rice	**Q:** What are the three types of food that you should eat sparingly? **A:** Fats, oils, sweets	**Q:** What is the most important meal of the day? **A:** Breakfast	**Q:** Which is better for you each day: to eat several small meals and snacks, or to eat three large meals? **A:** Several small meals and snacks
Q: Name one reason why you should limit your intake of sweets. **A:** Tooth decay	**Q:** Give an example of a breakfast that contains an item from each of the four food groups. **A:** One possible answer: cereal with milk and banana slices, and a hard-boiled egg	**Q:** How many servings per day should you eat of breads, grains, rice, and pasta? **A:** 6 to 11	**Q:** Which of the following items has the most fat in it: a piece of cake, a whole wheat cracker, or a handful of peanuts? **A:** A piece of cake
Q: Which is worse for you: unsaturated fat or saturated fat? **A:** Saturated fat	**Q:** Which is the healthiest kind of oil to use in cooking: vegetable oil, olive oil, or corn oil? **A:** Olive oil	**Q:** Name one source of protein. **A:** Meat, chicken, fish, beans, or nuts	**Q:** Which of the following foods has the most calcium (which is good for your bones and teeth): milk, apples, bananas, or bread? **A:** Milk
Q: Which of the following food pairs belongs to the same food group: steak and eggs, cheese and strawberries, or lettuce and rice? **A:** Steak and eggs	**Q:** Which one of the following is not a fruit: orange, banana, kiwi, or cucumber? **A:** Cucumber	**Q:** Which of the following foods must always be stored in the refrigerator: potato chips, cereal, yogurt, or peanuts? **A:** Yogurt	**Q:** What food group is missing from this lunch: roast beef sandwich with lettuce and tomato, and a peach? **A:** Dairy group
Q: Which of the following drinks is the healthiest: soda, coffee, water, or iced tea with sugar? **A:** Water	**Q:** Which of the following types of potato (from the vegetable group) is the healthiest: potato chips, baked potato with onions and chives, mashed potatoes with sour cream and butter, potato skins with melted cheese and bacon? **A:** Baked potato with onions and chives	**Q:** Which dessert is the healthiest: cheesecake, ice cream, fruit salad, or pudding? **A:** Fruit salad	**Q:** True or false: Protein is good for building muscles. **A:** True

Breakfast Potluck

Fancy That It's a Fact!

Breakfast is the most important meal of the day. It gives you the fuel you need to start your day and to stay alert in school. People all over the world eat different things for breakfast; there's no one right kind of breakfast to eat. We often get bored with breakfast, especially if we eat the same thing every day.

Materials

- pen
- invitations (page 35)
- hole punch
- colored yarn
- white paper

Let's Do It!

1. Make a guest list for your breakfast potluck.

2. Photocopy and fill out the invitations. Ask each person to bring one dish that contains foods from one of the following food groups: milk, yogurt, and cheese; meat, poultry, fish, and eggs; breads, grains, and cereals; fruits and vegetables. When you deliver the invitations, give each person a copy of the blank recipe form provided. Ask your guests to fill out the form and bring it to the potluck.

3. Plan a breakfast dish to make yourself. Make your own or use one of the quick and easy recipes that appear later in this section.

4. Have the potluck! Ask each person to introduce his or her dish to the group and say what the ingredients are. Remind your guests not to eat anything to which they might be allergic. Sample a little bit of every dish if you can!

5. At the potluck, collect everyone's recipe forms.

6. After the potluck, make copies of the recipes for each person who attended the potluck. These will form a cookbook.

7. Make a cover for your cookbook on a sheet of white paper. Think of a title and decorate it any way you want. Make enough photocopies of the cover for each person.

8. Make cookbooks for each person. Each finished cookbook should contain a cover followed by one copy of each recipe. Punch a hole in the upper left corner of each cookbook, thread a piece of colored yarn through the hole, and tie it in a bow.

9. Make sure everyone who gave you a recipe gets a copy of the cookbook!

Breakfast Potluck (cont.)

To: _____

From: _____

You're Invited

Join us for a breakfast potluck!

Place: _____

Date: _____

Time: _____

Given by: _____

RSVP by: _____

You are invited to bring a dish from the _____ food group. Enclosed is a recipe card. Please fill it out and bring it to the party. We can't wait to see you!

Breakfast Potluck (cont.)

Recipe Card Pattern

Dish Name: _____

Ingredients: _____

Directions: _____

Main Food Groups: (Please circle all that apply.)

Fruits and Vegetables

Meat, Poultry, Fish, Dry Beans, Eggs, and Nuts

Milk, Yogurt, and Cheese

Bread, Cereal, Rice, and Pasta

Prepared by: _____

Quick 'n' Easy Recipes

Fancy That It's a Fact!

When you feel like snacking, do it the healthy way. Here are some suggested snack recipes to get you started. Each snack serves 2 people. All ingredients should be available at your local grocery store. Be sure to have an adult help you prepare these snacks (and eat them too).

Let's Do It!

Fruit Salad

Suggested Ingredients (Choose fruits that you can get easily at your grocery store.)

- 1 12-oz. can of pineapple chunks in their own juices
- 1 banana
- 1 pint-sized box of strawberries
- 1 orange
- ⅛ cup (30 mL) shredded coconut

Utensils

- can opener
- large bowl
- knife
- large wooden spoon
- strainer

Directions

1. Open can of pineapple and strain off juices. (If you want, you can save the juice and drink it with your fruit salad.) Place pineapple in bowl.
2. Peel and slice banana. Place chunks in bowl.
3. Rinse strawberries in water. Remove stems and cut each strawberry in half lengthwise. Place them in the bowl.
4. Peel orange and separate it into sections. Place sections in bowl.
5. Stir fruit together.
6. Sprinkle shredded coconut on top. Enjoy!

Quick 'n' Easy Recipes *(cont.)*

Ants on a Log

Ingredients

- 2 medium-sized stalks of celery
- 4 tbsp. (60 mL) reduced-fat peanut butter
- 40 raisins

Utensils

- knife
- measuring spoons

Directions

1. Rinse celery under water until clean. Cut off leaves.
2. Cut each celery stalk in half so that you have a total of four pieces.
3. Spread 1 tbsp. of peanut butter on each celery stick.
4. Place 10 raisins on top of the peanut butter on each celery stick. Each person gets two. Yum!

Pizza Bagels

Ingredients

- 2 miniature bagels, plain
- 2 tbsp. (30 mL) tomato sauce
- ¼ cup (60 mL) part-skim mozzarella cheese
- dash of oregano

Utensils

- toaster oven
- knife
- spoon
- cheese grater
- plate
- measuring spoons
- measuring cups

Directions

1. Slice bagels in half lengthwise.
2. Toast bagels lightly. Remove from toaster oven and allow to cool slightly (about 2 minutes).
3. While the bagels are toasting and cooling, grate the cheese and divide it into four equal piles on a plate.
4. Spread ½ tbsp. (7.5 mL) tomato sauce on each toasted bagel half.
5. Sprinkle one pile of cheese on top of each toasted bagel half.
6. Toast bagels again until cheese is melted.
7. Sprinkle a dash of oregano on top of each pizza bagel. Delicious!

Quick 'n' Easy Recipes *(cont.)*

Ham and Cheese Roll-ups

Ingredients

- 2 pieces of thinly sliced deli ham (You can also use turkey, roast beef, or other meat.)
- 2 slices of low-fat or reduced-fat cheddar cheese
- mustard in squeeze bottle
- 2 dill pickle spears

Utensils

- plate
- toothpicks

Directions

1. Spread out each slice of ham on a plate.
2. Place one slice of cheese in the center of each slice of ham.
3. Ask each person eating how much mustard they would like. Squeeze mustard on top of cheese.
4. Place one pickle spear on top of each slice of cheese.
5. Roll up each slice of ham around the cheese and mustard. You may spear a toothpick through. Tasty!

Cheesy, Fruity, Yummy

Ingredients

- 1 cup (240 mL) cottage cheese
- 12 oz (350 g) can crushed pineapple in its own juices

Utensils

- 2 bowls
- cup
- can opener
- strainer

Directions

1. Place ½ cup (120 mL) cottage cheese into each bowl.
2. Open can of pineapple and strain off juices into the cup. Set juice aside.
3. Pour half of the pineapple on top of each mound of cottage cheese.
4. Pour some of the pineapple juice on top of each snack. Enjoy!

Quick 'n' Easy Recipes (cont.)

Berry Delicious Smoothie

Ingredients

- 1 cup (240 mL) vanilla or fruit yogurt
- 1 cup (240 mL) juice (apple or orange)
- 1 banana
- ¼ cup (60 mL) assorted berries (fresh or frozen)
- 4 ice cubes

Utensils

- measuring cups
- blender
- 2 tall glasses

Directions

1. Place ice cubes in blender.
2. Add juice and yogurt to blender.
3. Peel banana, break it apart, and place pieces in blender.
4. Dump berries into blender.
5. Put lid on blender and blend on high for 2 minutes or until smooth.
6. Pour half of smoothie mixture into each glass. Scrumptious!

Best Ever Breakfast Burritos

Ingredients

- 2 eggs
- 2 t. (30 mL) nonfat milk
- dash of salt and pepper
- nonfat cooking spray
- ½ green pepper
- ½ small onion
- ¼ cup (60 mL) grated, cheddar or jack cheese
- ¼ cup refried beans
- 2 tbsp. (60 mL) hot sauce or salsa (optional)
- 2 flour tortillas

Utensils

- measuring cups and spoons
- frying pan
- 2 bowls and plates
- spatula
- fork, spoon, and knife
- cheese grater

Directions

1. Put eggs, milk, salt, and pepper in a bowl. Beat until smooth. Set aside. Chop green pepper and onion. Set aside. Grate cheese into empty bowl. Set aside.
2. Coat frying pan with cooking spray. Sauté peppers and onions over medium heat for 2 to 3 minutes. Add egg mixture and cheese. Scramble until fluffy.
3. Warm tortillas (10 seconds-microwave, 1 minute-toaster oven). Heat beans (30 seconds-microwave, 2 minutes-stovetop). Spoon eggs onto each tortilla; spoon beans on top of eggs. Add hot sauce or salsa, if desired, and roll up. Ole!

Fitness

Get Ready to Go!

Fancy That It's a Fact!

Exercise is an important part of your life. It helps you to grow, helps you to get (or stay) fit, and helps you to live a longer and more enjoyable life. An exercise and fitness routine that leads to a healthy body and healthy lifestyle has three very important parts: moving, lifting, and stretching. To build a healthy body, you need to have *cardiovascular fitness* (moving), *muscle strength* (lifting), and *flexibility* (stretching). One part will not work without the others. Cardiovascular fitness will not help you touch your toes or tie your shoes. Strong muscles will not get you over the finish line at the end of a race, and flexibility will not help you carry heavy stuff. If you blend all three parts into your everyday life, you will find that you are able to run faster and farther, breathe more easily, and, in general, feel better. Fitness will not only improve your physical well being, but it can also soothe nerves and relax the mind.

Materials

- comfortable clothes
- sturdy gym shoes
- Exercise Journal (page 43)

Let's Do It!

1. Photocopy or re-make the Exercise Journal provided (page 43). As you work through the activities in this section, use it as a guide to make sure that you are getting enough of the right kinds of exercise and fitness activities each week.

2. Dress the part! Wear comfortable clothes that are appropriate for exercise, and make sure your shoes are sturdy and supportive.

3. Warm up for 2–5 minutes before you begin, and cool down for 2–5 minutes before completely stopping any of the moving, lifting, or stretching exercises you may do. Warming up and cooling down are important so that your body has time to adjust to changes in your level of activity slowly. To warm up, you just need to get your blood flowing. Warming up can be as easy as marching in place, doing jumping jacks, or climbing up and down a few flights of stairs. Cooling down is important as well. To slow your body down, continue with the same activity you were doing before at a slower pace, or you may prefer to do one of the warm-up activities, also at a slower pace.

4. Please see the drawing of your major muscle groups (page 44). Studying this drawing will help you to learn more about the parts of your body used in exercise and fitness activities, as well as to help you understand the terms used in this book.

Get Ready to Go! *(cont.)*

EXERCISE JOURNAL

	Sunday	Monday	Tuesday	Wednesday	Thursday	Friday	Saturday
Week 1	C S F D: _____ _____	C S F D: _____ _____	C S F D: _____ _____	C S F D: _____ _____	C S F D: _____ _____	C S F D: _____ _____	C S F D: _____ _____
Week 2	C S F D: _____ _____	C S F D: _____ _____	C S F D: _____ _____	C S F D: _____ _____	C S F D: _____ _____	C S F D: _____ _____	C S F D: _____
Week 3	C S F D: _____ _____	C S F D: _____ _____	C S F D: _____	C S F D: _____	C S F D: _____	C S F D: _____	C S F D: _____
Week 4	C S F D: _____ _____	C S F D: _____ _____	C S F D: _____	C S F D: _____	C S F D: _____	C S F D: _____	C S F D: _____

Key

C = 20 minutes of cardiovascular exercise (goal = 3 X 20 minutes per week)
S = 20 minutes of strength/resistance exercise (goal = 2 X 20 minutes per week)

F = 15 minutes of stretching exercise (goal = 4 X 15 minutes
D = Description—what you did per week

Get Ready to Go! *(cont.)*

Muscle Groups

Triceps

Biceps

Chest

Abdominals

Quadriceps

Hamstrings

Calves

Shoulders

Upper Back

Forearms

Lower Back

Buttocks

Lats

Hips

Stretching

Fancy That It's a Fact!

Stretching is an essential part of a healthy exercise plan and can easily be built into your schedule. Stretches can be done at any time but may be easiest to build into your routine if done daily, like when you get out of the shower. You could also add stretching exercises before and/or after your cardiovascular or strength workouts. Stretching is a way of lengthening your muscles, pulling them ever so slightly to increase their range of motion and bringing more oxygen to them. Practicing stretching exercises increases your flexibility and range of motion, allowing you to move more easily. It also helps to prevent injury from muscle strain. This is important because even the simplest tasks require movement—getting out of bed, stepping into the tub, jumping over a puddle on the way to school, or even putting on your shoes.

Materials

- bath towel
- mat, carpet, or some other soft place to lie

Let's Do It!

1. It is best if you can find time to do 15 minutes of stretching exercises at least four times a week. You can do this at any time of day. Use the Exercise Journal (page 43) to chart your routine.

2. Always warm up and cool down before stretching. It is important that your body be prepared to stretch. To warm up, try marching in place for 2–5 minutes.

3. Remember that stretching should NOT involve pain. You should be exerting only gentle tension on your muscles. If you feel any pain, STOP immediately.

4. Stretch slowly and stay relaxed. Move smoothly. Do NOT bounce or push to the point of pain.

5. Hold each stretch for at least 10 seconds. When you get used to the stretching exercises listed here, increase your holding time to 1 minute.

6. Remember to breathe at a constant rate when you stretch and to focus your mental attention on the muscles that you are stretching.

7. Always do some form of cooling down when you finish your stretching activities.

Stretching *(cont.)*

Some Stretching Ideas

Towel Tricks

1. Hold a medium-sized towel above your head with one hand at each end. Stretch it out. Bend forward. Keeping your arms straight, move the towel in front of you and down to your heels. Come back up, bringing the towel back over your head to the starting position. Repeat four times.

2. Stand with your legs far apart. Hold your towel stretched out in front of you with one hand on each end. Twist your body to the right side. Keeping your arms straight and the towel stretched out, bend down and touch your right foot with your left fist. Stand up straight again. Now twist your body to the left side. Bend down and touch your left foot with your right fist. Repeat four times.

3. Hold your towel at both ends behind your neck. Bend your head forward, stretching your neck. Now press your head backward, so that it rests on your towel. Pull the towel to the right while straightening your right arm and bending your left arm inward toward your left ear. You should be pressing your head down toward your right shoulder. Now do this stretch on the left side. Repeat four times.

4. Take your shoes off and drop your towel onto the floor. Grab it first with your little toe and try to pick it up. Then try to pick it up using the rest of your toes, just like you would use your fingers. Now try it with your other foot. Repeat four times.

Stretching (cont.)

Yoga for You

Yoga is a system of postures and body positions (or exercises) designed to help you obtain and maintain a flexible, bendable body and a relaxed and calm mind. It is a specific type of stretching. When you do these yoga exercises, the goal is to relax. You should try to move very slowly and to focus your attention on your movements. Be very quiet and try not to talk while you do these exercises. Try to listen to the sounds in your head and body.

The Frog

1. Sit on your heels. Place your hands on your thighs.
2. Spread your knees far apart and try to touch your toes in back of your buttocks.
3. In this position, slowly count to 10.
4. Bring your knees together again and sit on your heels.
5. In this position, again slowly count to 10.

Stretching (cont.)

The Cat

1. Sit on your heels. Place your hands on your thighs.

2. Lift your buttocks, positioning yourself in a kneeling position.

3. Spread your knees apart. Bend over and place your hands on the floor. Your hands and knees should be apart, like the legs of a table.

4. Move both your head and your chest at the same time, lowering your chest and chin to the floor. Your elbows will bend outward as you come down.

5. In this position, slowly count to 10.

6. In one smooth motion, lift your back like an angry cat. Pull in your stomach and let your head come down easily.

7. In this position, again slowly count to 10.

8. Relax your back and release your stomach.

9. Sit back on your heels and count to ten.

Stretching (cont.)

The Rooster

1. Stand up straight with your hands at your waist.

2. Breathe in as you slowly rise up on your toes. Stretch your arms out at your sides.

3. Hold your breath and balance on your toes. Slowly count to 10.

4. Breathe out slowly as you lower your arms back to your sides and come down off your toes and onto your heels.

5. Rest for a moment with your eyes closed. Slowly count to 10.

6. Open your eyes and repeat this exercise.

Stretching (cont.)

The Grasshopper

1. Lie on your stomach with your arms at your sides. Keep your legs together. Your chin should be on the floor.

2. Make your hands into fists. Your thumbs should be touching the floor. Keep your fists close to your sides.

3. Now, all at the same time, take a deep breath, push down on the floor with your fists, and raise your left leg.

4. In this position, slowly count to 10.

5. Now, as you breathe out, SLOWLY bring your left leg down.

6. Open your fists, put your cheek on the floor, and relax.

7. In this position, slowly count to 10.

8. Repeat the steps above with your right leg.

Stretching *(cont.)*

The Warrior

1. Stand up tall with your feet together.
2. Step forward as far as you can with your left foot, bending your left knee.
3. Turn your right foot to the side so that the inside of your foot is in line with your left heel.
4. Lift up your chin so that you are looking at the ceiling.
5. Raise your arms over your head and place your palms together.
6. Make sure that you can still see the tips of your toes over the bended knee.
7. In this position, slowly count to ten.
8. Repeat the steps above, but on your other side.

Stretching *(cont.)*

The Butterfly

1. Sit with the soles of your feet together.

2. Gently press your knees down toward the floor with your hands.

3. Hold for 10 seconds.

4. Stretch your chest forward, leaning down toward your toes.

5. Hold for another 10 seconds.

Stretching (cont.)

The Bridge

1. Lie on the floor on your back.

2. Place both feet flat on the floor with your knees bent.

3. Place your hands flat on the floor next to your ears. Your fingers should be pointed towards your toes.

4. Now straighten your arms and legs. This will push your body off the floor and into the air, making your body into a "bridge."

Cardiovascular Exercises

Fancy That It's a Fact!

Cardiovascular exercise, often called "aerobic" exercise, is another important part of a healthy workout plan. Aerobic exercises are those activities that increase the fitness of your heart, lungs, and circulatory system and increase the oxygen flow in your blood and to your muscles. Aerobic activity increases your heart rate and generally makes you breathe more heavily and quickly. There is really no need to learn specific exercises when trying to add cardiovascular or aerobic activity to your schedule. Anything and everything can count as cardiovascular activity as long as it puts your heart and lungs to work and is fun. Just make sure that you work long enough (20 minutes, three times a week) and hard enough to get your blood pumping and your heart beating.

Materials

- sturdy gym shoes

Let's Do It!

1. It is recommended that children exercise aerobically for 20 minutes or more at least three times a week. You can do this at any time of day and can divide the 20 minutes into chunks. For example, if you walk to and from school quickly for 10 minutes each way, you have achieved your daily goal of 20 minutes total. Use the Exercise Journal (page 43) to help chart your routine.

2. Always warm up and cool down for 2–5 minutes before and after cardiovascular exercise. Remember, this can be as simple as marching in place.

3. To prevent injury, exercise safely. You should stop exercising immediately if you feel any pain, dizziness, nausea, or extreme fatigue. Be careful not to overdo it, especially at first. A good rule is the "talk/sing rule": if you are breathing too heavily to sing but can still talk, the intensity is just about right. If you are breathing too heavily to talk, you are probably overdoing it.

Cardiovascular Exercises (cont.)

Some Cardiovascular and Aerobic Activity Ideas

Swimming

Basketball

Kick-boxing

Hacky sack

Frisbee

Ice or roller hockey

Bike riding

Rock climbing

Playing Twister

Jogging or running

Volleyball

Playing tag

Playing hopscotch

Ballet

Walking quickly

Nature hikes

Jumping jacks

Roller blading

Martial arts

Tossing a ball

Cross-country skiing

Doing fitness videos

Boat rowing

Climbing stairs

Sprints

Tennis

Dancing

Soccer

Jumping rope

Skateboarding

Playing with the dog

Gymnastics

Strength Training

Fancy That It's a Fact!

Strength training is the final component of a healthy workout routine. There are many muscles inside our bodies. These muscles help us to move and maintain our balance. They also help support the bones that make up our skeletal system. If you do not use your muscles regularly, they will become weak. If you do not exercise often, you may begin to feel tired sooner than you normally would. The exercises that follow (pages 57–66) are designed to strengthen the major muscle groups in your body. No free weights or machines are necessary. Try to add 20 minutes of strength training to your workout routine, at least two times a week. Strength training will build muscle tissue and tone your body.

Materials

- carpet, exercise mat, or other soft place to lie
- chair
- stairs or block of wood
- a friend or exercise partner

Let's Do It!

1. Try to do strength training for at least 20 minutes, two times a week. Use the Exercise Journal (page 43) to help chart your routine.

2. Remember to warm up your body before strength training and to cool down when you are finished.

3. As with stretching exercises, strength training should NOT involve pain. You should move slowly and smoothly and should STOP immediately if you feel any pain.

4. Begin by doing one set of exercises, repeating each one eight times. When you feel comfortable with the routine, increase to two sets of each exercise.

Strength Training *(cont.)*

Some Strength Training Ideas

A. Alone

Wall Push-ups: Upper body (shoulders, chest, triceps, and abdominals)

1. Stand facing a wall (about 2 feet [.6 m] away) with your arms straight out in front of you.

2. Touch the wall with your palms flat, and support your weight.

3. Slowly lower your chest to the wall, bending at the elbows but keeping your knees and back straight.

4. Push back out by straightening your arms.

5. Repeat.

Strength Training *(cont.)*

A. Alone *(cont.)*

Chair Dips: Upper body (chest, shoulders, and triceps)

1. Kneel on the floor in front of a sturdy desk chair. (You may want to place the chair against a wall to keep it from sliding.)

2. Place your hands behind you and grab the corners of the seat of the desk chair.

3. Extend your legs in front of you and straighten out your arms so that all of your weight rests on the heels of your feet and on the palms of your hands.

4. Now, lower your body slowly toward the floor by bending your upper arms. Your buttocks should come close to the floor.

5. Move slowly and then return to your starting position by again straightening your arms.

6. Repeat.

Strength Training *(cont.)*

A. Alone *(cont.)*

Sit Ups: Stomach and back
(abdominals and lower back)

1. Lie on your back on the floor and hook your toes under a heavy piece of furniture or a door.

2. Bend your knees comfortably, keeping them bent throughout the exercise.

3. Place your hands behind your head and lock your fingers together.

4. Curl your head, shoulders, upper back, and lower back slowly until they are raised off the floor and you are almost touching your knees with your head.

5. Hold the upright position for a second and then slowly uncurl your head, shoulders, upper back, and lower back until they again rest on the floor.

6. Repeat.

Strength Training *(cont.)*

A. Alone *(cont.)*

Squats: Thighs and buttocks (quadriceps, hamstrings, and buttocks)

1. Stand upright with your feet shoulder-width apart, toes pointed forward.
2. Bend your knees and lower your buttocks toward the floor.
3. Pretend you are sitting in an imaginary chair. Your thighs should be parallel to the floor and your knees in line with your ankles.
4. Keep your head still and continue to look forward.
5. Hold this imaginary sitting position for 10 seconds.
6. Return to a standing position.
7. Repeat.

Strength Training *(cont.)*

A. Alone *(cont.)*

Lunges: Thighs and buttocks (quadriceps, hamstrings, buttocks, and hips)

1. Stand upright with your feet shoulder-width apart, toes pointed forward.

2. With your left foot, take one medium-sized step forward. Plant your left foot on the floor, keeping your left knee steady.

3. Keep your back and chest straight while dipping your lower body straight down until your back knee (the right) comes close to the ground.

4. Hold this position for 10 seconds.

5. Now raise your body straight up, straightening your back knee (the right) and returning to the starting position.

6. Now switch legs so that you step forward with your right foot while bending your left knee.

7. Repeat.

Strength Training *(cont.)*

A. Alone *(cont.)*

Standing Calf Raises: Legs (calves)

1. On the bottom step of a flight of stairs or on a block of wood, stand upright with your feet shoulder-width apart, toes pointed forward.

2. Lock your knees and adjust your standing position so that only the balls of your feet are on the stair or wood block. Your heels should be off the stair or wood block.

3. Start the exercise by standing on your tiptoes as high as you can and flexing your calves.

4. Now lower your heels, still standing as tall as possible. Your heels should drop a bit below the stair or block. You should feel a stretch in your calves, but no pain.

5. Keep your legs straight and your knees locked. Do not bounce.

6. Repeat.

Strength Training *(cont.)*

B. With a Partner *(cont.)*

The Double Squat: Arms, thighs, and buttocks

1. Face your partner.
2. Stand an arm's length apart.
3. Hold hands.
4. Keep your feet straight forward.
5. Together, slowly lower yourselves until you are both squatting.
6. Hold your buttocks tight.
7. Use the front of your thighs to pull yourself back up into a standing position. See if you can do it without falling.

Strength Training (cont.)

B. With a Partner (cont.)

The Merry-Go-Round: Arms and legs

1. Sit on the ground, facing your partner with legs straight and spread widely apart.

2. Hold hands and touch toes.

3. Pull each other around like a merry-go-round. Lean to one side. Roll to the back and then around to the other side. Now roll to the front.

4. While you lean forward, your partner should pull as far back as he or she can.

5. When you lean back, you will pull your partner forward.

6. Keep your stomach pulled in all the time.

Strength Training *(cont.)*

B. With a Partner *(cont.)*

Foot Fight: Upper thighs and stomach

1. Lie on your back. Have your partner lie on his or her back so that you are facing each other. Keep your feet on the floor and your knees bent. Your feet should touch your partner's feet.

2. Lift your legs and place the soles of your feet against your partner's feet.

3. Push back and forth against your partner, one foot at a time (kind of like riding a bicycle).

4. Push from the thigh, holding your stomach in tight.

Strength Training *(cont.)*

B. With a Partner *(cont.)*

The Crab: Upper thighs

1. Sit back to back with your partner on the floor.

2. Hook your arms together behind you by locking your elbows. Your partner's right elbow should be locked with your left and his or her left elbow locked with your right.

3. Bend your knees, but keep your feet apart and flat on the floor.

4. Press against your partner's back, keeping your arms locked.

5. Now lift your buttocks up and off the floor and try to stand straight up.

6. Repeat step 5, going up and down four times.

Healthy Habits

Wash the Hand that Feeds You

Fancy That It's a Fact!

One of the best things you can do to stay healthy is to wash your hands often. That's right—many of the germs that make us sick get into our bodies from our hands. If you wash your hands after you use the restroom, before you eat, and after you handle trash, the common cold will have to find someone else to bother!

Materials

- light-colored construction paper
- lined writing paper
- pencil
- colored markers
- index cards
- scissors
- tape

Let's Do It!

1. On the lined paper, draw three columns with a pencil. Label the first column "Eating," the second column "Restroom," and the third column "Trash."

2. With this piece of paper, the pencil, and the clipboard, stroll around your house. Write down the following:

 Under "Eating": all the places where you and your family eat

 Under "Bathroom": where each toilet is

 Under "Trash": all the places where trash is kept

3. Count the total number of items in all three columns. Write this number on the back of the paper.

4. Trace your hand on construction paper once for each number of items you have. For example, if you wrote down eight places, trace your hand eight times on different-colored construction paper. Cut out the hands you drew.

5. For each hand you cut out, use a marker and write on an index card a clever saying that will help you and your family remember to wash your hands. For example, on an eating hand, you could write, "Wash the hand that feeds you!" For one of the hands in the restroom category, you could write, "Remember to wash when you go!" On a hand in the trash category, you could write, "Throw away the garbage and the germs! Remember to wash!"

6. Tape each index card to one of the hands you cut out so that it looks like the hand is holding the card.

7. Tape the hand to each of the places on your list. For example, you might tape one to the top of a toilet, another on the napkin holder on the kitchen table, and a third on the bathroom trashcan.

The Magic of Soap

Fancy That It's a Fact!

Every day we collect dirt on our bodies. It's in the air, on the ground, and on things we touch. Imagine if you never took a bath or a shower. You would have a layer of dirt on you so thick that no one would be able to tell it was you! A little soap and water works like magic to send the dirt and grime off your body and right down the drain. If you use this trick every day on your arms, legs, torso, head, and all over, you will stay squeaky clean.

Materials

- medium-sized bowl
- dish soap in a squeeze bottle
- ground pepper
- water

Let's Do It!

1. Fill the bowl with water. Pretend this is your bathtub.
2. Sprinkle pepper into the bowl, enough to cover the surface of the water (around five shakes). Pretend that the pepper is all of the dirt that needs to be washed off your body in the bathtub.
3. Turn the dish-soap bottle upside down and squeeze a stream of dish soap into the center of the water (Squeeze for about one second—count "one Mississippi" while squeezing.) Pretend the dish soap is your bath soap. Watch what happens to the "dirt." You should see the pepper back away from the soap and head toward the sides of the bowl. The center of the bowl of water, where the soap is, should be "clean."

Step 1: Add pepper.

Step 2: Add dish soap.

Sing Your Way to a Healthier Smile

Fancy That It's a Fact!

Brushing gets rid of the bacteria, called *plaque*, on your teeth. It's important to get rid of plaque because it causes tooth decay and gum disease, which can cause your teeth to fall out when you get older. Also, not brushing your teeth can cause bad breath and yellow teeth! There are four parts of your mouth that you should be sure to brush: your top right teeth, your top left teeth, your bottom right teeth, and your bottom left teeth. You should brush your teeth and gums for a total of 2 minutes, which means you should spend 30 seconds on each of these sections of your mouth. You should also run the toothbrush across your tongue a few times. If you brush your teeth twice a day and use a soft-bristled toothbrush and a toothpaste that has fluoride in it, you can keep your teeth clean and healthy.

Materials

- tape recorder
- blank cassette tape
- watch or clock with a second hand

Let's Do It!

1. Practice the following song, sung to the tune of "Three Blind Mice." Time yourself. It should take about 30 seconds to sing the whole song.

 Brush your teeth,
 Brush your teeth.
 See how they shine,
 See how they shine.
 Every morning and every night,
 We brush our teeth till they're pearly white,
 Have you ever seen such a beautiful sight?
 Those pearly whites.

 Brush your teeth,
 Brush your teeth.
 Get rid of the plaque,
 Get rid of the plaque.
 Brush your teeth and also your gums,
 And don't forget to brush your tongue,
 And always remember when you're done,
 To give yourself a smile.

Sing Your Way to a Healthier Smile *(cont.)*

2. Tape record yourself singing the song four times. Follow the pattern below when recording; in addition to singing the song, you will also say a few phrases to remind yourself to switch sections of your mouth. (When you play back the tape, you will brush the part of your mouth that the tape has told you while you listen to yourself sing, about 30 seconds. Then you will hear directions to switch to a different part of your mouth, and you will brush that section while you listen to the song. This will continue until you have brushed all parts of your mouth.)

3. Say, "Start with the teeth on the top right side of your mouth."

 Sing the two verses from Step 1.

 Say, "Now move to the teeth on the top left side."

 Sing the two verses from Step 1 again.

 Say, "Now move on to the bottom right side."

 Sing the two verses from Step 1 again.

 Say, "Now finish off with the bottom left side."

 Sing the two verses from Step 1 again.

 Say, "Now brush your tongue, and we're all done!"

4. Listen to the tape and time it with a watch or clock. Each time you sing the song, it should last about 30 seconds. If the songs are too long, record them again, but sing a little more quickly. If they are too short, record them again but sing a little more slowly. Time it again and keep recording it until each song is about 30 seconds long.

5. Play the tape every time you brush your teeth. Listen and follow the directions you recorded to make sure you brush all your teeth, your gums, and your tongue for two full minutes.

Sun Safety Mobile

Fancy That It's a Fact!

Too much sun can cause wrinkles, freckles, and skin cancer. The sun gives off dangerous ultraviolet rays that cause sunburn even on cloudy days, so it is important to protect your skin when you are outside. If any part of your skin is not covered, you should wear sunscreen with an SPF (Sun Protection Factor) of at least 15, and make sure to reapply it at least every two hours (especially between 10 A.M. and 4 P.M., when the sun is most dangerous). Sunscreen is a lotion that, when put on your skin, acts as a shield against the sun's harmful rays, just like a shirt. There are special ingredients in the sunscreen that block out the sun's rays and stop them from actually hitting your skin.

Materials

- two wire hangers
- string
- construction paper
- scissors
- glue or tape
- colored markers or crayons
- thin black marker
- thin white paper

Let's Do It!

1. Cut out six square pieces (4" [10 cm] sides) of construction paper of different colors.

2. Photocopy and cut out the patterns on pages 74–76 to hang on the mobile, or trace them onto thin white paper. Cut out the patterns from the white paper and color them. Glue or tape each picture onto a construction paper square. These pictures will help remind you how to protect your skin from the harmful rays of the sun.

Sun Safety Mobile *(cont.)*

3. With a thin black marker, write on the back of each square one short sentence about why the drawing is important. For example, on the back of the drawing of a sunscreen bottle, you could write, "When your skin is not covered by clothes, lots of sunscreen can help block the harmful rays of the sun."

4. Draw a sun on yellow construction paper and cut it out. With a crayon or marker, draw a smiley face on one side of the sun and a sad face on the other side.

5. Cut out one more construction-paper square with four-inch (10 cm) sides. Using the black marker, write your favorite thing about the sun on one side of the square. For example, you could write, "The sun keeps me warm," or "Sunny days make me smile." On the other side, write why the sun can be dangerous. For example, you could write, "If I stay in the sun too long, it can give me sunburn."

6. Now it's time to put the mobile together. Slide the end of one hanger into the opening of the other hanger so that the ends of the hangers are pointing in four directions. Tie the tops of the hangers together with a piece of string, and set them aside. Cut seven pieces of string of different lengths. Tape one end of each piece of string to the tops of each of the six construction-paper squares and the sun. Now tape the end of the string attached to the construction-paper square you made in Step 5 to the bottom of the sun, so that it hangs below the sun. Finally, tie the free ends of each string to different places on the hangers, and tie the sun so that it hangs in the middle. Ask an adult to help you hang the mobile in a sunny place.

Sun Safety Mobile (cont.)

Mobile Patterns

Umbrella or Parasol

Sunscreen

Sun Safety Mobile *(cont.)*

Long-sleeved shirt

Wide-brimmed hat

Sun Safety Mobile *(cont.)*

Shady tree

10:00 A.M.

AM

PM

4:00 P.M.

All in the Family

Fancy That It's a Fact!

We all need help to do things, even to stay healthy. Family members can help by reminding each other to exercise, eating healthy foods together, and listening to each other when they have problems. If you get to know your family members and their healthy habits, you can learn from each other and support and encourage each other for healthy living.

Materials

- construction paper
- three 6-inch (10 cm) pieces of colored yarn
- hole puncher
- glue
- colored markers
- pad of paper
- pen or pencil
- photographs

Let's Do It!

1. Interview your family members in person or on the phone. (Don't forget your aunts, uncles, cousins, grandparents, and anyone else close to you!) Ask each person two questions: What one thing do you do each day to stay healthy? What one thing do you sometimes do that is unhealthy that you wish you could change? Write their answers in pen or pencil on the pad of paper.

2. Ask each person you interview for a picture of himself or herself.

3. Make a family health album using construction paper, colored markers, and glue. Glue each picture onto a different piece of construction paper. Under each picture, write down what that person answered to each of your questions.

4. Make a cover for your family album out of construction paper and markers, and give it a title.

5. Punch three holes in the left-hand side of each page of the album, one at the top, one in the middle, and one at the bottom. Make sure the holes line up.

6. Thread a piece of yarn through each of the holes and tie on a loose bow.

7. Show your new family health album to all of your relatives!

All in the Family (cont.)

Sample Family Album Page

Every day, my grandmother goes for a morning walk to stay healthy. She is trying to quit smoking so that she can be even healthier.

78

Take Time Out from TV!

Fancy That It's a Fact!

Watching television is generally not considered exercise and is NOT a healthy habit. When we are inside in front of the TV, we are not outside playing and using our bodies in healthy ways. Think of all the things you could be doing with the time you spend watching TV.

Materials

- pencil
- television
- tape
- notebook
- string
- clock or watch

Let's Do It!

1. What would you do if you had more time? Make a list of things that you would have liked to do in the last week but didn't.

2. Using tape, attach a piece of string to the eraser end of your pencil. Now attach the other end of the string to your notebook, using a knot. You can tie the string to the spiral binder on your notebook or through one of the three holes punched in the papers.

3. Put this notebook and the clock or watch on top of your television set.

4. Every time you sit down to watch the television, write down your starting and stopping time, as well as the name of the television program you watched. (See Sample Log on page 80.)

5. At the end of one week, add up all the time that you spent watching television.

6. Look back to the list you made in Step 1. How many of these activities could you have done if you had watched less television?

7. Decide to add one of the activities you listed in Step 1 to your plans for next week. How much TV time will you have to cut out of your week? What program(s) could you cut out of your television schedule?

Take Time Out from TV *(cont.)*

Sample Log for TV Activity Notebook

1. What activities/things would I have liked to do last week but didn't.

2. AMOUNT OF TV WATCHED

Start Time	Stop Time	Total TV Time	Names of Shows Watched
4:30 P.M.	5:30 P.M.	1 hour	Gilligan's Island

An Egg-specially Healthy Day

Fancy That It's a Fact!

It's a lot of responsibility to take care of someone else. But it's also a lot of responsibility to take care of yourself and to do the things every day that keep you healthy. It's important to exercise, eat well, stay happy, and keep clean and safe. Once you learn to plan a healthy day for your "child," planning healthy days for yourself will become "egg-stra" easy!

Materials

- one raw egg
- pencil
- colored markers
- small notebook or paper

Let's Do It!

1. For one day, you will be a mom or dad, and the egg will be your child. Give your child a name, and decorate him or her however you want. You might draw a face, hair, or clothes on the egg. Use the colored markers to do the decorating.

2. Make a copy of the Egg Journal on page 84.

3. Plan a healthy and safe day for your child. (Don't break the egg!) Write down healthy activities that you and your child can do together. Here is a suggested plan, but you may make your own.

> **8:00** AM
> Eat a healthy breakfast (cereal, milk, and fruit).
> Brush your teeth (and your egg's).
> **10:00** AM
> Do 20 sit-ups.
> Do somersaults. (Don't break me!)
> **12:00** PM
> Eat a healthy lunch (tuna fish, salad, and water).
>
> **1:00** PM
> Write in journal.
> **3:00** PM
> Do smile exercises.
> **5:00** PM
> Take a bath.
> **6:00** PM
> Eat a healthy dinner (baked chicken, green beans, and a baked potato).

4. Children (and eggs) need lots of attention, and they shouldn't be left alone. This means that your egg should go everywhere with you on this day. Some challenges that might arise are listed on page 82. Write down how you will handle each problem ahead of time so that you can be prepared to respond. Some suggested solutions are provided, but be creative and make up your own, too!

5. Now you are ready for an egg-specially healthy day. Do everything in your plan with your child. When you do somersaults, help your child do them, too. When you eat your cereal, make sure to give some to your child. And after you're done with your bath or shower, give your child a bath in the sink. Make sure your child stays safe for the whole day.

An Egg-specially Healthy Day (cont.)

Problems and Plan of Action

Problem	Plan of Action
How will I carry my egg from place to place?	
What should I do if my egg cracks?	
What should I do if my egg breaks?	
What if I can't take my egg with me somewhere?	
What if my egg doesn't want to do some of the activities I planned?	

An Egg-specially Healthy Day (cont.)

Suggested Solutions

Problem	Plan of Action
How will I carry my egg from place to place?	Find a small bag with a strap. Wrap the egg in cotton, tissue, or something soft. Carry the egg in the bag, but be sure to take it out for fresh air when you get where you are going.
What should I do if my egg cracks?	A crack in your egg is like you having a scrape. Use scotch tape or an adhesive bandage to cover the crack, and be extra careful not to do anything that will make the crack worse.
What should I do if my egg breaks?	Accidents happen. Ask an adult to help you clean up the mess. Next time you have an egg-specially healthy day, plan activities that are less likely to cause the egg to break.
What if I can't take my egg with me someplace?	When your parents go out, what do they do with you? They probably ask someone to take care of you. Ask a friend or a family member to take care of your egg child while you are gone.
What if my egg (or I) doesn't want to do some of the activities I planned?	Plan to do these activities later in the day, or make up another healthy activity to do instead.

An Egg-specially Healthy Day *(cont.)*

Egg Journal

Write the activities you plan to do with your egg child under each time slot, as well as any comments you wish to add about your experience taking care of your egg. Was it easy? Did you have to be careful? Did your egg break?

TIME	ACTIVITY WITH EGG	COMMENTS
8:00 A.M.		
9:00 A.M.		
10:00 A.M.		
11:00 A.M.		
12:00 Noon		
1:00 P.M.		
2:00 P.M.		
3:00 P.M.		
4:00 P.M.		
5:00 P.M.		
6:00 P.M.		

Safety

Safety Scavenger Hunt

Fancy That It's a Fact!

You may be able to escape a visit to the doctor or emergency room if small accidents or injuries are taken care of properly and if the right first aid materials are on hand in a convenient place. This activity helps you to build a first aid kit for you and your family. After assembly, this kit should provide you with the materials needed to deal with small cuts, minor scrapes and burns, rashes, insect bites, etc. Remember, however, that this first aid kit will only help in case of minor problems or injuries. Any major accidents or minor problems that do not get better or go away after a few days should be brought to the attention of a health care professional.

Materials

- empty shoebox
- white and red construction paper
- glue
- scissors
- red marker
- checklist on page 87

Let's Do It!

1. Cover the entire shoebox with white construction paper. Use scissors to cut white paper to the right size for each side of the box, and then glue the pieces onto the shoebox.

2. Now, using the red construction paper, cut out the shape of a medical first-aid cross and glue it to the top of the box.

3. Using a red marker, write the words "First-Aid Kit" beneath the cross on the top of your box.

4. With your parent's help and permission, try to find first-aid and safety items around your house. Use the checklist on page 87 to see if you have the basic ingredients for a good first-aid kit. Check off items that you can find around the house. Make a list of the items that you cannot find, and ask your parents if they will purchase them at the store.

5. After locating all of the items on the scavenger hunt checklist, place them in your newly crafted first aid kit.

6. Ask your parents for a safe and convenient place to store your first aid kit. Make sure that all members of the household know where the first-aid kit will be stored.

Safety Scavenger Hunt (cont.)

Checklist for Basic First Aid Kit

HAVE	NEED TO GET	ITEM
		assorted sizes of adhesive bandages (Band-Aids)
		anti-bacterial ointment
		medical tape
		rubbing alcohol
		soap
		aspirin
		small scissors
		insect bite relief wipes
		first aid cream/burn cream
		assorted sizes of gauze pads
		iodine
		elastic bandage
		anti-itch cream (calamine lotion)
		cotton swabs
		tweezers

Safety Scavenger Hunt (cont.)

First Aid Kit

calamine lotion

iodine

cream for insect bites

aspirin

burn cream

gauze pads

medical tape

safety pins

scissors

adhesive bandages

Emergency Reactions

Fancy That It's a Fact!

Every second counts in an emergency situation. Prepare yourself in advance by practicing what to say and do when you come upon an accident. 911 is an emergency response phone system that should be used in the case of emergency situations only. If you dial 911, your phone number and location are immediately displayed on a screen to a telephone operator. The operator will then ask you several questions about your situation and send someone to help you immediately (police, fire department, poison control center, ambulance, etc.).

Materials

- paper
- markers
- glue
- index cards
- phone book
- scissors

Let's Do It!

1. Photocopy and cut out each of the pictures depicting accidents on pages 90–91, and glue each one to an index card. (If preferred, you may have your students create their own cards with drawings of emergency situations.)

2. Shuffle the index cards so that you do not know their order.

3. With an adult partner, draw one card from the pile.

4. Still with your partner, act out what you would do in the emergency scenario depicted. First decide whether it is best to call 911 or some other responsible adult. Remember that when you make an emergency call, it is important for you to tell your name, the phone number from which you are calling, the exact location of the injured person or emergency, and to clearly and calmly describe what happened. Ask the operator what you should do until help arrives. Do not hang up until the other person on the phone tells you to do so. Your partner should act as if he or she were the person you called.

5. Continue playing the game until you have worked through all of the index cards.

6. Now, think about all of the numbers you could have called in each of the emergencies. Using your local and family phone book, make a list of these important emergency numbers, as well as the phone numbers of friends and relatives who live nearby and may be able to help out in an emergency.

7. Post this list near every phone in your house.

Emergency Reactions (cont.)

Emergency Card Patterns

Girl falling off bike, scraped knee

Grease fire on kitchen stove

Thief breaking into house

Boy falling out of tree house, sprained ankle

Emergency Reactions *(cont.)*

Emergency Card Patterns *(cont.)*

Woman passed out on floor

Man with a large, deep cut on finger from cutting vegetables in kitchen

House with smoke coming out of the upstairs window

Small child crawling on floor with an open bottle of pills spilled on floor nearby

Fire Drill

Fancy That It's a Fact!

Would you know what to do if a fire started in your home in the middle of the night? Fires are scary and confusing. They can be loud and burn very fast, and their smoke can make a room or home very dark. This exercise will help you to protect yourself, your family, and your home from fires by helping you to practice fire drills. Pretend you are the family fire chief, and make sure your family knows what to do and where to meet in case of a fire.

Materials

- paper
- pencil
- calendar
- smoke detectors (and new batteries)

Let's Do It!

A. Preparation for Fire Drill

1. Go through your house and write down the location of all fire detectors. There should be at least one in every bedroom, in the kitchen, at the top of any stairs, and in the attic and/or basement. If one of these rooms does not have a smoke detector, urge your parent to buy and install one as soon as possible.

2. Test all of your family's smoke detectors, using the directions that come with the detector. Listen to the sound of the alarm. Try to remember what it sounds like so that you would recognize it at the time of an emergency. Change the batteries in those detectors that need it. Using a calendar to keep track, pick a time to replace all the batteries at least once a year.

3. Talk with members of your family about what you would do in case of a fire. If there is a fire, try to get out of the house as quickly as possible. Remember to crawl low in heavy smoke.

4. As a group, you and the other members of your household should pick at least two possible escape routes from your house. For example, what would be the quickest exit if you were in your bedroom at night? What if that route was blocked by fire?

5. Now, as a group, pick a meeting place outside of your home and far enough away from a fire to be safe. Agree to meet with other members of your family in this place if you have to escape your house quickly.

6. Write these routes and the decided-upon meeting place on a piece of paper. Copy the routes and meeting place onto pieces of paper for each of your brothers and/or sisters.

7. Post the papers with the escape routes and meeting place on the inside of your bedroom door, as well as on the inside of each family member's bedroom door.

Fire Drill *(cont.)*

B. Doing a Fire Drill

1. Choose one person in your family to be the "fire chief." This person will be responsible for choosing the secret fire drill time and for setting off the alarm.

2. When the alarm goes off, each person in the family should take one of the designated escape routes out of the house and meet at the prearranged meeting place.

3. After meeting, talk with your family members about what went right and what went wrong with the drill. What could each of you have done differently to make the escape better?

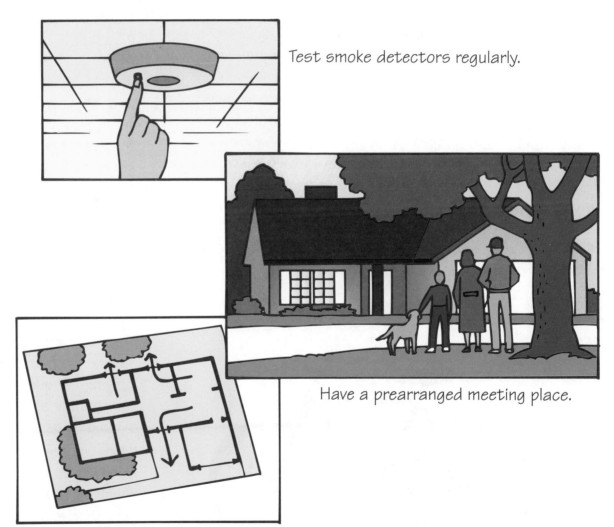

Test smoke detectors regularly.

Have a prearranged meeting place.

Prepare escape routes.

Bike Safety Party

Fancy That It's a Fact!

When you ride your bike, you are taking on a lot of responsibility. You are responsible for your safety when you ride. Cars will not always watch out for you, so you need to watch out for them. Also, you need to make sure that your bike has all of the necessary safety equipment and that it is in good shape. Don't ever ride anywhere without your bike helmet. In many places, it is illegal for children to ride bikes without a helmet. Is there such a law in your town?

Materials

- index cards
- colored markers
- tape

Let's Do It!

1. With a parent, arrange a convenient time and place for your bike safety party.

2. Use the index cards to make invitations for your friends to come to a bicycle safety party. Use as many index cards as you have friends you would like to invite. On the front side of the invitation, write the following: "You are invited to a kids-only bicycle safety check." On the other side of each invitation, write the time and place that you plan to do the safety check. Remember to tell them to bring their bikes and helmets. Deliver your invitations.

3. On the day of your bike safety party, use the safety checklist on page 96 to examine your friends' bikes. Let each person know what he or she is missing and urge them to correct this. You can either photocopy our sample bike safety checklist or make your own by copying our questions onto notebook paper. Also, teach your friends about the rules on page 95 and the turn signals on page 96.

4. When you are done checking each person's bike, tape the checklist to the bike's handlebars. Have each person check his or her list. If there is a "No" on their list, have your friends ask their parents to help them fix the problem or to take their bike to a bicycle repair shop.

Bike Safety Party *(cont.)*

Rules of the Road

· **Obey same rules as traffic:**
- Ride on right side or the road.
- Ride in single file with traffic, not against it.

• Keep a safe distance from any vehicles ahead of you on the road.
• Never "hitch" on cars.
• Walk your bike across the street.

• Wear a helmet at all times.
• Wear bright clothing in the daytime.
• Wear reflecting clothing at night.

Bike Safety Party *(cont.)*

Safety Checklist

My bicycle has the following:	Yes	No
1. a clear front reflector.		
2. a red rear reflector.		
3. one clear and one red side reflector on rear wheel.		
4. one clear and one orange side reflector on front wheel.		
5. pedal reflectors.		
6. horn or bell.		
7. properly adjusted brakes.		
8. properly adjusted gears.		
9. properly adjusted seat.		
10. securely attached handlebars.		
11. front light visible for 500 feet (for night riding).		

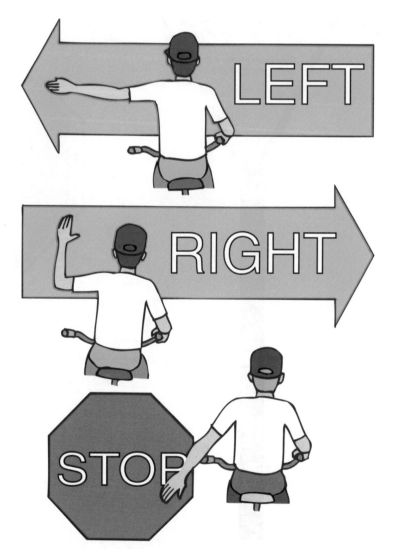

Sports Safety Magazine

Fancy That It's a Fact!

Although playing sports can be a lot of fun, it can also be dangerous if we do not use the right equipment. It is important to remember to use protective gear, like a helmet when riding a bike or wrist pads when roller blading. Painful bone breaks or bruises can often be avoided. Get into the habit of wearing the right gear for each sport.

Materials

- construction paper
- stapler
- scissors
- glue
- old magazines (sports-related, if possible)
- colored crayons or markers

Let's Do It!

1. Make a magazine of your own out of construction paper and staples. Put together five pages of construction paper and staple them together on the left side so you can flip through the pages like a magazine.

2. Decorate the cover of your magazine with your crayons or markers. Invent a title for your sports-safety magazine and write it on your cover.

3. On the top of each page, write the names of different sports or exercise activities that you think are fun. For example, on one page of your book you could write "Swimming," while on another you might write "Jogging" or "Bike Riding."

4. Go through old magazines and cut out pictures of people doing each of the sports and/or exercise activities you chose.

5. Glue the pictures you chose on the appropriate pages of your magazine. For example, glue pictures of people riding bikes on your bike-riding page.

6. Look through all of the pictures you have glued in your book. With a marker or crayon, draw a heart around all of the appropriate equipment and protective gear being used.

7. Now look through all of the pictures in your book again. With a different colored crayon or marker, draw squares around the pictures of people playing sports or exercising without proper gear. For example, draw squares around people skateboarding or roller blading without helmets or pads.

8. In each of the pictures, either draw in the appropriate gear or write the names of the missing pieces of gear under the square.

Feeling Good

Emotional Journey Journal

Fancy That It's a Fact!

People have lots of feelings, especially young people who are growing up and are going through a lot of changes. What goes on in our minds can have an effect on all parts of our lives. If we are unhappy, we might not feel like doing fun things or spending time with friends. If we are angry all the time, we might have trouble communicating with our friends and family, and we may get into a lot of unnecessary arguments. Remember, it's natural to feel bad once in a while, but sometimes it gets to be too much. One way to try to increase your good feelings and decrease your bad feelings is to identify what causes those feelings. Keeping a journal is a good way to keep track of your thoughts, feelings, and coping strategies (how we deal with different situations).

Materials

- notebook
- pen or pencil

Let's Do It!

1. Make a seven-day log out of your notebook. Each day should have its own page, with the day, date, and two columns—one for good feelings and one for bad feelings. See the Sample Journal Page (page 101). The eighth page will be your weekly summary. (See sample on page 102.)

2. Each time you experience a feeling, write a sentence or two about it. For example, if you are feeling angry, write what made you angry, who made you angry if someone else was involved, what finally made the anger go away, and anything else you think is important. Sometimes you might feel more than one emotion at the same time, and you should write this down, too.

Emotional Journey Journal *(cont.)*

3. At the end of the week, look back through your journal and answer the following questions on page 8 (your weekly summary):

 a. How many times during the week did you feel good feelings (happiness, excitement, love, compassion)? How many times did you feel bad feelings (anger, fear, sadness, confusion, discouragement, hurt, stress)? If you continue to make journal entries for more than a week, compare these numbers each week. Are you feeling more good feelings and fewer bad feelings as time goes by?

 b. Pick three situations that made you feel bad. Circle them on the journal pages where you wrote about them. How could you have made lemonade out of the lemons?

In other words, how could you have looked at the situations in a way that might have produced good feelings instead? For example, you may have felt discouraged because you didn't understand a math problem right away at school. However, if you had looked at the math problem as a challenge to be overcome by working hard and being persistent (even if you didn't get it right the first time), you might have felt excitement instead.

 c. Was there any thing or any person that consistently made you feel bad? Think about why these people or things make you feel badly. Make a plan to try to change the situations that make you feel this way. Using the math example again, if on several days you had trouble in math and felt discouraged and confused, plan to talk to your teacher after school. Explain that you are having trouble and ask him or her how you might get some extra help.

 d. Was there any person or thing that consistently made you feel good? Think about why these people or things make you feel good. Make a pledge to do the things that make you feel good whenever you can, and set aside time to spend with people who make you feel good as often as possible.

Emotional Journey Journal *(cont.)*

Sample Journal Page

Day:_____

Date:_____

Good Feelings	**Bad Feelings**

Good Feelings

I felt happy when my mom kissed me before I went to school.

I felt excited when the teacher told us we would see a movie after lunch.

2 Good Feelings

Bad Feelings

I felt hurt and angry when Johnny called me a bad name at school. I ignored him and felt better after a while.

I felt discouraged when I kept falling off the new bike that I got for my birthday.

3 Bad Feelings

Emotional Journey Journal *(cont.)*

Sample Weekly Summary

Number of Good Feelings: 10

Number of Bad Feelings: 12

Making Lemonade from Lemons:

1. When Johnny called me a bad name, I could have reminded myself that he's just being mean because someone was mean to him first. It's not his fault.

2. Even though I fell off my new bike a lot this week, I should keep practicing. Soon I'll be able to ride without falling and maybe even be able to do a few tricks!

Feeling Bad

I don't like to play with Johnny because he is mean to me. Instead, I will play with Michael at recess. If I do play with Johnny, I will try to be really nice to him so he will be nice back.

Feeling Good

I like to play baseball with my dad. I will ask him if we can play every Saturday.

Laugh It Up

Fancy That It's a Fact!

Laughter is good medicine for bad moods. Not only does it feel good to laugh yourself, but it's also a lot of fun to make other people laugh. Sometimes when you're feeling blue, a smile or a laugh can pick you up, especially when you're surrounded by people who care about you. When you or your family are having hard times, laughter can help to improve everyone's mood.

Materials

- scissors
- roll of thin ribbon

Let's Do It!

1. For each member of your family, cut five 18-inch (48 cm) pieces of ribbon.
2. Tie the ends of each ribbon together so they make "necklaces."
3. Pick a time when you and your family are all at home together and play the ribbon game!

Rules of the Game

1. Give each family member, including yourself, five ribbons to place around his or her neck.

2. Decide how long the game will last (e.g., 20 minutes). Decide how long each person's turn will be (e.g., 1 minute).

3. The goal of the game is to try to make each other laugh, so sit in a circle and take turns trying to make the others in the family laugh. Make each other laugh by telling funny stories, by making funny faces, or by doing other funny things. Tickling is not allowed.

4. Each time a person makes someone else laugh, the one laughing has to give a ribbon to the one who made him or her laugh. For example, if you make your sister laugh, she should give you a ribbon, or if you make your whole family laugh, they must each give you a ribbon. Tell jokes, make funny faces, do imitations, and most importantly, use your imagination!

5. If a person runs out of ribbons before the game is over, he or she can still play and should try to earn ribbons back by making other people laugh.

6. There are two ways to win. When time is up, the person with the most ribbons wins! Or, if someone has all the ribbons before time is up, that person is the winner!

Pocket Full of Smiles

Fancy That It's a Fact!

Even the happiest of us feel bad about ourselves sometimes. If we have a bad day, someone says something mean to us, or we don't accomplish something we wanted to do the first time around, it can be very frustrating. If you say nice things about yourself in your head, you can overcome these bad feelings, especially if you know that others think these nice things about you, too.

Materials

- paper
- colored paper
- pencil
- scissors

Let's Do It!

1. Sit down with the members of your household. Ask each person to write at least one thing that they like about every other person. You should participate as well. Collect all of the papers.

2. Make a list for each person of all the nice things that the others said about him or her. Be sure to put each person's name at the top of the list belonging to that person. You can write the lists by hand or type the lists and print them. Use colored paper. Write or type the lists so that they are about the size of a playing card, and then cut them out.

3. (optional) Take the lists to a local copy store and have them laminated.

4. Sit down with your household members and pass out the cards. Ask each person to read the nice things that the others said about him or her.

5. Have everyone keep their cards in their pocket, wallet, purse, or backpack. Whenever someone is feeling blue, he or she can pull out the list and remember how great he or she really is!

Fun with Limericks

Fancy That It's a Fact!

When boredom strikes, creativity can come to the rescue! Writing funny poetry allows us to express ourselves and makes us feel happy. If you share your fun and laughter with your family and friends, everyone's day will be brightened.

Materials

- paper
- pencil

Let's Do It!

1. Choose a humorous or happy topic for your limerick. For example, think of something funny one of your family members does, something silly that you did once, a hilarious habit that your pet has, or a fun time you had with one of your friends. If you want, make up a wild story and turn it into a limerick.

2. Now write your limerick! The rules for how to write limericks are provided here. (Also, see the sample limericks on page 107.)

3. Share your limerick with your family and friends for fun and laughs.

Rules for Writing Limericks

1. A limerick has five lines.

2. The rhyme scheme is AABBA. This means that lines 1, 2, and 5 (all As) have to rhyme with each other and lines 3 and 4 (both Bs) have to rhyme with each other.

3. The A lines (1, 2, and 5) have eight or nine syllables each, and the B lines (3 and 4) have five or six syllables each.

Fun with Limericks *(cont.)*

Tips for Writing Limericks

1. Before starting, make two lists of words that rhyme. Pick three words from one list to use in lines 1, 2, and 5, and pick two words from the other list to use in lines 3 and 4.

2. If you are having trouble, try thinking of a different way to say something. For example, if line 3 of your limerick says, "I fell down the stairs" but you can't think of anything that rhymes with stairs, you might change the line to say, "Down the stairs I fell."

3. Sometimes it is easier and more fun to write limericks with other people. Ask a friend or a family member to help you.

4. For practice, we have given you some unfinished limericks to complete (on page 108). Work on these before starting your own.

I fell down the stairs,

Stairs Fell Bell
Chairs Well Sell
Bears Tell Smell
Pairs Yell

Fun with Limericks *(cont.)*
Sample Finished Limericks

Funny topic: My dog can't roll over.

There once was a dog named Roofus,

He really was kind of a doofus,

 "Roll over!" I said,

 But he played dead!

I think I'll rename him Goofus.

Funny topic: My dad couldn't blow out all the candles on his birthday cake.

I made a birthday cake for my dad,

He's no longer a very young lad,

 "I'll blow out one candle,

 That I can handle,

But forty? I think you've gone mad!"

Funny topic: My sister is good at making funny faces.

My sister calls herself Millie,

I think she is very silly,

 She sticks out her tongue,

 And when she's all done,

She runs around willy nilly!

Funny topic: I put my shirt on inside out.

Yesterday I rolled out of bed,

I still had a very sleepy head,

 I put on my shirt,

 With Ernie and Bert,

"You're shirt's inside out!" my mom said.

Fun with Limericks *(cont.)*

Sample Unfinished Limericks for Practice

1. In my backyard I climbed a tree,
 But I fell down and scraped my _____.

 My mom came to help,

 I let out a _____

 When I saw that the scrape was so
 _____!

2. My favorite food is the bean,
 I like best the kind that is _____

 I eat them for lunch,

 Because I like to _____

 I like to share them with my friend _____.

3. On the ground I found a nickel,
 I went to go buy me a pickle.

 _____,

 That joke it sure gave me a tickle.

4. _____

 His name was Michael,

 He liked to cycle,

 _____.

Suggested Answers for Unfinished Limericks

1. Knee, yelp, wee
2. Green, munch, Jean
3. The salesperson there, Tried to sell me a pear.
4. A friend of mine has a pet bear. He's covered with thick, dark black hair, And he loved to perform at the fair.

Well Wishes

Fancy That It's a Fact!

When people get sick or are not feeling well, they often appreciate a little sympathy and kindness from their friends and family. It almost always makes us feel better just knowing that other people care and are thinking about us. Make a "Get Well" card for a sick or injured friend or family member. Not only will it bring a smile to his or her face, but doing something nice for someone else will also make you feel good!

Materials

- crayons
- colored construction paper
- markers
- scissors
- glue
- old magazines

Let's Do It!

1. Fold a piece of construction paper in half widthwise to make a card.

2. On the cover of your card, write a greeting to your sick or injured friend. See suggestions on page 110. If you like, glue pictures that you have cut from old magazines to the front of your card.

3. On the inside of your card, share your tips for getting better. Across the top of the inside of the card, write, "When I feel sick, these are the things that make me feel better" Then decorate the card with pictures of those things that make you feel better. You can either draw pictures with crayons or markers, or you can glue pictures that you have cut out of old magazines.

4. On the bottom of your card, or on the back page if there is no more room on the inside, write, "I hope that these things will also make you feel better."

5. When you are finished creating the card, talk to a parent or other adult about how to best deliver it to the person for whom you made it. You may be able to deliver the card in person, or you may need to mail it.

Well Wishes *(cont.)*

Suggestions for Special "Get Well" Messages for Front of Card

- Feeling sick? Get well quick!

- I heard you were under the weather. Hope this card brings some sunshine to your day!

- Turn that frown upside down, and get well soon.

- [Your Name]'s Quick and Easy "Get Well" Guide

- Open up for something even better than chicken soup.

- Sing a tune, and you'll get better soon!

- Roses are red; violets are blue. Here's a special "Get Well" message just for you!

- Being sick is a real drag. Hope this card helps you drag out a smile.

- Friendship is the best medicine.

- I'll give you a hug to get rid of that bug!

Jill's Quick and Easy Get Well Guide

Dealing with Anger

Fancy That It's a Fact!

When you get angry, how long do you feel that way? Did you know that you have the power to make your anger go away? It's no fun to stew and fume all day when something bad happens. You can learn to control your anger and put yourself in a better mood. It just takes a little practice.

Materials

- large empty jar or small box
- index cards
- pencil

Let's Do It!

1. The jar or box will be your very own anger-management container. Label the jar or box with a name you invent, such as "Jane's Just-Cool-Off Jar" or "Dana's Down-With-Anger Box."

2. On each index card, write something you can do to control, reduce, or take a break from your anger. Make as many cards as you like.

3. Whenever you feel angry or stressed, instead of yelling or getting upset, go to the jar and pull out an index card. Do what it says on the card to help you relax.

Suggestions for Taking a Break from Anger

- Count to ten.

- Take several deep breaths with my eyes closed.

- Tense all the muscles in my body for five seconds and then relax them completely. Do this several times.

- Take a bath or a shower.

- Take a walk.

- Read a book.

- Write a letter or call a friend.

- Talk with an adult I trust about why I am angry.

- Write in my journal.

- Draw a picture.

- Close my eyes and imagine that I am lying on a cloud or on the beach on a sunny day.

Holiday Health

All Occasion: Mother's Day, Father's Day, Birthday, Any Day

Fancy That It's a Fact!

Any day can be a holiday when you show people that you care about them. Giving little gifts or doing special things can turn any day into a special one. When the special things are good for you, your occasion will not only be happy, but also healthy.

Materials

- colored construction paper
- colored markers
- hole punch
- yarn or ribbon

Let's Do It!

1. Cut each piece of construction paper in half, so that you have several pieces that are 8 inches (20 cm) long and about $5\frac{1}{2}$ inches (14 cm) wide. These will be your coupons. (You can also copy the blank coupon provided on page 115 onto white or colored paper.)

2. On each piece of paper, write, "This coupon is good for. . . ." Underneath, write something for which your mom, dad, or other special person can exchange the coupon. (See sample finished coupon on page 114, or use the pattern on page 114 as a model.) Try to

think of things that will help them stay healthy and happy. Some ideas are provided below. Decorate each coupon with markers.

3. Punch a hole in the top left corner of each coupon. Arrange the coupons in a booklet. Tie them together with a piece of yarn or ribbon.

4. Give your coupon booklet to your mom on Mother's Day, your dad on Father's Day, or to another special someone on his or her birthday.

Suggestions for Coupons

- One healthy breakfast in bed
- One shoulder massage after a long, hard day
- One afternoon walk with me
- One nature walk with me
- One day of playing in the park with me
- One household safety check, done by me
- One exercise class, led by me
- A hug and a kiss

All Occasion: Mother's Day, Father's Day, Birthday, Any Day *(cont.)*

Sample Coupon

Mom

Mom

This coupon is good for
1 low-fat breakfast in bed,
prepared by Janie.

Happy Mother's Day!

114

All Occasion: Mother's Day, Father's Day, Birthday, Any Day *(cont.)*

Coupon Pattern

This coupon is good for

_____.

Give a Little Love on Valentine's Day

Fancy That It's a Fact!

There will probably be lots of cookies and candy to eat on Valentine's Day. Help your friends and family avoid eating too many sweets by sharing your healthy recipe ideas with them.

Materials

- red or pink construction paper
- glue
- scissors
- colored markers
- glitter, lace, or other decorations for making Valentine's cards
- healthy snack recipe (See page 37–40 for ideas.)

Let's Do It!

1. Using the pattern on page 117, draw a heart on red or pink construction paper. Cut it out. This will be your Valentine's card.

2. Decorate one side of the heart any way you like. Write a friendly Valentine message or poem that shows you care about the person's health. At the bottom of the card, write, "Turn over for a heart-healthy Valentine's recipe."

3. Type a healthy snack recipe (See Nutrition section for ideas.) on a word processor, or write it on a piece of white paper. Cut it out and glue it onto the back of your Valentine.

4. Make lots of these for your family and friends!

Healthy Valentine's Messages

Roses are red
Violets are blue
Eating food that's healthy
is good for you.

Candy and cookies are good for a while.
They usually can even make you smile.
But I'd like to share a little secret with you:
There are snacks that are healthier, and they taste better, too!

Give a Little Love on Valentine's Day (cont.)

Card Pattern

To: _____

From: _____

Will you be my Valentine?

Turn this card over for a heart-healthy Valentine's Day recipe.

Eggs-tra Special Easter Recipes

Fancy That It's a Fact!

Egg yolks have a lot of cholesterol, which can lead to heart disease, but not as much as we once thought. Now we know that you can actually eat up to four egg yolks a week and as many egg whites as you want. So enjoy your Easter eggs. They're good for you! Remember to get help from an adult to make these. Each of these recipes serves four people.

Angeled Eggs

Ingredients

- 4 hard-boiled eggs
- 2 tbsp. (30 mL) low-fat mayonnaise
- dash of paprika
- small white onion and/or low- or reduced-fat white cheese (cheddar, Swiss, or American)

Utensils

- plate
- bowl
- measuring spoons
- knife
- fork

Directions

1. Peel shells from hard-boiled eggs and discard shells.
2. Slice eggs in half lengthwise and remove yolk. Put yolks in a bowl and place egg whites on a plate.
3. Add mayonnaise to the bowl with yolks. Mash with a fork until all egg yolks are coated with mayonnaise.
4. Spoon egg yolk mixture into the hollow of each egg white.
5. Sprinkle eggs with paprika.
6. Slice onion into rings, or halos. (This is what makes them "angeled" eggs instead of "deviled" eggs.)
7. If you don't like onions, you can make the halos out of cheese, or you can have both onion and cheese halos. Slice cheese into circular pieces. Cut out centers so they look like halos. Store extra cheese bits to eat another time.
8. Arrange eggs on a plate. Garnish with onion and/or cheese halos.

Eggs-tra Special Easter Recipes (cont.)

Eggs-ellent Salad

Ingredients

- 8 hard-boiled eggs
- ½ cup (120 mL) low-fat mayonnaise
- 1 small onion
- 2 stalks celery
- ½ tsp. (2.5 mL) salt
- ⅛ tsp. (.5 mL) pepper

Utensils

- mixing bowl
- measuring spoons
- fork
- knife

Directions

1. Peel shells from hard-boiled eggs and discard shells.
2. Chop eggs (whites and yolks), onion, and celery into small pieces. Place them all together in a mixing bowl.
3. Add mayonnaise to bowl. Mash with a fork until egg mixture is coated with mayonnaise.
4. Mix in salt and pepper, and stir.
5. Serve alone, or make egg salad sandwiches.

Toasted Egg Sandwiches

Ingredients

- 4 hard-boiled eggs
- 8 slices of wheat bread
- 8 tsp. (40mL) low-fat margarine
- dash of salt
- dash of pepper

Utensils

- knife
- 4 plates

Directions

1. Peel shells from eggs and discard shells.
2. Toast bread. Place two slices on each plate.
3. Warm eggs slightly in microwave (15 seconds) or oven (2 minutes).
4. Slice each egg lengthwise into five thin slices.
5. Spread 1 tsp. (5 mL) of margarine on one side of each piece of toast.
6. Place the egg slices on top of the buttered side of four of the toast slices. Sprinkle eggs with dashes of salt and pepper. Lay the other four slices of toast on top of the eggs.

Lotsa Matzo Recipes for Passover

Fancy That It's a Fact!

Matzo is a delicious nonfat, low-sodium food that is high in carbohydrates, which your body needs. It makes a great snack, either by itself or combined with other good foods such as fruit, vegetables, chicken, or fish.

Trail Mix

Ingredients

- matzo
- dried fruit (cranberries, apricots, cherries, apples, banana chips, etc.)

Utensils

- bowl
- large spoon

Directions

1. Place dried fruit in a bowl.
2. Crumble matzo on top to add some crunch (instead of nuts and sunflower seeds, which are high in fat).
3. Toss fruit and matzo with a large spoon.

Matzo House

Ingredients

- matzo
- peanut butter
- raisins

Utensils

- butter knife
- plate

Directions

1. On a plate, take one piece of matzo and decorate it like the front of a house. For example, use raisins to make the outline of a door on the matzo. Use peanut butter to stick the raisins on the matzo.
2. Spread a thin layer of peanut butter on the outside edges of four pieces of matzo. Include the piece you have already decorated as one of the four.
3. Now, build a house using your matzo pieces, with the peanut butter as glue. Stand the pieces upright to make a box.
4. Lay another piece of matzo on top for a roof.
5. Display your healthy matzo house, and then enjoy eating it as a good-for-you Passover (or anytime) snack!

Give Your Teeth a Break on Halloween

Fancy That It's a Fact!

It's always important to brush your teeth and floss, but it's especially important at Halloween time when you are eating a lot of candy. Sugar can cause cavities, and brushing can help to prevent them.

Materials

- candy (enough for trick-or-treaters)
- dental floss, toothbrushes, or small tubes of toothpaste (enough for trick-or-treaters — either purchase them at the store or ask your dentist for samples)
- black and orange ribbon
- plain white paper, 8 ½ X 11 inches (21.5 x 28 cm)
- hole punch
- pencil
- thin black and colored markers

Let's Do It!

1. With a pencil, draw a line lengthwise down the center of the white paper. Then draw three lines across the width of the paper so that it is now divided into eight sections. Cut along the lines so that you have eight pieces of paper.

2. In each section, write a healthy Halloween message with a black marker (or use one of the samples below). Decorate each message with colored markers. Use the hole punch to make a hole at the top of the paper.

3. Cut several pieces of black and orange ribbon, each about 12 inches (30.5 cm) long. Put a black and an orange ribbon together, and thread the ribbons through the hole of your Halloween message. Use the ribbon to tie together a piece of candy and a toothbrush, tube of toothpaste, or dental floss.

4. Hand out your special Halloween treats to trick-or-treaters.

Suggestions for Healthy Halloween Messages

- Take care of your fangs this Halloween!
- Candy is dandy, but don't forget to brush/floss!
- After your chocolate, have a mint . . . mint toothpaste, that is!
- Keep away the cavity monsters this Halloween. Remember to brush/floss!

Take care of your fangs!

A Thanksgiving to Remember

Fancy That It's a Fact!

Thanksgiving is an especially good time to remember all of the people and things in your life that make you happy. Sharing your thanks with your friends and family will bring a warm, happy feeling to the dinner table. Whenever you are feeling blue, remember all of the wonderful things there are to be thankful for and let these thoughts put a smile on your face.

Materials

- brown and orange construction paper
- colored markers
- lined paper
- pen
- scissors

Come Celebrate and Give Thanks!

Let's Do It!

1. Trace your hand onto a piece of brown construction paper and cut out the outline.

2. Decorate your paper hand so that it looks like a turkey. Make a wattle (for its chin) and legs with the orange construction paper; draw feathers and eyes with markers. Make one for each person that will be at your Thanksgiving dinner.

3. On the back of each turkey, write an invitation for the dinner. Ask each person to prepare a short paragraph about what they are thankful for. Try to deliver the invitations at least one week before the dinner so that each person has enough time to prepare.

4. Write your own paragraph about what you are thankful for. Think about your friends, your family, your health, your accomplishments, your opportunities, and all of the things in your life that are special to you.

5. At Thanksgiving dinner, go around the table and invite each person to read his or her paragraph.

The Dreidel Game

Fancy That It's a Fact!

Holiday games can be a lot of fun, especially when you feed your body healthy snacks instead of cookies and candy. The more nutritious your snacks, the more energy you'll have to keep on playing.

Materials

- ruler
- pencil
- scissors
- colored markers
- drinking straw
- glue or tape
- raisins, nuts, and dried fruit
- poster board or other thick paper

Let's Do It!

1. Trace the dreidel pattern on page 124, or photocopy the pattern. Cut out the pattern and place it on the poster board. Trace the outline of the dreidel pattern onto the poster board. Draw in lines to make folds with a ruler. Draw the Hebrew letters with a marker.
2. Cut out the dreidel shape from the poster board. Cut a small hole in the top flap (number). Fold along the lines, and glue or tape the flaps with the matching numbers together. Let your dreidel dry.
3. Cut a piece of straw about 4 inches (10 cm) long. Slide the straw into the hole in the top of the dreidel. Secure it with tape. Play the dreidel game!

Rules of the Game

1. Put the food in a bowl. Give each player 25 pieces of food. Leave the rest for healthy snacking while you are playing. Each player then puts one piece of food in the center of the table. This is called the pot.
2. The first person spins the dreidel. What he or she should do depends on which Hebrew letter comes up:

Nun נ = nothing. The person who spun receives none of the pot.

Gimel ג = the whole thing. The person who spun wins everything in the pot.

Hey ה = half. The person who spun gets half of the pot.

Shin ש = put. The person who spun must count how many pieces of food are in the pot and must then add that many pieces to the pot.

4. After each spin, each person must put one piece of food in the pot before the next player takes a turn.
5. The game continues until one person wins all of the food. If a person runs out of food, he or she is out of the game.

The Dreidel Game *(cont.)*

Dreidel Pattern

Have A Cherry Christmas

Fancy That It's a Fact!

It's very easy to eat lots of cookies and candy during the holidays, but don't forget that healthy snacks can be delicious, too. They also make great holiday decorations!

Materials

- needle and thread
- dried cherries (or cranberries)
- popped popcorn (no butter or salt)

Let's Do It!

1. Cut a piece of thread about 6 feet (1.8 m) long (or longer). Thread the needle. Bring the two loose ends of the thread together at the bottom and tie them together in a knot. The thread should now be at least 3 feet (.9 m) long.

2. String the cherries and popcorn on the thread in any pattern you like. You might try one cherry followed by one piece of popcorn, three cherries and then three pieces of popcorn, one cherry and then three pieces of popcorn, or any other pattern.

3. Make as many strands as you want, and then decorate your tree! Don't forget to eat some of the popcorn and cherries while you are decorating. They are healthy holiday snacks.

Recycle or reuse your wrapping paper.

When you are not in the room, don't forget to turn off your Christmas tree lights to prevent a fire.

When baking holiday goodies, use lower-fat ingredients—skim milk instead of whole milk, low-fat margarine instead of butter, and applesauce instead of butter.

Environmental Health

Sherlock "Homes"

Fancy That It's a Fact!

Many common household and garden products can be dangerous if used improperly. Such items are called toxins or poisons since they may cause injury, illness, or death if not used according to their specific directions. Some common household toxins include paint, paint thinner and solvent, garden chemicals, batteries, pest control supplies, and detergents. Although laundry detergent is very helpful in cleaning our clothes, it can make us very sick if swallowed. Other items, such as window cleaner or bleach, will burn if left on your skin. It is important to know which of the items in your home are potentially dangerous. This activity will not only help you identify toxic and poisonous products in your home, but it will also help you to know what to do in case of an emergency involving these products.

Materials

- colored marker
- scissors
- phone book
- pencil
- glue or tape
- writing paper
- colored construction paper

Let's Do It!

1. Make ten photocopies or tracings of the Yuck Face Pattern on page 128. Glue or tape the faces onto colored construction paper. Using scissors, cut out each of the faces.

2. With the help of an adult, walk around your house and look for toxic substances named on the list on page 128, as well as anything else which might be poisonous.

3. Glue or tape one of your yuck faces to each substance you find. This unhappy face will remind you and other members of the family to be very careful with these products and that they are dangerous.

4. Now talk with an adult about what you would do if you (or someone you knew) were hurt by a toxic or poisonous product. What would you do if someone swallowed a toxin or had poison spilled on his or her skin or eyes?

5. After talking with an adult, use paper, markers, and glue to post telephone numbers next to the household phone of people to call for help if you or someone in your house is hurt by toxins.

Sherlock "Homes" *(cont.)*

List of Toxic Household Items

- paint
- paint thinner
- window cleaner
- laundry detergent
- bleach
- ammonia
- batteries
- garden supplies
- insect repellent
- bathroom cleaners
- wood polish
- pesticides
- fertilizers
- plant food
- silver polish
- glues
- nail polish and remover

Yuck Face Pattern

Food Map

Fancy That It's a Fact!

The ways food gets to our table is a very complicated process. Many people are involved along the way, and food is often moved a very long distance before reaching your house to be cooked into a delicious dinner. Someone has to grow the food, harvest or butcher the food, and transport the food. The food must be packaged and transported to the store. Then another person must unload the truck and stock the shelves in the store. Finally, someone goes to the store, buys the food, brings it home, and prepares and/or cooks it.

Materials

- crayons
- notebook paper
- white construction paper or poster board
- glue
- scissors
- pencil
- old magazines

Let's Do It!

1. Draw a picture of your favorite food or cut a picture of it out of a magazine and glue it to the top left corner of the construction paper or poster board. This is the end of your food map.

2. Think about all of the steps that must happen before you can eat that food. How did the food get to your house? Who brought it home? Where did that person get the food (store, garden, farm)? How did it get to the store? Where was it before that? (See the Sample Map on page 130.)

3. On a sheet of paper, write a story about how you think the food got to your table. You can make up your own story, or do some research at the library or on the Internet about where your food comes from and how it gets to the store. The Resource List (pages 156–160) may be helpful.

4. Using the story you wrote, make a food map on the construction paper. Start in the bottom left corner. In your story, where did the food begin? Draw a picture of where the food began, or cut one out of a magazine. Glue it in the bottom left corner. Draw an arrow pointing to the right. What is the next step in your story? Draw or cut out another picture. Continue this food map until your favorite food arrives on your table at home (your picture on the top left).

5. Glue your written story to the back of your food map. Share your food map with friends and family! Tell them about all of the steps that the food has taken to get to your table.

Food Map (cont.)

Sample Map

Water, Water Everywhere

Fancy That It's a Fact!

Many people think that water is everywhere and that there will always be enough water for all of the people, plants, and animals in the world to survive. But this is not true. Not only is the total amount of water available on earth getting smaller, but the amount of water available on earth that is clean enough to drink is also shrinking drastically. Each day more and more water sources (streams, lakes, natural springs, etc.) are polluted and made unfit to drink. When water is polluted, it must go through a costly cleanup process before it can be used by humans. It is important that we take an active part in saving the clean water that still exists. Two important ways in which we can help are *conservation* and *protection*. To *conserve* water means that we should not waste it and that we should use as little as possible in our daily routine. To *protect* water means that we should help to prevent water sources from being polluted.

Materials

- pencil
- scrap paper
- glue
- old magazines
- scissors
- white construction paper or poster board

Let's Do It!

1. Make a list of all of the places where water can be found. Water can come from both natural and artificial (or man-made) sources. For example, a stream is a natural part of the environment, while a kitchen faucet is man-made source of drinkable water. Go through your list and circle the natural water sources.
2. Go through old magazines and cut out all of the pictures of water that you can find (examples: waterfalls, lakes, oceans, water in drinking glasses).
3. Draw a line dividing your construction paper or poster board in half lengthwise. Now, glue all of your pictures of water in a collage on the bottom half of your paper. This represents the ocean.
4. What causes water pollution? Go through the old magazines again, cutting out pictures of activities or things that may pollute water (examples: factories, garbage, cars, boats).
5. Glue all of the pictures of potential water pollutants in a collage on the top half of your paper.
6. Make a title for your poster that explains the importance of protecting water from pollution. Use the information from Fancy That It's A Fact! and the resources in the bibliography at the end of this book to help you. Display your poster where others can see it.

Get a Hold on Mold

Fancy That It's a Fact!

Microorganisms are tiny plants and animals—often so small that we cannot see them. Sometimes, however, if a large number of microorganisms are together in one place, we can see them. Microorganisms live, grow, and reproduce all around us. They can be both good and bad for our health, depending on the type of microorganism and the place that it is found. For example, mold found on old or rotten foods in our homes is not good for us, while other molds, such as those in the medicine called *penicillin*, help to make us well when we are sick. This exercise will teach you about mold growth and how to best store foods so that they do not get moldy.

Materials

- 6 small glass jars or containers with lids
- tape
- 3 pieces of bread
- boiling water
- pot holders
- refrigerator
- pencil
- calendar
- paper
- scissors

Let's Do It!

1. Ask an adult to help you boil some water and sterilize three of the six glass jars or containers. Do not do this without the help of an adult. To sterilize jars, make sure they are totally covered with boiling water for at least two minutes. Use pot holders when handling the hot jars. Do not sterilize the other three jars.

2. Let each of the three, newly sterilized jars dry completely before moving on to the next step. Do not dry the jars with a towel. Instead, allow them to air dry.

Get a Hold on Mold *(cont.)*

3. Cut out the pre-made lables on page 134 or use them as examples and make your own.

4. After all of the jars are dry, tape on your labels. Don't forget to write today's date on each label. Be sure to attach the correct labels to the correct containers. It is important that only those containers that you sterilized are marked "sterile."

5. Now, place half of a piece of bread in each of the six jars. Put on their lids, sealing container with tape by taping around the lid.

6. Put the jars in the locations marked on their labels. For example, the two jars labeled "refrigerator" should go in your family's refrigerator. The two marked "sunshine" should be put on a sunny windowsill, while the two marked "room temperature" can be left in your room or in any other convenient place in your home.

7. Use the calendar on page 135 to mark the date of two weeks from today.

8. After waiting two weeks, pull all jars from their storage places and examine the pieces of bread. Compare the jars. What do you see? Do you notice a difference in mold growth among the jars? Which jar seems to have the most mold? Which jar has the least? Jars left in the refrigerator, in sunlight, and in sterile jars should have little or no mold growth. Jars not sterilized and jars left at room temperature should have abundant mold growth.

9. With an adult, discuss what this means for food storage in your home. Would it be best to store food in sterilized or non-sterilized containers? Would it be best to store foods in the refrigerator or at room temperature?

10. When you are done examining and talking about the jars, ask a parent to help you rinse them out with water. Do not re-use the jars; recycle them instead.

Get a Hold on Mold (cont.)

Jar Labels

Jar 1: refrigerator —
sterile

Today's date_____

Jar 2: refrigerator —
not sterile

Today's date_____

Jar 3: sunshine — sterile

Today's date_____

Jar 4: sunshine —
not sterile

Today's date_____

Jar 5: room temperature
— sterile

Today's date_____

Jar 6: room temperature
— not sterile

Today's date_____

Get a Hold on Mold *(cont.)*

Calendar

Sunday	Monday	Tuesday	Wednesday	Thursday	Friday	Saturday

The Litter of Life

Fancy That It's a Fact!

Trees shed their leaves, flowers drop their petals, and birds lose their feathers. These are examples of nature's litter. These things are all part of a natural cycle and, when dropped on the ground, they will eventually rot or *biodegrade*, slowly turning into dirt. Humans drop candy wrappers, cigarette butts, and unwanted plastic containers. These are examples of human litter, often called *garbage* or *pollution*. Many of the things that humans throw away are *non-biodegradable*. This means that they do not "rot" like natural litter. This is a problem because we are running out of places to store our litter. This is why it is important for each of us to think more about the amount of human litter we produce and about ways we can decrease the amount we create.

Materials

- two clean, wide-mouth glass jars with lids (labels removed)
- dirt (from ground outside or purchased potting soil)
- water
- masking tape
- paper and pencil
- calendar
- rubber gloves or plastic bag
- newspaper
- notebook paper

Let's Do It!

1. Go outside and collect three or four small pieces of human litter that you find lying on the ground (cigarette butts, pop tabs, foil wrappers, plastic, etc.). Wear rubber gloves or use a plastic bag to pick up the objects.

2. While outside, also collect three or four small pieces of natural litter that you find lying on the ground (dead leaves, twigs, apple cores, etc.).

3. While still outside, fill each of the wide-mouth jars half full with dirt.

The Litter of Life *(cont.)*

4. Place pieces of human litter in one jar and pieces of natural litter in the other jar. Cover the litter with enough dirt to fill the jars. Add a small amount of water to each jar and screw on their lids.

5. Use masking tape and pencil to label the jars: "Human Litter" or "Natural Litter."

6. On a piece of notebook paper, describe what you think the litter in each jar will look like after one month. Keep this paper with the jars.

7. Now ask your parent or another adult in the house if he or she knows of a safe, dark place where you might store your jars for one month. After getting permission, put the jars in this place.

8. On your calendar, mark off the days that you will check the jars. (See the sample on page 139.) You should try to look at least once a week. On a separate piece of paper, write down the place where you stored the jars and the dates when you are supposed to check them. Post this note in a place where you will be able to see it and where it will remind you to look at the jars (refrigerator, bathroom mirror, etc.).

9. On each of the dates you have chosen, look at the jars. Look through the jars to see if you can see any changes happening inside. When one month has passed, do a final check on the jars. Go outside and dump the contents of each jar onto a piece of newspaper. Compare what you see to what you wrote on your paper one month ago. The human litter should look almost the same as it did when you put it in the jar over a month ago. The natural litter should look different. The natural litter should have begun the rotting process and should look like it is slowly on its way to turning back into dirt.

10. Talk with your friends, parents, and other adults about why human litter is a problem. Perhaps you can explain to them why human litter is called pollution and natural litter is simply considered natural.

11. When you are done examining and talking about the litter, using your gloves, remove any remaining pieces of litter from the dirt pile and place in the garbage.

The Litter of Life (cont.)

Human Litter and Natural Litter

Human Litter

Natural Litter

138

The Litter of Life *(cont.)*

Calendar

Month: _____

Sunday	Monday	Tuesday	Wednesday	Thursday	Friday	Saturday
			Put jars in a dark place.			
			Check jars.			
			Check jars.			
			Check jars.			

Month: _____

Sunday	Monday	Tuesday	Wednesday	Thursday	Friday	Saturday
			Check jar a final time and dump.			

Recycled Art

Fancy That It's a Fact!

Many of the items that we consider garbage can actually be reused or recycled. To reuse an object means that when we are done using it for its original purpose, we clean it and use it again for another purpose. For example, many people clean old car tires and reuse them by making tree swings for kids. To recycle an object means that when we are done using it for its original purpose, we turn it into another product. For example, when we recycle soda cans, we return them to the manufacturer, who cleans them, melts them, and uses the melted aluminum to make new cans. In this exercise, we will recycle trash by turning it into art.

Materials

- paper bag
- glue
- string
- scissors
- clothes hanger
- hammer and a nail
- gloves
- recyclable objects collected by you (aluminum cans, plastic bottles, paper, etc.)

Let's Do It!

1. From either inside or outside of your home, collect recyclable objects that have been abandoned by people as trash (Use gloves.). For example, take a walk around your block or town and collect objects such as cans, newspaper, and/or pieces of wire or plastic. Use your paper bag to carry the found objects.

2. Talk to friends or relativess about ways that each of the objects you collected could be recycled or reused.

3. Rinse and dry the items if they are dirty or sticky.

4. Choose those objects from your paper bag that you think would look nice or would make nice sounds if attached to a mobile or wind chime. Choose about six objects.

Recycled Art *(cont.)*

4. Cut pieces of string to several different lengths. Some can be as long as one foot (30.5 cm), while others can be as short as 4 inches (10 cm). You should have the same number of string pieces as you have recyclable objects.

5. Now attach each of your chosen recyclable objects to a piece of string. Do this by either tying the object onto the string with a knot or by gluing the object to the string. Be sure to let the glue dry for at least five minutes before moving on to the next step. If you are using metal (aluminum or tin) objects, ask an adult to help you make a hole through which you can tie a string. An adult can use a hammer and nail to pound a hole into metal objects.

6. Attach the free end of each string to the clothes hanger so that the objects hang next to each other in an interesting pattern. To attach the strings, simply knot them to the bottom of the coat hanger. To keep them from moving and sliding, you can glue the strings in place after they have been knotted.

7. Hang your recycled art (mobile or wind chime) outside so that the sun can light up the objects and the wind can blow them around. If you would prefer to keep your wind chime inside, hang it in a window or doorway so the recyclable objects can move freely.

Helping Hands for Change

Fancy That It's a Fact!

A *political advocate* is a person who is willing to speak up for what they think is right and to persuade *political officials* (like town representatives, city mayors, state governors, etc.) to make changes. Every person has a right to speak out and make his or her concerns known to those people in government who make decisions. Even you can make a difference by speaking your part and telling your story. Ask your local representative to act in your community. Let him or her know that you have something to say and want something changed by sending a letter and asking for a helping hand.

Materials

- white paper
- envelope
- pencil
- postage stamp
- name and address of official (county supervisor, mayor, congressperson, etc.)
- scissors

Let's Do It!

1. Place your hand palm down on a piece of white paper. Use your other hand to hold a pencil and trace the outside of your hand. When you are done, you should see an outline of your hand on the paper.

2. Now cut out the outline of your hand with scissors.

3. Write "Be a helping hand" on one side of your cutout hand.

4. On the other side of your cutout hand, write a short sentence describing one thing you would like to have fixed or changed in your town. Be sure to mention the name of your town and the reason you would like to see a change.

5. Sign your hand-shaped postcard. Be sure to write your address as well as your name.

6. Discuss with your parents the problem you have identified and ask them to mail your message to the appropriate political representative or official. You can find the correct address in the government pages in the telephone book.

Be a Helping Hand!

Community Trash Pick-Up Day

Fancy That It's a Fact!

Your neighborhood is not safe from pollution. Every day, people drop trash on the street, on the sidewalk, and out of car windows. Each little piece lands on the ground, eventually building up and polluting your neighborhood. This litter is not only ugly and sometimes unsanitary, but it can also cause other problems such as ground water pollution. Some neighborhoods and communities have organized clean-up days. Check to see if yours does by asking at your local school, post office, or community center. If nothing is already organized or if you want to help out more by "doing your own thing," get together with some of your friends and do something about it. Pick up unsightly trash and make your neighborhood more beautiful.

Materials

- friends
- garbage bags
- rubber or plastic gloves
- colored marker
- masking tape

Let's Do It!

1. Invite some of your friends in the neighborhood to participate in a community trash pick-up for an afternoon.

2. Using masking tape and a colored marker, label one garbage bag "Non-recyclable Trash," another "Recyclable Plastic," and another "Recyclable Glass." Finally, label one garbage bag "Recyclable Paper."

3. Discuss with an adult what type of trash should go into each labeled bag.

4. With your group of friends and at least one adult volunteer, walk around your neighborhood and "clean it up." Place the trash that you pick up into the appropriate trash bags. Make sure that you and all of your friends are wearing rubber or plastic gloves while picking up the garbage.

5. Take all of the recyclable trash that you collected to the appropriate recycling center.

Community Health

Your Healthy Community

Fancy That It's a Fact!

What does community mean to you? A *community* can be people who live in your neighborhood. A community can be people who share your ethnic background and culture. A community can be a group of people who have similar interests. To what communities do you belong?

Although there are many things we each can do on our own to protect our health, such as brushing our teeth and eating a balanced meal, there are many health problems faced by communities that can only be solved as a group. Becoming involved in your community is an important and effective way to ensure that everyone has the opportunity for healthy living. The activities in this section are suggestions for how to become involved in your community and how to get members of your community to take action to improve their health. Each activity requires your creativity and imagination. In addition, because you will be working with lots of people, you will have to find a way to communicate with everybody. Consider using one or more of the following methods of communication to help you in organizing the activities: telephone or telephone chain, fliers handed out or posted in the community, e-mail, contact lists, meetings, talking to people face to face, and announcements at group functions. Also, think about the places where you can

contact groups of people, such as at school, at church, at community meetings, at community centers, and at fairs or festivals. Some of the activities could be adapted to raise money for a charity or organization. If you choose to do this, first contact the charity to find out their procedures for raising money and whether or not they have someone who could help you organize your project. Be sure to designate a responsible adult to be in charge of the money.

Your Healthy Community *(cont.)*

Some Ideas

1. Community Triathlon

Organize a triathlon in your community. Pick three sports in which most people can participate (e.g., jumping rope, biking, and running) and find a location to hold the triathlon, such as a local park or a school playground. Form a committee of community members to make up the rules, get the equipment, publicize the event, recruit participants, and plan for refreshments.

2. Grocery Store Inventory

Go to your local neighborhood grocery or convenience store with a clipboard, paper, and pencil. Write down the kinds of foods they sell, both the healthy and the not so healthy. See the Nutrition sections (beginning on page 21) for more information on the value of foods. Remember that nutritious and fresh foods are often better for you than sweets and other processed foods. Which types of food are the easiest to find on the shelves? Notice the kinds of food that are located at the checkout stands. How many aisles have healthy foods? How many aisles have "junk food"? If you find that there is too much unhealthy food and not enough healthy food, start a neighborhood petition. Ask the store to carry more fruits, vegetables, and healthy snacks and fewer potato chips, candy, and other unhealthy foods. Present the petition to the store manager.

3. Advertisement Advocacy

Gather a group of friends and adults to walk around your neighborhood. Look at billboards and other advertisements posted. How many are for healthy products or activities (e.g., healthy food, medical care), and how many are for unhealthy products and activities (e.g., cigarettes, alcohol)? Keep a list of the good and bad advertisements in a notebook. If you notice that your community has more negative advertising than positive, send a letter to your local representative requesting action. (See telephone directory for addresses.)

Your Healthy Community *(cont.)*

4. Seatbelt Safety Weekend

Make some large signs that say "Seatbelts save lives!" or "Buckle up!" and/or other seatbelt safety messages or pictures. Ask local store owners if they are willing to hang your signs for a weekend. Get people talking! Make a special attempt to talk to people that weekend about the importance of seatbelts and why it is important to wear them. Ask your neighbors and friends if they have seen your signs and if they wear seatbelts. Don't forget to take your signs down and to thank the store owners after the weekend.

5. Neighborhood Watch

Call your local police department and ask them how to set up a neighborhood watch on your block. A neighborhood watch can not only help to reduce crime but it can also help the members of your block get to know each other better.

6. Preparing for Disasters

Call the Red Cross and ask them what you need to do to be prepared for a natural disaster such as an earthquake, flood, tornado, or hurricane. Share this information at a neighborhood meeting or see if the Red Cross is willing to send a representative to talk to your group. Instead of preparing as individual families, your community may decide to share the responsibility for being prepared. For example, five people might be in charge of storing most of the water, and five people might be in charge of storing most of the medical supplies. Supplies could be stored in a communally accessible location.

Your Healthy Community *(cont.)*

7. Neighborhood Walk

Start a regular, weekly neighborhood walk. Pick one route you will walk every week, or pick a new route each week. Make a goal to get at least one new person to join you on the walk every week.

8. Plant a Tree

Find a local park where you can plant a tree. Be sure to get permission from park officials. Purchase a tree at a nursery and plan a tree-planting ceremony. Invite members of the community to the event, and gather in the park afterwards for refreshments, fun, and games.

9. Neighborhood Clean-up

Is there a public place such as a beach, park, or sidewalk in your community that needs to be cleaned up? Could picking up pieces of trash and litter make a difference? Organize a group of people to make the place cleaner. Invite others to see the wonderful job you did.

Your Healthy Community *(cont.)*

10. Volunteer

Find a local agency that needs volunteers. Sign up with an adult to be a volunteer. You might deliver meals to people who are sick, visit people in the hospital, read books to blind people, or collect canned food or old clothes for the homeless or needy. Participate in walks, runs, and bike rides that support AIDS, breast cancer, or other important causes. By getting involved in your community, you will not only help others, but you will also have a lot of fun!

11. Community Poll

Knock on your neighbors' doors and ask them what their most important concerns are about the community. They might mention things such as violence, graffiti, poor public transportation, poor housing conditions, or a lack of public parks in which children can play. Type up what everyone says and present your results to your local government representative.

12. Community Newsletter

Start a community or neighborhood newsletter or Web page that focuses on health issues. In each issue, do a story about a different person in the community and what he or she does to stay healthy. Get other ideas for what to include from the health section in your local newspaper, on the Internet, and from friends and neighbors. Ask local businesses if they would like to sponsor coupons for products that can help people stay healthy and safe (e.g., coupons for low-fat snacks, sports equipment, car seats, etc.).

Your Healthy Community *(cont.)*

13. Alternative Transportation Day

Plan a day for everyone in your apartment building, on your block, or in your neighborhood to find an environmentally healthy way to get to work. People might decide to carpool, ride the bus, walk, or ride a bike. Have people sign up to participate, and distribute the list so that people can arrange to travel together.

14. Buddy System

Pair up people in your community to be "better behavior buddies." Some people might want a partner to take morning walks. Others might want someone to call who can talk them out of eating a candy bar when they are on a diet. Have people sign up on the list if they want a buddy or want to be a buddy. Ask them to say what they are looking for in a buddy. Pair up people according to their needs and interests.

15. Speak Out with Pictures

Get a group of people together and take pictures of the good things in your community and of those that need improvement. Develop the pictures and have a group meeting where you pick the pictures that tell the best story about your community. Together, make two collages: one that shows the positive aspects of your community and one that shows the things that need improvement. You might display these in a local community center, church, or school. Pick one thing that needs improvement and decide as a group what needs to be done. You may need to get help or support from local government representatives, school officials, or the police department, depending on what you choose to do. Make a plan and do it!

16. Community Resource Directory

Make a directory of community resources for health and safety. Include contact information for your local police department, the Red Cross, local hospitals and clinics, hotline numbers for suicide and other problems, and anything else you think is important. Talk to your neighbors and friends for more ideas. Contact your local health department and ask them if they have a list of community health resources. Distribute the directory to community members.

Glossary

Glossary

A

Advocate—the act of pleading for or supporting a cause; a person who is willing to speak up and act for what he or she thinks is right and to speak on behalf of others.

Aerobics—exercise that increases the fitness of the heart, lungs, and circulatory system by pumping oxygen through the body.

Anger—a feeling of displeasure and/or frustration.

Antibodies—proteins in the body that fight off infection.

B

Biodegradable—able to be broken down into parts by living things; able to rot.

C

Cardiovascular System—the system that allows the heart and lungs to work, pumping blood and oxygen through the body.

D

Dendrite—branch-like part of a nerve that sends messages toward the nerve cell body.

Disease—a condition in which normal bodily health is impaired; illness or sickness.

E

Emergency—a set of conditions or circumstances that demand immediate action and assistance.

Emotions—feelings and impulses such as happiness, anger, and sadness.

F

Fitness—the quality of being in good physical and mental condition.

Flexibility—the quality of being able to move and bend easily.

Glossary (cont.)

G

Germs—very small living organisms (like bacteria) that can enter human bodies and make them sick.

H

Habits—those activities or actions that a person does on a regular basis (daily, hourly, etc.).

Hygiene—set of guidelines or ways to act that promote good health.

I

Illness—when a person does not feel well; sickness.

Infection—to be contaminated with germs or other illness-causing agents.

L

Lymphocyte—a type of white blood cell that uses antibodies to fight off infection.

M

Matzo—unleavened (cooked without yeast) bread; a wafer of unleavened bread.

Mineral—a chemical element needed by the body for good health; a nutrient.

Muscle—a part of the body whose special function is to help with motion.

N

Nervous system—a network of nerves responsible for coordinating messages among different parts of the body and for telling the part(s) how to move and react.

Nucleus—central part of a cell.

Nutrients—good and healthy ingredients of food (e.g., vitamins and minerals).

Nutrition—the study of how the body needs and uses food.

Glossary *(cont.)*

P

Phagocyte—a type of white blood cell that fights off infection by eating unwanted cells.

Pollution—the action of polluting, being unclean, or contaminating something that pollutes.

Poison—any product that when introduced into the body causes harm, injury, or death.

R

Recycle—to reuse an object or to process its material for another use.

S

Sensory Organs—those organs in the body which allow it to feel and interact with the environment (e.g., eyes for seeing, nose for smelling, and skin for feeling).

Stress—a factor or influence that causes physical or emotional tension.

Symptom—a sign that indicates illness or other changes in normal bodily function.

T

Tooth decay—the process of breakdown and rotting of the teeth.

Toxins—substances that can cause injury, illness, or death if introduced to the body.

V

Vitamins—special components of food that are very important for normal bodily function and good nutrition; a nutrient.

Resource List

Resource List

General Health

Internet

About.com: http://home.about.com/health/index.htm

American Medical Association: http://www.ama-assn.org

AskERIC: http://ericir.syr.edu/

Ask NOAH About:
http://www.noah.cuny.edu/qksearch.html

Centers for Disease Control: http://www.cdc.gov

KidsHealth.org (The Nemours Foundation):
http://www.kidshealth.org

World Health Organization: http://www.who.int/

Books

Brown, Laurie Krasny, and Marc Brown. **Dinosaurs Alive and Well! A Guide to Good Health.** Little, Brown, 1990.

Ptacel, Greg. **Champion for Children's Health: A Story About Dr. S. Josephine Baker.** Carolrhoda, 1994.

Body Basics

Internet

The American Heart Association:
http://www.americanheart.org

The Franklin Institute Science Museum, The Heart: An Online Exploration: http://www.fi.edu/biosci/heart.html

The Immune System:
http://library.thinkquest.org/10348/find/content/immune.html

Neuroscience for Kids: http://weber.u.washington.edu

Books

Balkwill, Fran. **Cells Are Us (Cells and Things).** Carolrhoda, 1994.

Berger, Melvin. **Germs Make Me Sick!** HarperCollins, 1995.

Bryan, Jenny. **What's Wrong with Me? What Happens When You're Sick, and Ways to Stay Healthy.** Thomson Learning, 1995.

Cole, Joanna. **The Magic School Bus: Inside the Human Body.** Scholastic, 1989.

Resource List *(cont.)*

Body Basics *(cont.)*

De Paola, Tomie. ***Now One Foot, Now the Other.*** Putnam, 1981.

Frasler, David and Kelly McQueen. ***What's a Virus, Anyway? The Kids' Book About AIDS.*** Waterfront, 1993.

Forbes, Anna. ***When Someone You Know Has AIDS.*** Rosen/Power Kids, 1996.

Janulewicz, Mike. ***Yikes! Your Body, Up Close.*** Simon & Schuster, 1997.

Katz, Bobbi. ***Germs! Germs! Germs!*** Scholastic, 1996.

Parker, Steve. ***The Body Atlas: A Pictorial Guide to the Human Body.*** DK Publishing, 1993.

Saunderson, Jane. ***Heart and Lungs.*** Troll, 1992.

Suzuki, David, and Barbara Hehner. ***Looking at the Body.*** Stoddart, 1991.

Vigna, Judith. ***When Eric's Mom Fought Cancer.*** Albert Whitman, 1993.

Nutrition

Internet

Food Fun for Kids: http://www.nppc.org/foodfun.html

The Kids' Food Cyberclub: http://www.kidsfood.org/

Meals for You: http://mealsforyou.com

Mom's Kid Page: http://www.seaside.net/homepage/bernardy/menupage.html

24 Carrot Press: http://www.nutritionforkids.com/

United States Department of Agriculture Food and Nutrition Information Center: http://warp.nal.usda.gov/fnic/

Books

Brown, Laurie Krasny. ***The Vegetable Show.*** Little, Brown, 1995.

D'Amico, Joan, and Karen Eich Drummond. ***The Science Chef: 100 Fun Food Experiments and Recipes for Kids.*** Wiley, 1994.

Ellison, Sheila, and Judith Gray. ***365 Foods Kids Love to Eat.*** Sourcebooks Inc., 1995.

Resource List (cont.)

Nutrition (cont.)

Griffin, Margaret, and Deborah Seed. **The Amazing Egg Book.** Addison-Wesley, 1990.

Leedy, Loreen. **The Edible Pyramid: Good Eating Everyday.** Holiday, 1994.

Nissenberg, S., and H. Nissenberg. **I Made it Myself! Mud Cups, Pizza Puffs, and Over 100 Other Fun and Healthy Recipes for Kids to Make.** Chronimed, 1998.

Patent, Dorothy Hinshaw. **Nutrition: What's in the Food We Eat.** Holiday, 1992.

Powell, Jillian. **Food and Your Health.** Raintree Steck-Vaughn, 1997.

Pinkwater, Daniel. **Fat Men from Space.** Dell, 1980.

Robinson, Fay. **Vegetables, Vegetables!** Children's, 1994.

Fitness

Internet

Benny Good Sport: http://www.bennygoodsport.com

Betterbodz: http://www.betterbodz.com

The Fitness Partner Connection:
http://primusweb.com/fitnesspartner/

Lifestyle Changes:
http://www.fitnesslink.com/changes/kidsfit.htm

Books

Parsons, Alexandra. **Fit for Life.** Watts, 1996.

Powell, Jillian. **Exercise and Your Health.** Raintree Steck-Vaughn, 1997.

Healthy Habits

Internet

American Dental Association Kids' Corner:
http://www.ada.org/consumer/kids/index.html

Centers for Disease Control, Smoking Prevention Tips for Kids: http://www.cdc.gov/tobacco/tipskids.htm

National Council on Alcohol and Drug Dependence, Information for Youth: http://www.ncadd.org/youdir.html

Smart Kids Against Drugs:
http://www.keystonehall.org/kids.htm

Resource List (cont.)

Healthy Habits (cont.)

Books

Haughton, Emma. **A Right to Smoke?** Watts, 1997.

Kreimer, Anna. **Let's Talk About Drug Abuse.** Rosen, 1996.

Langsen, Richard C. **When Someone in the Family Drinks Too Much.** Dial, 1996.

Ripley, Catherine. **Why Is Soap So Slippery? And Other Bathtime Questions.** Firefly, 1995.

Safety

Internet

Just for Kids! Police Safety Tips:
http://citylf.lfc.edu/police/misc/kidspage.htm

National Crime Prevention Council:
http://www.ncpc.org/ncpc1.htm

United States Fire Administration Kid's Page:
http://www.usfa.fema.gov/kids/index.htm

Books

Boelts, Maribeth, and Darwin Boelts. **Kids to the Rescue! First Aid Techniques for Kids.** Parenting Press, 1992.

Loewen, Nancy. **Emergencies.** Child's World, 1996.

Feeling Good

Internet

National Mental Health Association:
http://www.nmha.org/children/index.cfm

Books

Berstein, Joanne E., and Paul Cohen. **Dizzy Doctor Riddles.** Whitman, 1989.

Keroppi and Friends: **The Best Friends Book.** Scholastic, 1989.

Lanksy, B. **Kids Pick the Funniest Poems: Poems That Make Kids Laugh.** Meadowbrook Press, 1991.

Environmental Health

Internet

Agency for Toxic Substances and Disease Registry:
http://www.atsdr.cdc.gov/

Environmental Protection Agency: http://www.epa.gov/

Kids for Saving Earth Web Page:
http://kidsforsavingearth.org

National Institute of Environmental Health Sciences:
http://www.niehs.nih.gov/

Resource List (cont.)

Environmental Health (cont.)

Internet (cont.)

Sally-Save-Water Awareness Program: http://www.sally-save-water.com/

Books

Bang, Molly. **Common Ground: The Water, Earth, and Air We Share.** Scholastic, 1997.

Burningham, John. **Hey! Get Off Our Train.** Crown, 1990.

Gates, Richard. **Conservation.** Children's, 1982.

Gibbons, Gail. **Recycle! A Handbook for Kids.** Little Brown, 1992.

Greene, Carol. **Caring for Our Land.** Enslow, 1991.

Lauber, Patricia. **Who Eats What? Food Chains and Food Webs.** HarperCollins, 1995.

Sexias, Judith S. **Water—What It is, What It Does.** Greenwillow, 1987.

Seuss, Dr. **The Lorax.** Random, 1971.

Community Health

Internet

Community Learning Network, Open School, Open Learning Agency, For Kids Only: http://www.cln.org/kids/index.html

National Wildlife Federation: http://www.nwf.org/nwf/.html

Peace Corps Kids World: http://www.peacecorps.gov/kids

Books

Asch, Frank. **Hands Around Lincoln School.** Scholastic, 1994.

Kopstick, Anne. **My First Camera Book.** Workman Publishing, 1989.